DRAWING
WILDLIFE

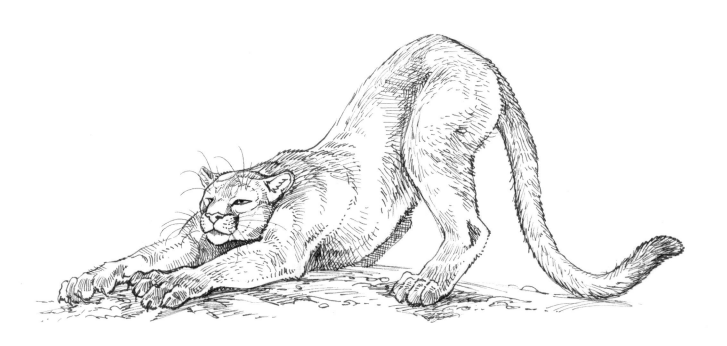

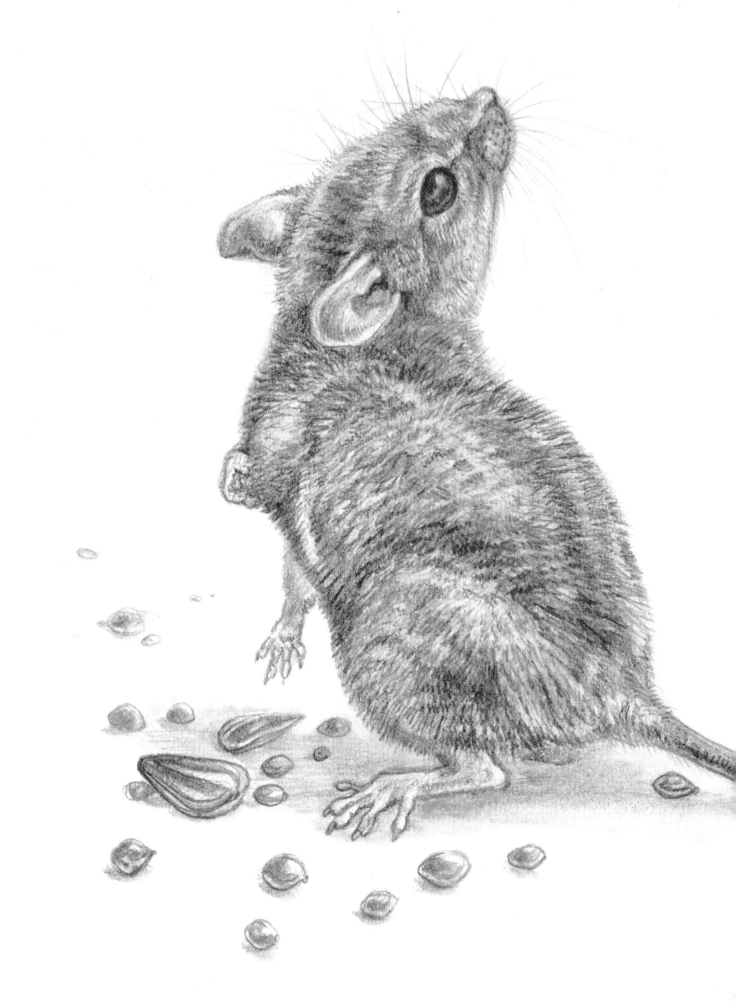

DRAWING WILDLIFE

J.C. AMBERLYN

WATSON-GUPTILL PUBLICATIONS / NEW YORK

This book is dedicated to my mom. She has been a lifetime supporter of my art and education, and has been the picture of patience and good grace over the years as I dragged home one dead thing after another! She has always been my rock, and I am very grateful to her.

I also dedicate this book to my deaf dog, Mack, who has been here by my side from start to finish.

ACKNOWLEDGMENTS

THIS BOOK WOULD NOT HAVE BEEN POSSIBLE without the generous assistance and time of many people. I would like to thank the following people for their support, help in finding reference material, or just plain encouragement: Candace Raney, Michelle Bredeson, and Watson-Guptill for giving this book the green light, Den Miles, Debbie Hagan, Melba Hagan, Laurine Hayden, Mike Tacha, Judith Doerr, Ingrid and Charley (and Rocky) Lee, Marc, Lynne, and Shea Stiegler, Andrew, Stephanie, and Caytlin Reece, Jay Burnhan-Kidwell, Alice Selby, Dick Snell, John Phelps, Steve Transue, J. D. and Yula Daniels, Dr. Paula Acer, Henry Aguilar, Lee Henry, Mel Wilhelm, Gwen Brock, Kristina Bossaert, Stevi Brock, and David Hagan. A special thanks to Stan and Gaye Hagan for the wonderful tolerance they showed when I picked up that dead 'possum on the way to their daughter's wedding! The Arizona Game and Fish Department was very helpful, and I'd like to thank Kristen Hoss and the other members of the Arizona Black-footed Ferret Recovery Team. Thank you to my friend Rosie Bruno and the others who helped me at the Adobe Mountain Wildife Center. I also extend a heartfelt thanks to my friends for their help and reference material: Eric Elliot, Kayotae Blackwolf, Lex and Dale Nakashima, Karena Kliefoth, Scott Ruggels, Roz Gibson, Dwight Dutton, Heather (Kyoht) and Gre(7)g Luterman, Tracy and Brian Reynolds, Harry Kyle (Timberwolf), Lori Piestrup, Ashley Cleveland, Ron Johnson, Michael Russell, Erin Middendorf, Dan Pankratz, Katy Hargrove, Michelle Ridge, "Vantid," "Orca Noda," "Level Head," "Kayucian," and all my other on-line friends! Thank you to all who have provided friendship and support over the years!

EXECUTIVE EDITOR: Candace Raney
EDITOR: Michelle Bredeson
DESIGNER: Patricia Fabricant
PRODUCTION MANAGER: Hector Campbell

Library of Congress Cataloging-in-Publication Data

Amberlyn, J.C.
 Drawing wildlife / J.C. Amberlyn.
 p. cm.
 Includes index.
 ISBN 0-8230-2379-6 (alk. paper)
 1. Mammals in art. 2. Drawing—Technique. 3. Mammals—North America. I. Title.
 NC780.A475 2005
 743.6'9—dc22

 2004026383

Manufactured in the U.S.A.

First printing, 2005

1 2 3 4 5 6 7 8 9 / 13 12 11 10 09 08 07 06 05

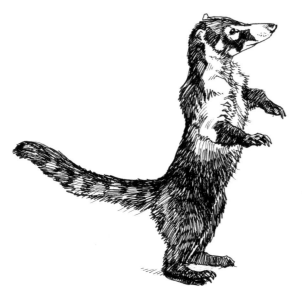

CONTENTS

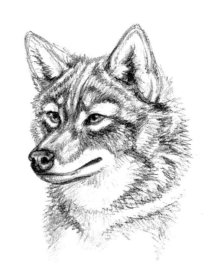

INTRODUCTION

THERE IS SOMETHING ABOUT ANIMALS that speaks to the human soul, and something magical about the attempt to "capture" that spirit and put it down on paper for posterity. That elusive and intangible element is magnified a hundred-fold when the subject of such a drawing is a wild animal, that creature that lurks at the edges of our communities and our consciousness. However, wild animals can be known, they can be drawn, and they can even become familiar individuals, with stories and faces of their own, if only we allow enough time to get to know them. It is not an easy process, but it is, I think, an immensely satisfying one, and every person's journey into their world is different.

In this book, I focus on the wildlife I know best—North American mammals. Here you will find detailed information about most of the common mammal species of North American wildlife, including color markings, body shapes, and behavior. While the focus of this book is on the structure and appearance of various animal species, I believe that a knowledge of animal behavior is vital to understanding your subject and what makes it "tick," and therefore, to creating a convincing piece of animal art that goes beyond a mere construction of anatomy and into a semblance of life.

Despite the focus on North American species, I hope that this book will also be helpful to wildlife artists around the world. Many species found in North America, such as the brown bear, gray wolf, red fox, elk (red deer), moose (elk), weasel (stoat), otter, and marten, are also found elsewhere as either the same or a very similar species. There may be subtle differences from one continent to another, but the basics should be the same.

HOW TO USE THIS BOOK

This book assumes that you already possess some fundamental drawing skills, such as how to build a frame or form using common building blocks like circles and squares, and a little about such basics as how light and shadow add depth to a form. I will touch upon some of these things in this book, but it is not meant to be a beginner's guide to drawing.

This book is the result of my experience observing wildlife and my interpretations of what I have seen. There are many different ways of interpreting the same information, and while I have done my best to portray wildlife as accurately as possible, do not take my art or text as the final word. Get out there and do your own research. In a few cases, the information I obtained about a particular species came from one individual animal that I was able to study up close. While I have strived for accuracy and tried to back up my findings with information from other sources, there is the possibility that part of what I believe is typical for a species may instead be unique to an individual that I have studied, and not representative of all of its kind. Once again, doing your own research is important. This book, and the drawings in it, are meant to help you understand the form and function of animal bodies and to clarify markings, concepts, and shapes that may be difficult to see in life or even in a photo. It is meant to be a useful guide and a starting point—it is not meant to relieve you, the reader and artist, of doing your own research and finding your own artistic voice and knowledge. Some of you are further along that path than others; to the more advanced artists, I hope that you find the information in this book helpful. If you are like me, you may at least find it interesting to see how another artist tackles some of the same problems that have

challenged you. I have tried to put in a variety of information on each animal type, with the idea that hopefully there will be something here for everyone.

Throughout the book, I have used a combination of detailed, realistic drawings that are meant to be literal interpretations of wildlife, and much more stylized, abstract drawings in which I try to emphasize particular shapes, patterns, proportions, or "rhythms" that make one species or group stand out from another. In these I tend to exaggerate the building blocks of the form and show how it is put together and how the parts fit together. I also have many small step-by-step drawings scattered throughout, showing various ways of building up a form. Experiment with drawing these, and try finding your own methods, too. At the end of each family or other group of animals, I include a detailed step-by-step demonstration of a particular animal from that group. You are encouraged to use the drawings in

this book to help you practice and learn techniques that may help you when you are coming up with drawings of your own. There is no shame in copying from others while learning to draw; most, if not all, artists have gone through that stage. Ultimately, your goal should be to draw without copying (although using some reference is fine)—then you will have truly come into your own and be producing your very own, unique style of wildlife art.

Beyond all this, I would like to thank you, the reader, for picking up that pencil or pen and tackling the sometimes tricky but immensely rewarding subject of wildlife drawing. As our human population grows, and wildlife habitat shrinks, it becomes increasingly important that there are those of us who can capture some essence of the beauty and drama that is the wild world, and share it with others, so that they know it exists, and hopefully, so that they CARE that it exists.

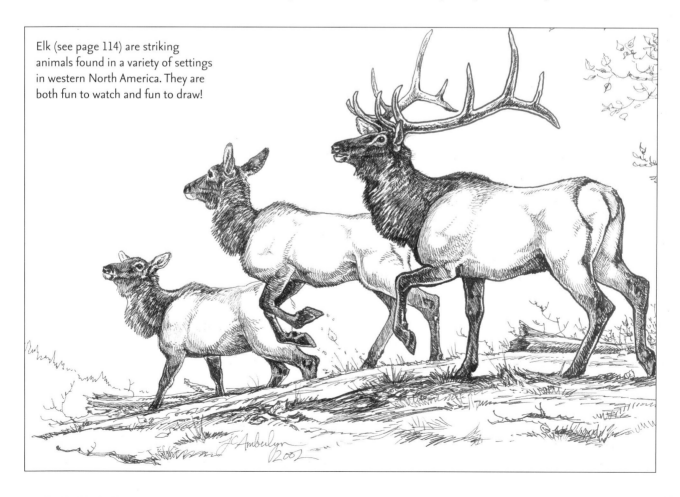

Elk (see page 114) are striking animals found in a variety of settings in western North America. They are both fun to watch and fun to draw!

THE BASICS

THE FIRST PART OF THIS BOOK is titled "The Basics," and is intended to be just that: a broad look at some basic concepts and techniques to help you on your artistic journey into the world of wildlife. In it you'll find a combination of tried-and-true art techniques used by many people and some things that reflect more of my own personal experiences.

Drawing wildlife is a delicate balance of science and art. It is a challenge to convey true-to-life species depictions while transcending mere repetitions of features and form. A knowledge of the scientific side of the equation provides artists with the confidence to experiment, while remaining true to the essence of their subject. A knowledge of the artistic side enables one to convey knowledge in a more innovative manner. But wildlife art without scientific understanding (or scientific knowledge without artistic expression) is usually lacking, and people notice it.

I cannot overemphasize the importance of studying anatomy to further your understanding, and this section features several discussions of musculature, bones, and body structure. A wildlife artist (especially of mammals) must also be able to draw fur, hair, antlers, and other features, as well as understand how the animal interacts with its environment.

This book is meant to provide some of this information, but doing your own research is crucial to gaining a true comprehension of your subject. Fortunately, spending time face to face with wild creatures is a uniquely satisfying experience. In the following pages, I offer some suggestions on ways to begin or to continue research of your own.

BASIC ANATOMY

IN ORDER TO CORRECTLY DRAW WILD ANIMALS, and to be able to draw them in any pose you desire, it is essential that you understand basic anatomy. There is no other single more important aspect of becoming good at drawing wildlife—you must understand at least the basics of what is going on beneath the fur and skin.

Underlying muscle creates many bulges and hollows on the surface of a short-haired animal that must be drawn correctly, or it will throw off your entire drawing. Even drawings of long-haired animals are not very forgiving of anatomical errors. In fact, understanding anatomy can be even more critical with such a furry subject, especially in your ability to look at references (live specimens or photos) and interpret what you see correctly. You cannot overdo research on anatomy. Study illustrations and photos and copy down every bone. Examine skeletons on display at your local natural history museum. Gently poke and prod your dog or cat (or rabbit or ferret or...), to the extent that it will allow you to, feeling its bones and muscles and seeing how they work. Look at road kill. Use any opportunity to learn about anatomy.

SKELETON, MUSCLES & SURFACE STRUCTURE

In this case, I have chosen a medium-size canine to illustrate basic mammal anatomy. Dogs are more generalized than specialized and provide an acceptable start toward understanding mammal skeletons in general. Other mammals share the same basic structure, but the proportions may be different. For instance, a weasel has a similar skeleton, but it's "stretched" and the legs are much shorter. Also note that bones are not generally straight but are curved to some degree.

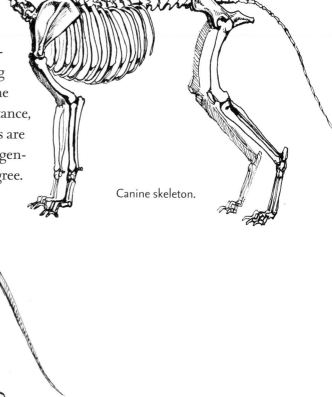

Canine skeleton.

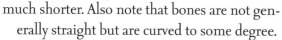

Canine muscular structure.

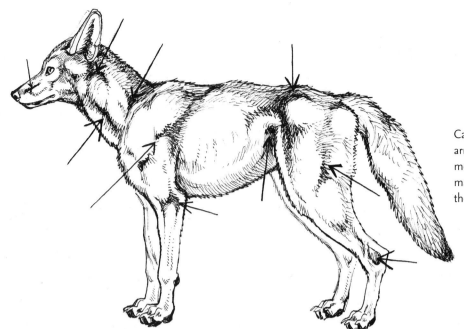

Canine showing surface anatomy. The arrows indicate some of the more common hollows, creases, or bulges seen on many mammal's bodies as a result of the muscles and bones underneath.

COMPARING HUMAN ANATOMY

You also have one other source of anatomical knowledge—and it can be found in the nearest mirror—yourself! Because humans are mammals, we share similar skeletal and muscular structure, although ours is an upright frame. However, if you break our structure down into parts, such as legs or hands, you will find that it is similar to an animal's structure. Visualizing the human body can be helpful in solving anatomical challenges in drawing animals.

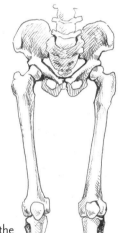

Notice the similarities and differences between the pelvis of a mule deer (LEFT) and a human (RIGHT).

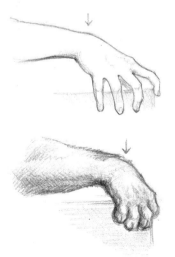

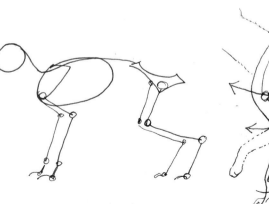

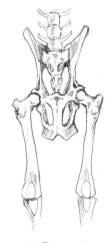

FRONT LEG HIND LEG

Note how the structure of the human hand (TOP) is echoed in the structure of this mountain lion's paw (BOTTOM). The arrows indicate the location of the wrist in both species.

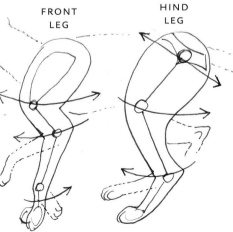

Also note that our joints move the same ways, and that they move the same on all the mammals in this book. The arrows in the above illustrations denote the most forceful path of movement for each joint: frontwards, backwards, or both.

BODY TYPES

In this section, we will look at some basic body types I have observed in wildlife: the carnivore, the omnivore, the hoofed mammal, and the small mammal. Some animals may fall into more than one category; the weasel, for instance, is a mix of carnivore and small mammal. An animal's body reflects what that animal needs to be able to do. Rodents are like furry springs, ready for action at any moment. A weasel or ferret's body reflects its way of catching food: going down long underground burrows in search of prey. A moose has long legs, a strong chest, and a snow shovel-like nose—perfect for plowing through deep snows.

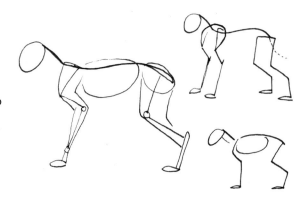

The carnivore varies in body type, from the generalized canine to the specialized stalk-and-pounce feline, but is usually a powerful, agile animal ready to run and pounce.

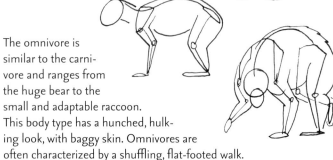

The omnivore is similar to the carnivore and ranges from the huge bear to the small and adaptable raccoon. This body type has a hunched, hulking look, with baggy skin. Omnivores are often characterized by a shuffling, flat-footed walk.

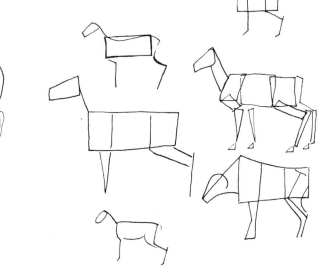

The small mammal has a crouched, ready-to-spring appearance. It usually has a larger head and eyes, proportionately, than the other body types.

The hoofed mammal has a somewhat rectangular body that tends toward fleetness and grace or compactness and power. It can be either slender-legged with a long neck, or compact and short-legged with a short neck and powerful shoulders.

SPRINGS AND TABLES: Another way of looking at large versus small mammals is to think of springs and tables. Small animals are small, nervous, and light-of-foot—always prepared to run from danger. Their bodies are built something like springs, ready for quick action. Larger animals are more like tables: They have much more weight to support with each of their four legs. The larger and heavier the animal gets, usually the straighter its legs stand. The legs all have to balance one another and the weight they hold. Medium-size animals are often some kind of combination of the two.

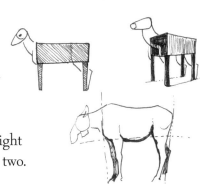

BODY DETAILS

In addition to basic anatomy, there are a few things about a mammal's body I'd like to cover here, rather than mentioning the same thing many times in individual species descriptions.

EYES: The eyes breathe life into a drawing, and if the eyes in a drawing are lifeless, the animal will be too. A highlight brings immediate life to an animal's eyes, because it indicates moisture, which a dead animal's eyes lack. Study animal eyes and how their surroundings are reflected in them. Sometimes you can see faint outlines of trees or grass in a reflection. Reflections may be sharp and white, or soft and muted, depending on the weather, the environment, and other factors. For instance, highlights will be sharper and brighter in bright sunlight, and much more muted and fuzzy on a gray, overcast day.

EARS: The size and shape of an animal's ears vary by family and species. One thing I'd like to point out is the presence of "ear pockets," which can be a source of confusion for artists. The ear pocket is the little pouch of skin found in the inside of the ear of many mammals. It looks as if the skin has been pinched in and a pocket has formed on the outer edge inside the ear. The pocket is behind the pinched area, so it is less noticeable when the animal is directly facing you than in a side view. Indicate the ear pockets on your next wildlife drawing, and it will likely look more accurate. Just be sure that the species has ear pockets!

NOSE: The nose on an animal consists of two nostrils and a fleshy nose pad, which varies in shape and size according to species, in between them. See the various family and species descriptions for more information.

TAIL: Tails can be problematic for some wildlife artists. The key is to study the underlying structure. Try to think of the tail as a geometric shape. Get the shape right, then worry about the fur. Also keep in mind how the fur poofs out in a circle from the tail bone.

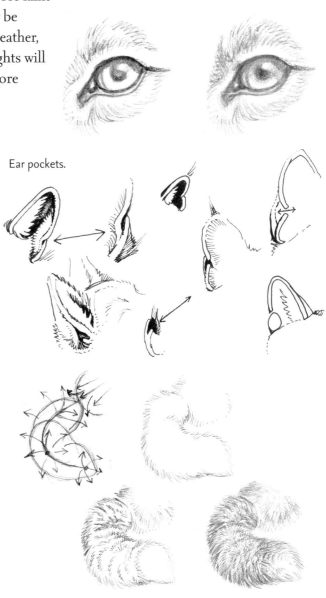

Ear pockets.

Here is an example of a drawing (in pencil) of a red fox tail that is coming slightly forward, toward the viewer. Note how the surface of the hair, or the tips of the hair, circle around the tail bone and, thus, how the fur tips are drawn in a circular manner.

FUR

Having hair is one of the defining characteristics of being a mammal, so fur is an important element in your drawings of wild animals. Fur can be soft on a rabbit, coarse on a bison's beard, or brittle on a pronghorn. Not only does it differ from species to species, but it may change according to season, as well. Most mammals have a summer and winter coat of hair. Their summer coat is shorter and scragglier, and their winter coat is thick, warm, and sleek. Some animals change color from summer to winter, like the startling change of the Arctic fox or the "red to blue" seasonal change of some deer.

Fur can be broken down into geometric clumps or tufts of hair. Keeping geometric shapes in mind as you draw fur may help you to understand it better.

Drawing fur entails the use of many different kinds of lines and shading—study fur to familiarize yourself with drawing it. For this patch of fox fur I used a variety of types of lines.

Soft rabbit fur drawn in pencil. Note how I used soft shading combined with more distinct lines to indicate specific guard hairs (the longer, coarser hairs).

Deer neck hair drawn in pen and ink. Here I used uniform, short lines to indicate the flat, less "fluffy" nature of deer hair.

PORTRAYING DEPTH: The same patch of fur can look different depending on the angle from which you are viewing it. This has a lot to do with the base of the hairs (where they attach to the skin) and how much of them you can see compared to the tips. Hair is often a different color at its base than at the tip. If you are looking at fur "straight-on"—that is, pointed directly at you, you see more detail and more of the base color in the cracks and partings of the hair. If it is angling away from you, you see more of the tips and cannot see down to the base and the skin, so the fur looks sleeker and less detailed. Try to draw the lines indicating the base of the hair, and indicate the hair partings where clumps break from each other, instead of drawing only the outside tips of the hair.

Ringtail fur. Note how the partings themselves flow with the directions of the arrows I've drawn.

WILDLIFE DRAWING BASICS

THERE ARE MANY POTENTIAL MATERIALS AND METHODS to use in drawing wildlife, and few "wrong" ones. Finding what suits you best is a matter of trial and error. In this section, I present the materials I find most useful in rendering wildlife, as well as some tips and techniques for improving your drawings.

DRAWING MATERIALS

There are so many high-quality drawing materials available, your main problem will be deciding which you like best. Here are a few of the materials I use most often and the ones I used for the drawings in this book. What works for me may not work for you. You may find a certain kind of pen is especially fluid and comfortable in your hand, or perhaps you enjoy the smudgy soft shading of a particular charcoal pencil.

PENCILS: As you may already know, drawing pencils come in letters or numbers that indicate softness of lead, from the very hard 6H, to the fairly standard medium softness of the HB, to the very soft 6B. In doing the drawings for this book, I generally used a 2H pencil to lightly block in the basic form, then went in with a 2B for most of the drawing. I rarely used a 6B lead. I usually use Turquoise, Staedtler, Tombow Mono 100, and Semi-Hex drawing pencils, as well as Techniclick 2 mechanical pencils.

PENS: I often use Pigma Micron pens. They are good pens that which allow firm control and offer many line sizes. I used sizes 02, 03, and 05 for most of the drawings in this book. I also enjoy using brush pens, such as Pigma Brush or Tombow's ABT #N15 (black). I didn't use them in the creation of this book, however, because I was looking for more exact control and accuracy than artistic interpretation. I do encourage artists to use ink mediums that allow them to vary their line widths, such as brushes, brush pens, and calligraphy pens, because using a variety of lines will add life and vitality to your work.

CONTÉ CRAYONS: I also enjoy using Conté crayons. They resemble a mix between charcoal and pastel and come in many colors in addition to black.

CHARCOAL: Charcoal comes in pencils and in stick form. Both kinds vary in softness. The softest smudge the easiest, but can be harder to control. Pencils give you more control than sticks, which may or may not be what you want! I often use General's charcoal pencils.

COLORED PENCILS: Colored pencils were the first color art medium I used as a kid (besides crayons and finger paint!). I've used them ever since. I have always used Berol Prismacolor pencils, because I find they have a rich, consistent color and texture.

PAPER: I find Strathmore Bristol Smooth Surface 300 series paper to be a high-quality paper that is a good setting for both pencil and pen work. I like that it is thick enough to withstand repeated erasing with no tearing. Another feature to look for when creating a piece of artwork that you want to last is the "acid-free" or "archival" designation. This paper will last longer and become less yellow with age than paper that is not acid-free.

ERASERS: Kneaded erasers can be molded to fit any diameter or shape to erase exactly what you want to have erased. I usually use Design brand kneaded erasers.

TIPS & TECHNIQUES

As I stated earlier, this book is not intended to be a beginner's guide to drawing. However, there are a few drawing techniques I would like to share with you, because I find that they are especially helpful when drawing wildlife.

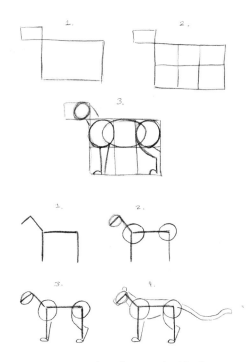

BUILDING FORM: There are many different ways to approach building the framework of a figure. Some people draw with no framework at all, but others find it helpful to block in the basic shapes and check the proportions before getting into details. Some artists may build shapes with squares and rectangles, while others may use more organic, circular shapes. Some sketch in a very simplified skeleton before proceeding.

MEASURING AND PROPORTION:

It helps to have a way of measuring what you see so you can put in the correct proportions. A standard method of measuring is to take the width of the head and measure how many head-lengths it takes to get the length of the back, or a front leg, or whatever. When working with a close-up part of the body, such as the head in profile, it may help to measure in ear-lengths or some other small unit of measurement.

Here are two examples of ways to build a form.

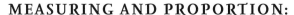

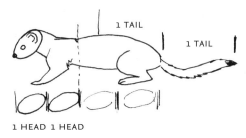

NEGATIVE SPACE: When putting proportions down on paper, there is another "trick of the trade" that helps immensely in establishing accuracy—looking at the negative space. Try to see the "negative" shapes being formed between the parts of the animal's body, or "positive" parts. Another technique is to look at your picture in a mirror, or upside down—the reverse image you see will often bring out any proportional flaws that you had missed before.

CONTRAST: Something I find helpful to keep in mind is how contrast brings things forward. For example, by increasing the intensity of the black and white areas on the "nearest" parts of the antlers shown here, I can bring those parts forward, while the more muted, less contrasting parts fade into the background.

REFLECTED LIGHT: Reflected light is bounced back onto the surface of an object from its surroundings.. The example here shows both a ball and an antler exhibiting reflected light—the dotted arrows indicate the light source, and the solid arrows point to the reflected light. In the ball example, the light travels from the light source, hits the surface the ball is resting on, and bounces back onto the shadowed side of the ball itself. There is a related phenomenon called "reflected color." For example, a mountain goat standing in a field of green grass would catch subtle green reflections in its hair.

16

ADDING LIFE & PERSONALITY TO YOUR DRAWINGS

Being able to get an exact likeness of a wild animal is only half the battle. You also want your drawing to come alive and engage the viewer. Here are a few ways of breathing life into your drawings.

ADDING DRAMA: How do you add drama and interest to your drawings? This is a question all wildlife artists seek to answer. One way is to draw animals from angles or views that most of us are not used to seeing. Seen from eye level or below, a small, scurrying squirrel suddenly becomes a creature to be reckoned with, and a nice black-tailed deer buck becomes a "majestic" blacktail! An eye-level view is more immediate and intimate.

Drawing animals in action can also add interest to your artwork. A drawing of a bobcat springing upon its prey, or of two bull moose engaged in a rutting battle, is automatically more dynamic than a simple, standing animal. If you do draw a simple, standing animal, add a hint of drama through implied action, such as a raised paw or hoof that indicates the animal is preparing to leap away. Or perhaps it was just feeding, and a piece of food is still hanging from its mouth. Details like these add interest to your work.

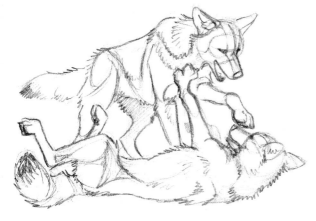

These young gray wolves are playfully wrestling. An "action shot" like this can be much more exciting than a simple portrait.

BEHAVIOR: The more you know about the behavior of the animals you are drawing, the better you will draw them. This knowledge gives you important information about how the species lives and how it interacts in (and is affected by) its environment. For example, during the fall pronghorns and deer go into what is known as the rut, or mating season. Males' necks grow much thicker than normal during this time of battle and mating. If you draw a buck in the fall or early winter, his neck will likely be swollen. By late winter his neck may be thin like a doe's.

INDIVIDUALITY: Every animal is an individual, and individuals of even the same species may look and act differently. If you sketch or photograph only one animal of a species, try to be sure that it is representative of its species before using it as your only visual reference.

As you get to know wildlife more, you will begin to differentiate individuals more clearly. I got a lesson in this during an excursion to the mountains near my home. There is a lodge up there that feeds the mule deer and elk, and one may get quite close to these animals while remaining safely inside a building. Being familiar with deer through many years of study, every deer I saw looked unique to me. However, the elk, with which I am much less familiar, all looked the same. I should've known better. When the lady who feeds these elk came in, she was able to recognize each individual and called them by name.

PHYSICAL ENVIRONMENT: An animal's body is partly shaped by adaptations to its surroundings. There are three biological "laws" that illustrate this concept, and they are true of most mammals throughout the world.

Bergmann's Rule states that the farther a geographic race is found from the equator, the larger the mass of its body will be. This is why, for instance, a southern white-tailed deer in the United States is much smaller than a thick-bodied northern whitetail. Cold-weather species need a large, compact body to conserve heat, while warm-weather species need to expel it.

These more stylized drawings of a mountain goat (TOP) and opossum (BOTTOM) are the direct results of working on those particular species for this book.

Allen's Rule says that the physical extremities (ears, tail, and legs) of warm-blooded creatures are larger or longer in the warmer areas than in the cooler areas. For example, a desert-dwelling coyote has longer legs and bigger ears than its compact, high-mountain relatives. Larger extremeties help to dissipate heat, while smaller ones conserve it.

Finally, there is Gloger's Rule, which states that dark pigments are more prevalent in warm-blooded animals that are found in warm, humid (and forested) habitats. Arctic animals or desert-dwelling animals are often paler than their eastern woodland relatives. This can be seen in rabbits and hares; some of the darkest species are the southern, wetland-dwelling marsh and swamp rabbits. Western and northern bunnies tend toward lighter colors—some northern species are all-white in winter.

SOCIAL/BEHAVIORAL ENVIRONMENT:
Animal's bodies often convey signals to other animals, both within and between species. Some of the more dramatic elements of an animal's markings may be so because they need to be able to clearly communicate with others. For instance, the tail of a white-tailed deer is a very noticeable signal: When it is raised up in alarm, the white underside flashes, warning other deer and possibly also signaling predators that they've been spotted and pursuit is now futile. A skunk's dramatic black-and-white color pattern is a clear signal to be left alone!

STYLIZATION:
Finally, I encourage you to "let loose" once in a while and have a little fun stylizing the animals you draw. Stylization can not only be fun, but it can allow you to search for the patterns and shapes of various species and solidify them into your thinking by exaggerating and emphasizing them in your drawings.

DOING YOUR OWN RESEARCH

Research brings you into contact with your subjects. Spend as much time as you can learning, observing, and sketching animals wherever you can find them. Here are a few ideas.

ZOOS: Zoos, wildlife rehabilitation centers, and other live animal collections can provide a wealth of opportunities for study. Keep in mind, however, that captive animals do not have to run down their food, escape predators, or fight for survival. They also do not usually have much room in which to roam. Captive animals are often fatter and less alert than wild animals. They also often spend a lot of time rubbing against walls or bars, and their antlers or fur may get rubbed down or deformed.

MOUNTED SPECIMENS: Mounted animals, such as you might find at a natural history museum, can be a good source of information (as long as you realize their limitations) and they hold a pose as long as you need it! Be aware that a mount is only as good as the taxidermist who created it, and many mounts may contain errors.

PHOTOGRAPHS: Getting a wild animal to stand still, or hold a pose indefinitely, is near impossible. A good photograph is the next best thing.

When you look at photos you've taken yourself, you see and sense not only what is recorded, but the smells, sights, and sounds of that day as well. The more pictures you take, the more likely you are to get something useful. Even a blurry photo can have a helpful piece of information in it. Keep track of where and when you take these photos, as an animal's appearance may change according to time of year. When photographing a wild animal, please keep its welfare in mind. Do not be in such a hurry to get that close-up photo that you begin to harass your subject—use a telephoto lens instead.

Photographs taken by other people can be helpful in obtaining reference on creatures we have never seen, or in finding a particular pose. However, keep in mind that most published photographs are copyrighted, and if you simply copy from a photograph you are stealing from the photographer. There is generally no problem in copying photos for your own study. Many artists use photos from time to time to obtain bits of reference. As long as it is mostly your own work and not recognizable as someone else's, it is usually acceptable, but be careful in this area.

PARKS AND PRESERVES: Wild animals in parks and wildlife refuges are not hunted and are usually quite approachable—sometimes almost too approachable! Again, please be respectful of the animals and your own safety and do not get too close. Using common sense, you can get excellent experience watching wild animals. You can also study their habitat and how they move about within it. In some cases, you can bring a sketchbook and a camera, sit down in view of a wild animal, and spend long minutes or even hours obtaining reference.

BONES AND ROAD KILL: Road kill is a great way to learn by studying (hopefully freshly) dead animals. Before you pick up road kill, however, check with your local wildlife agency to ensure that it is legal. You may also find bones or antlers while wandering the great outdoors. With common-sense precautions, such as using gloves to handle carcasses, and washing your hands afterward, you can gain a lot of useful information. Be careful around rodents that you find dead—they may harbor disease. I study them where I find them, and then leave them there.

EVERYDAY LIFE: Wildlife is more accessible in some areas than in others, but keep your eyes open at all times. Let people know of your interest in observing wildlife. So many people never even see what lives in their own backyards—don't be one of them. Get out there and look!

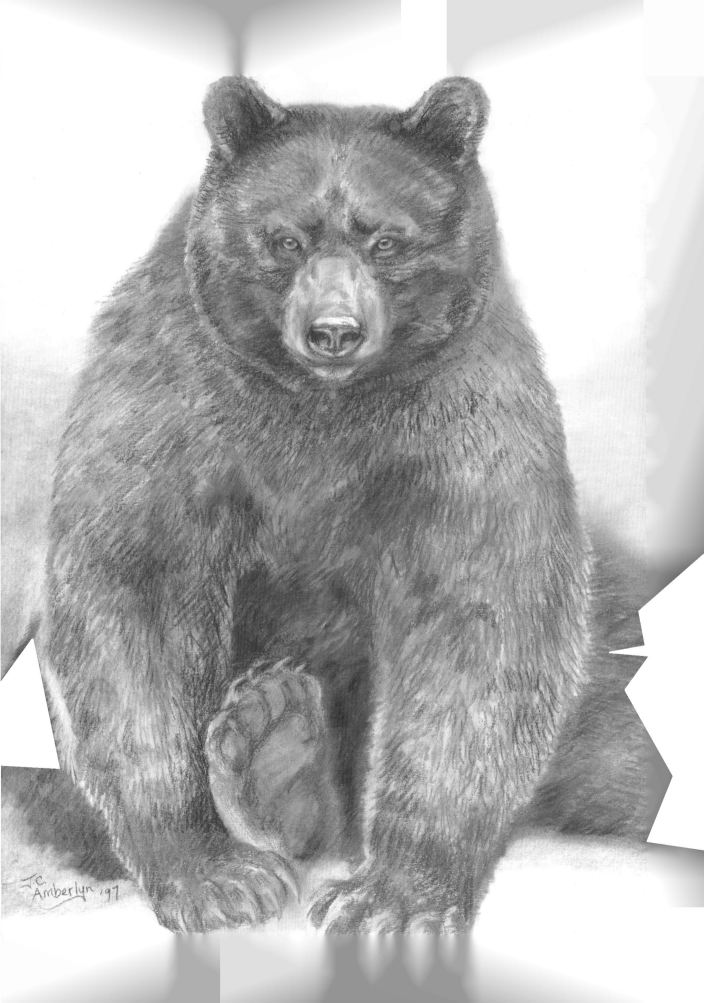

JC
Amberlyn '97

CARNIVORES & OMNIVORES

THE ANIMALS FEATURED IN THIS SECTION are an impressive and charismatic group. Carnivores, or meat-eaters, capture the human imagination with their power, intelligence, beauty, the way they care for their young, and their fearsome teeth. Wild cats, wild canines (foxes, coyotes, and wolves), and weasels are carnivores. Bears and raccoons are considered omnivores, members of the order Carnivora that regularly add a large portion of vegetable matter to their diets.

All carnivores and omnivores are well-equipped to kill other animals for food or to defend themselves from attack. Some are runners, some are stalkers, and others are more generalized in their physical build, but all possess sharp teeth or claws. Carnivores and omnivores tend toward higher levels of intelligence and learning ability, important for animals that must be able to anticipate and overtake a prey animal's defenses. Because of the long learning curve a young predator must go through in order to learn to hunt and survive, most carnivore and omnivore females are devoted parents to their offspring (in the wild canine family, both the male and female are dedicated parents).

Young carnivores and omnivores engage in play to help them learn to stalk and pounce, to keep their bodies coordinated and brains occupied, to let them release pent-up energy, and because it's fun. Play also allows them time to learn how to deal with one another with a minimum of bloodshed.

Most carnivores and omnivores live on land, but a few carnivores, such as seals, sea lions, walruses, and sea otters, spend some or almost all of their time in the water. In this book I have chosen to concentrate on terrestrial carnivores.

WOLVES, FOXES & COYOTES are great

subjects for wildlife art, and those who wish to draw them have a big advantage over many other wildlife artists: Their subjects' domesticated relatives are in abundance all around them. If you know what a dog looks like, you're well on your way toward knowing how to draw a wolf, which is the animal the dog descended from in the first place! You can use domestic dogs as an easy source of information on the basic structure and anatomy of their wild cousins in the family Canidae.

THE HEAD

A wild canine's head is characterized by a long muzzle and a pair of pointed, cupped, and upright ears. Many wild dogs, especially males and canines in their winter coats, feature a cheek ruff that frames their face.

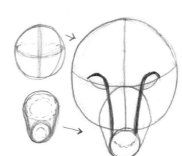

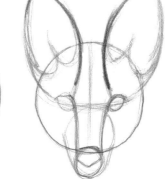

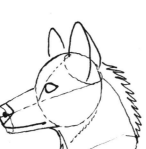

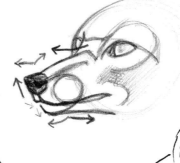

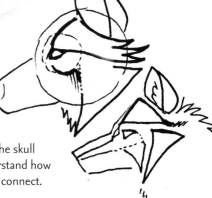

The more you understand about the skull underneath, the more you'll understand how the eyes, ears, muzzle, and mouth connect.

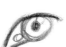

EYES: A wild canine's eyes are somewhat slanted and almond-shaped. They are rimmed with black eyelids and eyelashes and have a long, dark tear duct that points down toward their nose. This tear duct is least apparent when a canine is facing you and most visible when viewed in profile. The contrast between the dark lid and a pale canine eye hit by sunlight can be quite dramatic.

There is a cluster of whiskers above the eye. In some domestic dog breeds, this area features a spot of color, called an eyespot. Wild canines don't generally have dramatic eyespots, but this swath of fur adds depth to the brow when drawn correctly.

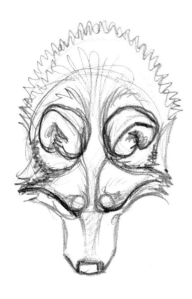

EARS: The wild canine ear is upright and cupped with a semi-pointed tip. It can rotate back and forth in a circular fashion because of the ear muscles, called the ear butt, underneath. The ears rotate to catch sounds in various directions or to show expression. They can only rotate so far, however, being attached as they are to the head.

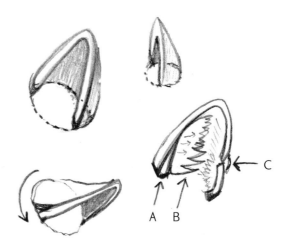

A. There is often a noticeable triangular swath of fur here.
B. Largest grouping of hair in inner side of ear.
C. The "pocket" present in many mammal ears.

NOSE: A wild canine's nose is a little like a box that from the front appears to be rounded into almost a heart shape. Remember to indicate highlights and shadows so that the nose appears to have depth and moistness.

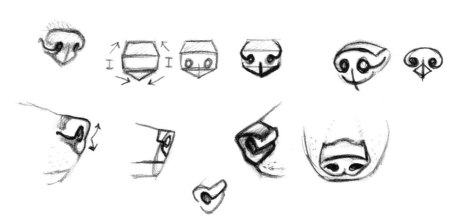

THE BODY

One of the most distinctive features of the wild canine clan is that they are runners and are built for speed. They have deep (although generally narrow) chests to accommodate large lungs; long, slender but strong legs; and pointed, streamlined faces.

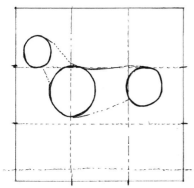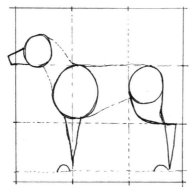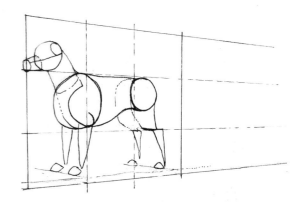

You can use a grid section to help visualize a wild dog's body build.

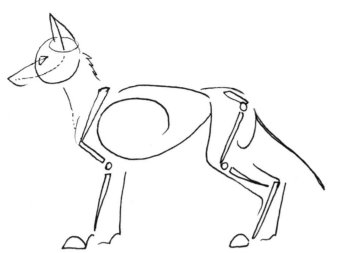

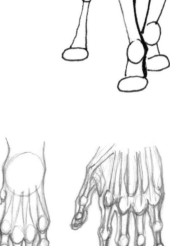

FEET: Wild dogs have relatively rounded paws. They walk on the tips of their toes and have large pads on the bottom of their toes to cushion their landings and to grip surfaces. They have long, medium-size claws that can get worn with running and digging.

The toes and foot have an appearance of sweeping forward, ending with the point of the claws. The foot has a more rounded, blocky appearance when standing on the ground, and looks more elongated when the feet and toes are relaxed or up in the air.

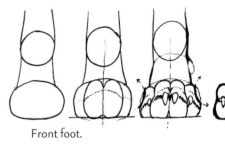

Comparison of a canine front foot (LEFT) and a human hand (RIGHT). Note how the dewclaw and thumb are placed in similar positions.

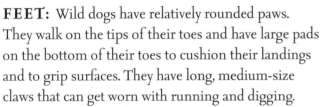

Front foot.

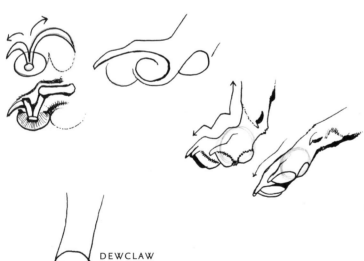

WRIST →

DEWCLAW (THUMB)

TOES (FINGERS)

There is a small, less noticeable toe, called the dewclaw, on the inside part of the front foot. It has a claw and a small pad but hangs above the four toes that actually touch the ground. Above the dewclaw, and on the back of the front leg, is another small pad.

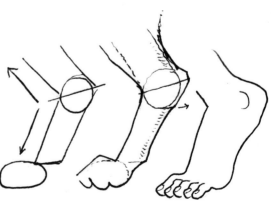

The hind feet are similar to the front feet but the actual padded foot is usually smaller. In addition to the padded toes, the foot extends up into a joint, which is called the ankle, or hock. Dogs walk about much like a person might walk on tiptoe.

LEGS: Wild dogs have powerful, heavily muscled shoulders and hindquarters. Their legs are strong and muscled but also on the long and slender side. A knowledge of the bone structure will help you understand the muscle structure, which in turn will help you understand the way the fur and skin lie upon the form of the animal.

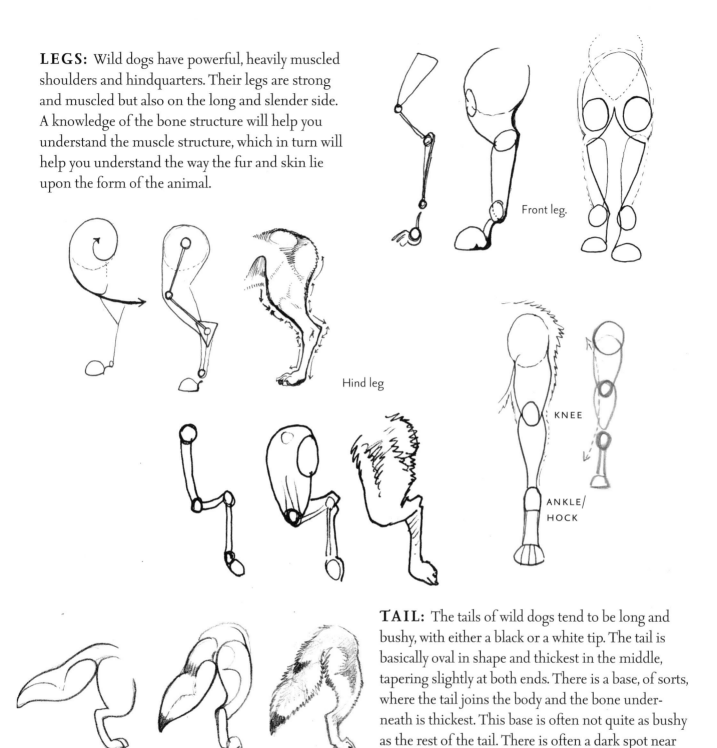

Front leg.

Hind leg

KNEE

ANKLE/ HOCK

TAIL: The tails of wild dogs tend to be long and bushy, with either a black or a white tip. The tail is basically oval in shape and thickest in the middle, tapering slightly at both ends. There is a base, of sorts, where the tail joins the body and the bone underneath is thickest. This base is often not quite as bushy as the rest of the tail. There is often a dark spot near the top base of the tail, where a scent gland is located.

FUR & TEXTURE

The fur of wild canines tends to be long, shaggy, and medium to soft in texture. Their thick fur hides their rather slender, runner's physiques, especially in winter. Male canines tend to be heavier, thicker-muzzled, and have fuller cheek and neck ruffs than females. Their winter coats grow thick and warm but are shed by the time summer comes around. Spring and summer canines can appear very skinny and scruffy in comparison to their winter counterparts.

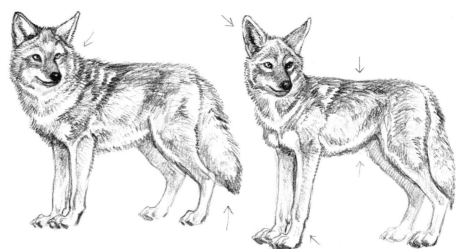

Note the difference between the winter coat (LEFT) of this coyote and its summer coat (RIGHT). In the winter, the coyote's neck is fuller and its tail longer and bushier. In the summer the ears appear larger, the torso is thinner, and the legs look longer.

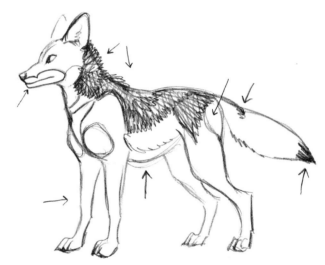

Wild dog fur consists of layers. First, there is a woolly, dark under-coat, which provides insulation and warmth. An observer of wild canines tends to see only hints of this layer, usually where the fur is parted or short. The much more visible outer layer consists of the guard hairs, which are longer, finer hairs that help siphon off water and can be raised or flattened depending on the mood or temperature needs of the animal.

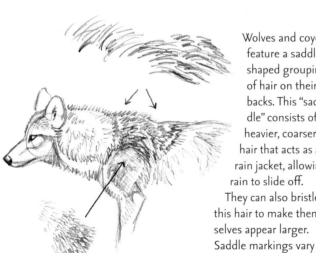

Wolves and coyotes feature a saddle-shaped grouping of hair on their backs. This "saddle" consists of heavier, coarser hair that acts as a rain jacket, allowing rain to slide off.

They can also bristle this hair to make themselves appear larger. Saddle markings vary by individual.

All North American canines (except the winter-coated Arctic fox) have high-contrast lip/muzzle areas, whitish bellies and throats, and darker dorsal, or back, areas. These color markings aid in body language; for instance, the white belly of a submissive canine rolled over on its back signifies that it is not a threat. Canine leg and shoulder fur is not usually as long as the nearby body and side/neck hair. The rump fur tends to be extremely thick and cushioned, and sometimes appears lighter than the surrounding fur. Most canines have a black- or white-tipped tail and often a dark spot near the top base.

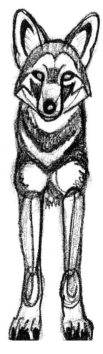

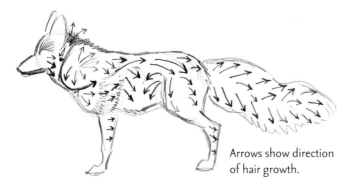

Arrows show direction of hair growth.

From the front, most wild canines' shoulders feature rather prominent white shoulder patches. These shoulder patches vary in size and shape, from ovals to circles to a more triangular pattern.

WILD DOGS IN MOTION

Canines are runners. They move in a loping run, head stretched out and tail streaming behind. They glide along the ground effortlessly, eyes intent on the terrain ahead and lanky legs carrying them quickly. They can move in a ground-eating, tireless trot that carries them for miles in search of food or company.

Usually when canines walk they move one front leg and the opposite hind leg almost at the same time, but sometimes one can be observed walking by moving the two legs on the same side of their body together, then using the other side's legs. It seems to depend on speed.

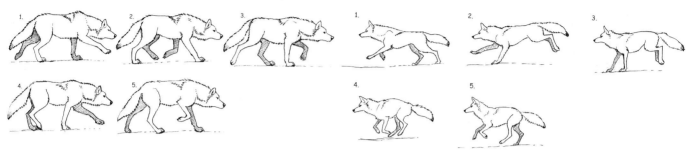

A wolf walking using the most common method.

Foxes and coyotes are both known for their amazing leaps when "mousing," or stalking and pouncing upon small rodents in grass or snow.
Here, a red fox mouses.

Both the walking wolf and this running coyote show some of the major poses these animals assume while in action. "Everyone" knows that coyotes always run with their tail down—everyone, that is, except the coyotes! Coyotes often travel with their tail hanging down and wolves often travel with their tail slightly higher, but both animals may raise or lower their tails as they move, depending on mood, the situation, or their place in the pack hierarchy.

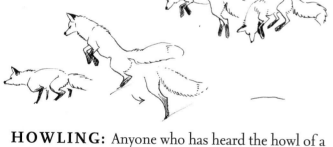

HOWLING: Anyone who has heard the howl of a wolf or coyote will not soon forget it. In attempting to correctly portray a wolf or coyote howling, it is important to remember the position of their jawbones and nose upon their skull. Also, a howling wolf or coyote does not have to be standing or sitting in a "show dog" pose—it may howl while lying down or moving about. In my mind the "classic" wolf pose is a bit dignified—a standing or sitting animal that lifts its head in one slow, graceful movement and emits one long, drawn-out howl. This wolf's mouth is slightly puckered and rounded into a C-shape. The classic coyote, on the other hand, is much more energetic. Its head moves about from side to side and it may shift its footing and move its weight around. Its mouth is stretched as wide as possible as it howls and yaps. These are only generalizations, however, and both animals can howl either way.

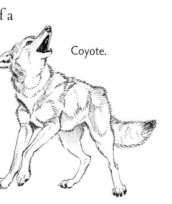

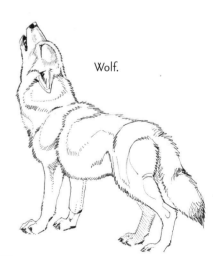

Coyote.

Wolf.

GRAY WOLF

CANIS LUPUS

Few animals have been as loved or as hated throughout history as the gray wolf. A creature of the wilderness, its haunting howl and untamed stare speak directly to our primal soul. Recent public awareness of the intricate ecological role and social nature of this ancestor of the domestic dog have renewed an interest and concern for its continued survival.

THE HEAD

A wolf's head is broad and characterized by strong jaws, a heavy muzzle, and upright ears. The wolf's eyes appear slightly smaller relative to its head than the coyote's.

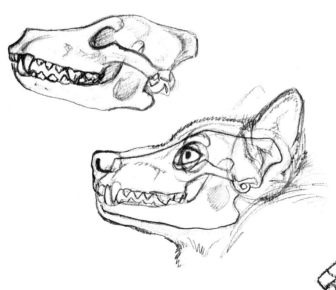

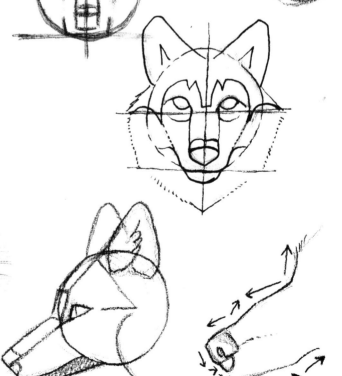

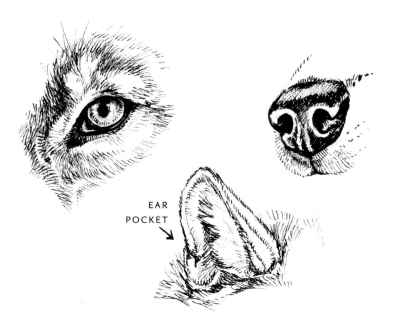

EYES, EARS, AND NOSE: Wolves have yellow to dark amber eyes with a round pupil. They have blue eyes only when they are very young. A wolf's ear has a visible "ear pocket" (see page 13) that is important to include for an accurate depiction. The nose looks like a little box that has been rounded almost into the shape of a heart in the front.

EAR POCKET

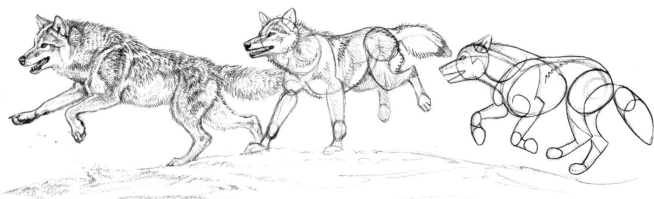

THE BODY

The wolf looks like a large sled dog, but with bigger feet and a narrower chest. Long legs carry this canine effortlessly over miles of wilderness in search of food. Study large dogs to gain insight into wolf anatomy and behavior. Part of the "big dog" look of the wolf is achieved by making its head smaller in relation to its body than that of any of the other wild canines.

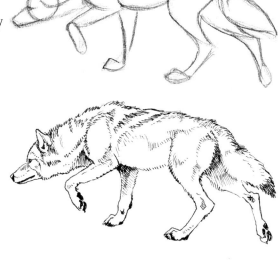

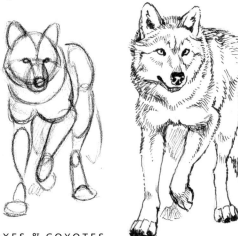

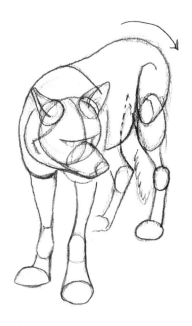
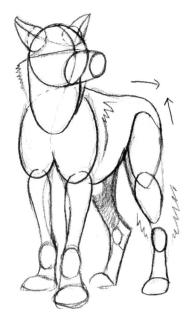

Study your subject from all different angles. For instance, when looking at a wolf from above (LEFT), a three-quarter view shows off the rounded back of the canine, and the hip blends in. At eye level or from below (RIGHT), a three-quarter view of a wolf's (or other wild dog's) hip tends to look angular because the hip often visibly protrudes.

LEGS AND FEET: Wolves have strong, slender legs and large, wide paws. Their paws are wider than the more "pinched"-looking paws of a coyote or fox.

TAIL: A wolf's tail is bushy and black-tipped, and there is often a spot of black along the top base of the tail.

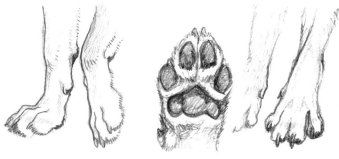

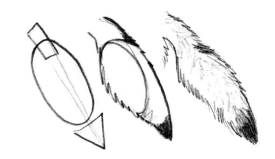

COLOR MARKINGS

Wolves are usually gray, but they can range in color from all-white to all-black and variations of silver and brown. The average gray wolf is, not surprisingly, a grayish color. A wolf's fur is grizzled with black and white guard hairs. Wolves often have light patches of color around their eyes, but the color is not as distinctively marked as with, say, a malamute or a husky. As mentioned earlier, wolves have a saddle-like grouping of hair on their backs—the longest fur on their bodies. They have white bellies, shoulder patches, and throats and black-tipped tails. The white fur often extends down their inner legs to their feet.

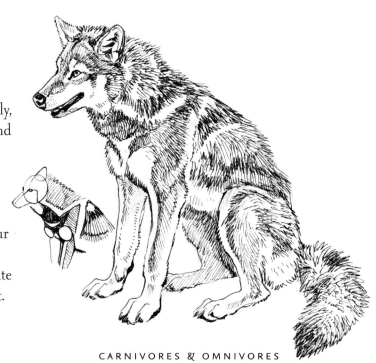

COYOTE

CANIS LATRANS

COYOTES ARE A VERY OLD, VERY ADAPTABLE, and very intelligent species that can survive just about anywhere. They can tolerate cold Alaskan winters and hot Arizona summers, and their appearance reflects their chosen habitat. Coyotes eat anything from deer and mice to berries and cactus fruit. They combine some of the looks and abilities of both foxes and wolves. North America would be a much less interesting place without these masters of adaptation.

THE HEAD

The key to capturing a coyote's head on paper is to give it some of the broadness and thickness of the wolf's while emphasizing the long nose, big ears, and sharp, slightly foxy look. Note that the coyote's eyes appear slightly larger relative to its head than the wolf's.

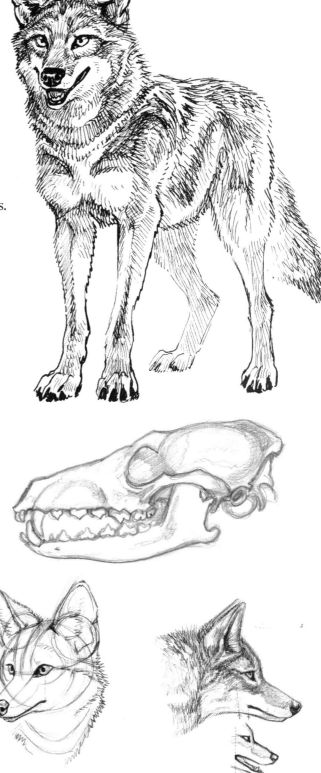

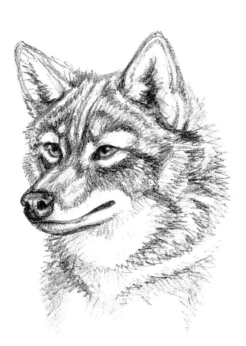

Eastern coyotes (ABOVE) are much larger than their western cousins. When drawing one of these canines, note that their ears are smaller in proportion to their heads, and their heads broader, than western coyotes. They also sometimes have dark markings below their eyes.

The lips of coyotes, as well as the other wild dogs, tend to end at a point generally underneath their eyes. However, when their mouth is stretched wide because they are panting, the lip stretches and extends farther back.

EYES, EARS, AND NOSE: Like wolves, coyotes have a round pupil and yellow- to amber-colored eyes. They have blue eyes for just the first few weeks of their life. Occasionally, a coyote (or other wild canine) will expose the white of its eyeball and the dark rim around the iris when glancing to the side. The backs of coyote ears are usually orangish-red and have very soft fur. Coyotes have typical canine noses.

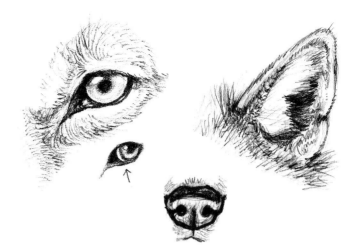

THE BODY

Some people tend to think of coyotes as rather scruffy in appearance, perhaps due to cartoon depictions, but while desert coyotes can be scruffy in the summer, these same animals can be full-coated and handsome in the winter. A well-fed winter coyote can be as thickly furred and majestic as any wolf.

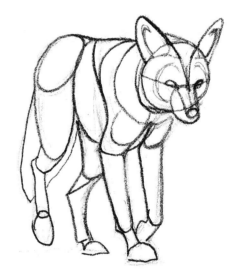

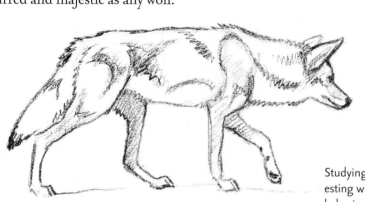

Studying animal behavior is an important part of creating interesting wildlife art. Here are two depictions of normal coyote behaviors not often seen or drawn by humans. The drawing on the left shows the humped up, submissive-aggressive posturing peculiar to coyotes and sometimes seen in social interactions around food. The drawing on the right illustrates the strong pair bond between coyotes, which are as dedicated to their family and mates as wolves are but are not as well-known for it.

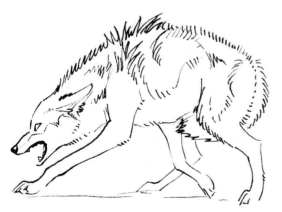

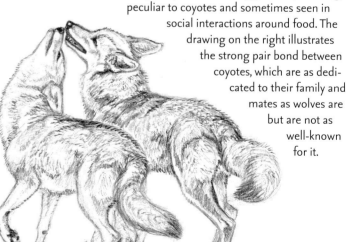

LEGS AND FEET: Coyotes have the same long, slender and strong legs as the rest of the canines. Their feet have a more "pinched" look than a wolf's.

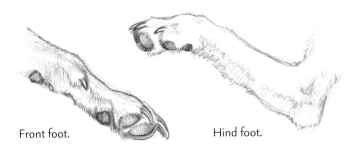

Front foot.

Hind foot.

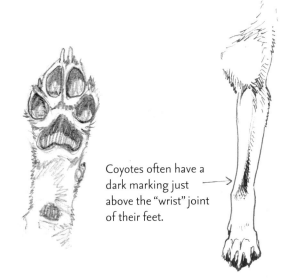

Coyotes often have a dark marking just above the "wrist" joint of their feet.

TAIL: The coyote's tail is usually similar to the wolf's. However, a few coyotes have a white-tipped tail. Proportionately, a coyote's tail appears slightly longer than a wolf's, but not as long and bushy as a fox's.

COLOR MARKINGS

The color markings of the coyote are similar to the wolf's: gray to reddish-brown coloration on the top, a dark "saddle" marking on the back and shoulders, and a whitish belly. Coyotes usually have a reddish-brown muzzle, ears, and (often) legs. Northern coyotes are usually paler and more silver-gray in coloration than the more reddish-brown southern ones. Color phases are rare in coyotes, but eastern coyotes seem to have the greatest propensity for them. Black seems to be the most common of the unusual colors, which include cinnamon-red, tan, and the very rare white.

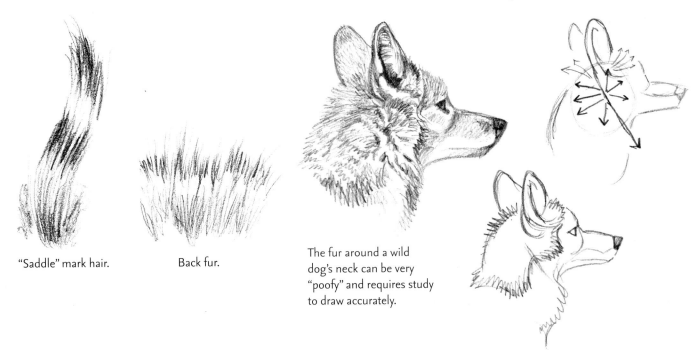

"Saddle" mark hair.

Back fur.

The fur around a wild dog's neck can be very "poofy" and requires study to draw accurately.

RED FOX

VULPES VULPES

RED FOXES ARE WHAT MOST PEOPLE THINK OF when the word "fox" is spoken. Found throughout most of the world, they are one of the most widespread carnivores— a very successful species. Their striking looks make them a popular and attractive subject for wildlife artists.

THE HEAD

Foxes are well-known for their "pixie" faces, sharp muzzles, and pointed ears.

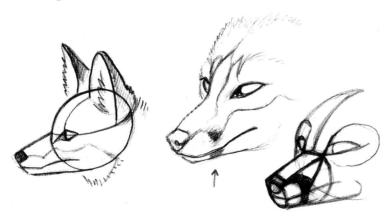

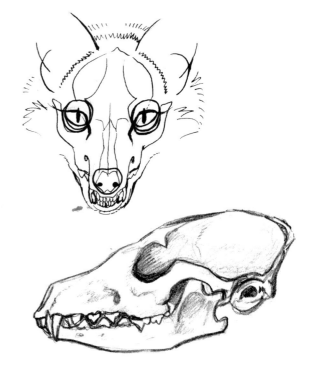

EYES, EARS, AND NOSE: Red foxes have elliptical pupils like a cat's. Their eyes are generally amber to brown. A red fox's ears are blackish-brown on the back and mostly white in the front. The reddish body coloration bleeds into both the front and back of their ears, especially along the edges. Foxes have typical canine noses.

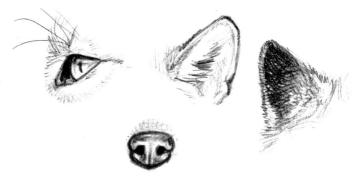

THE BODY

Foxes have a somewhat crouched appearance, almost a nervous readiness to spring into action and pounce on prey or take cover on a second's notice. A big, bushy tail is also an important trademark: A fox's tail is much larger in proportion to its body than a coyote's or a wolf's. The lush fur of a fox in winter hides a slender, graceful physique.

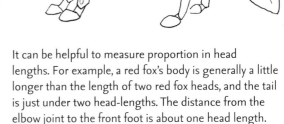

It can be helpful to measure proportion in head lengths. For example, a red fox's body is generally a little longer than the length of two red fox heads, and the tail is just under two head-lengths. The distance from the elbow joint to the front foot is about one head length.

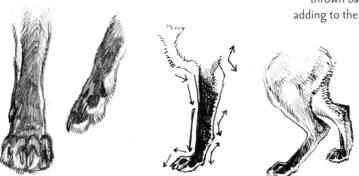

Red foxes have a distinctive way of fighting. Two individuals brace against each other with their front legs, stand on their hind legs, and push, shove, and mouth at each other. When drawing such a scene, the little details are important. Notice the tracks in the snow, evidence that these two have been moving and interacting with their environment. Note that I left white space on their legs to help differentiate the tangle of black legs. I showed that the left fox's head is thrown back by darkening the area where the neck joins the body, adding to the sense of compressed fur.

LEGS AND FEET: Red fox legs and paws are blackish-brown with white and red inner markings and often feature reddish markings on the toes. Individuals vary in the amount of black coloration.

TAIL: Fox tails are much like wolf or coyote tails, but have a white tip.

COLOR MARKINGS

Red foxes are normally their namesake orangish-red color, with black legs and ears, and white lips, throat, and belly. They have dark markings where their whiskers attach to their muzzle. However, red foxes can actually come in a variety of colors, from all-black and silver foxes to the "cross" fox, which has a dark face, belly, back, and shoulders. It has a cross-shaped color pattern on its shoulders if viewed from above. All color phases of the red fox usually have a white-tipped tail.

Some western regions, especially places like Alaska, have a high incidence of these various color phases.

"Cross" fox.

GRAY FOX

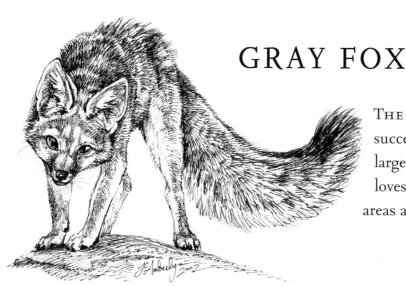

Urocyon cinereoargenteus

The gray fox is a very primitive, but successful, species of fox found throughout a large portion of North and Central America. It loves brushy canyons, rocky ledges, and wooded areas and is known for its tree-climbing ability.

THE HEAD

Gray foxes have a "pixie" face, alert orange ears, and distinctive black markings on their muzzle and lips. Note the elevated bump on the nasal ridge between the eyes.

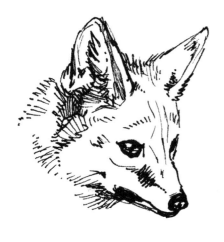

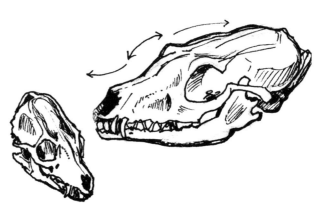

EYES, EARS, AND NOSE: Like cats and other foxes, gray foxes have elliptical pupils. Their eyes are brown and darker than a red fox's. Gray fox ears are like a red fox's ears but with no solid black markings. On the back of the ears, the very tips do have some gray shading. Overall, they are an orangish-rust color that extends from their ears down either side of the neck to their shoulders. One wide line of gray color extends between these two orange bands from the top of the fox's face down its neck to its back. The gray fox's nose is similar to a red fox's.

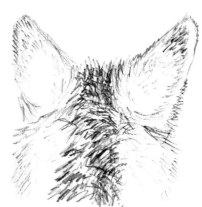

THE BODY

Gray foxes are somewhere in between the red fox and kit fox in appearance. Western gray foxes tend to have larger ears and sometimes smaller bodies than eastern ones.

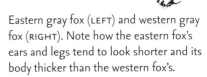

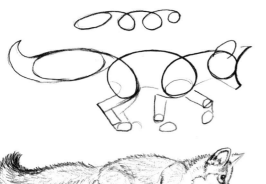

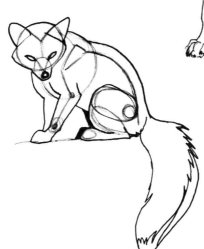

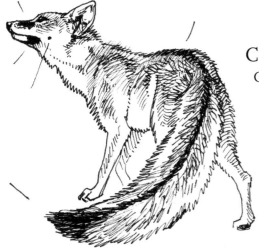

Eastern gray fox (LEFT) and western gray fox (RIGHT). Note how the eastern fox's ears and legs tend to look shorter and its body thicker than the western fox's.

LEGS AND FEET: The feet of the gray fox are the least heavily furred of all the North American foxes.

TAIL: The gray fox's tail is its most distinctive feature—black-tipped, with a stripe that extends all the way to the base. Gray foxes sometimes carry their tails in an arched position, with the highest point in the middle.

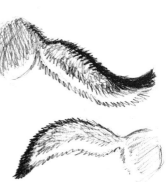

COLOR MARKINGS

Gray foxes are salt-and-pepper, grizzled gray in color with rusty orange accents along their throat, neck, flanks, sides of tail, and legs. They also have black markings on their muzzle, in front of their eyes where their whiskers attach, and a large patch under the jowl. There is a small black spot just behind this area, where cheek whiskers grow.

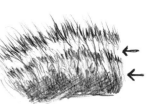

Gray fox fur has distinctive black and white layers and is coarser in texture than a red fox's.

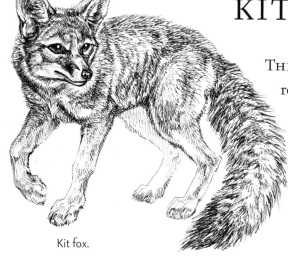

KIT & SWIFT FOXES

Vulpes macrotis and Vulpes velox

THE TINY KIT FOX WAS SO NAMED because of its superficial resemblance to a baby, or kit, of the larger red fox. Its sandy coat mimics the colors of the desert and plains, letting it blend into its arid, open environment as it hunts for small mammals and insects. Kit foxes and the more northern swift foxes are similar in appearance. They are the smallest wild canines in North America. Some sources consider them to be of the same species.

Kit fox.

THE HEAD

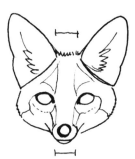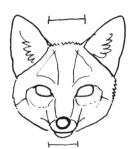

A kit fox (LEFT) and a swift fox (RIGHT).

Kit and swift foxes have a disproportionately large head and big eyes, adding to their "young" look. The kit fox has larger ears, while the swift fox's face is broader than that of the kit fox, and the space between its ears is greater. The swift fox sometimes (to this author, at least) seems to have a "squinty" look, like it has been out in the wind too long! The eyes are brownish and often appear dark compared to the light face, and the nose is similar to that of other canids.

Kit fox skull.

THE BODY

Kit and swift foxes have similar bodies to other foxes, but are smaller and appear more "delicate." The swift fox is slightly thicker-bodied than the kit fox.

LEGS AND FEET: Kit foxes in particular have long legs. Kit fox feet are heavily furred, perhaps to increase traction on hot desert sand.

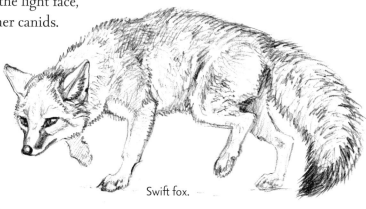

Swift fox.

COLOR MARKINGS

Kit and swift foxes are colored like a miniature, paler version of a gray fox. They have the same darker back and rusty sides with a white belly, but they are much more sandy-brown, however, and may have a faint reddish-brown dorsal (back) stripe. They do not have a black stripe up the tail.

TAIL: Like other foxes, kit and swift foxes have tails with black tips.

ARCTIC FOX
Vulpes lagopus

Arctic foxes are well-suited to survive harsh Arctic winters with their small, heat-saving ears and eyes and their thick fur coats. There is a pronounced difference between the summer and winter coats of this fox. In the winter the Arctic fox is usually heavily furred and pure white; in summer, it is brown or blue-gray and less furry.

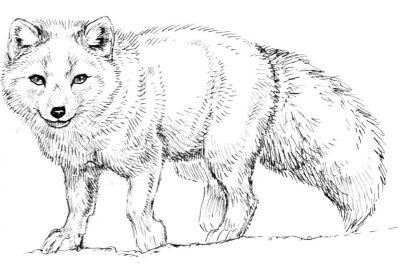

THE HEAD

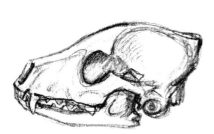

The Arctic fox has a wide, broad, "blocky" head compared to most of its kin. Its ears and eyes are smaller relative to their heads than those of most other foxes to protect them from the biting cold.

EYES, EARS, AND NOSE: Like other foxes, Arctic foxes have elliptical pupils. Their eyes are a reddish-brown color that from a distance appears darker in contrast to the white fur of the face. The Arctic fox's ears are small and rounded. Its nose is similar to that of other foxes; however, some Arctic foxes seem to have pink spots on their noses, perhaps caused by rubbing them in snow.

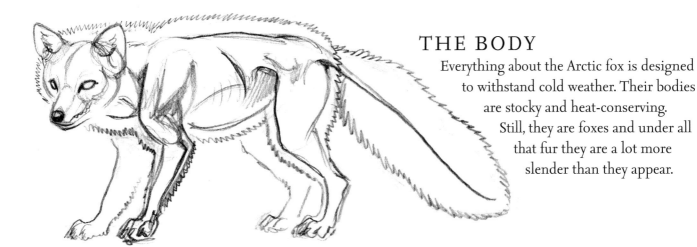

THE BODY

Everything about the Arctic fox is designed to withstand cold weather. Their bodies are stocky and heat-conserving. Still, they are foxes and under all that fur they are a lot more slender than they appear.

LEGS AND FEET: Arctic foxes have the furriest feet of any North American fox—their paw pads are barely visible in winter.

TAIL: The Arctic fox's tail is like that of other foxes, but without the tip coloration.

COLOR MARKINGS

The Arctic fox is the only fox that changes color by season. The familiar white-colored fox is actually seen only in winter. During the summer, Arctic foxes change to a brown color with white on lower areas like the neck, sides, and underneath the tail. Their fur is noticeably shorter in summer. Arctic foxes also come in different colors; in some areas, the "blue" fox is common. This fox has a blue to gray coloration and may have a white stripe up its forehead from its nose to its ears. Some are "blue" year-round.

"Blue" color phase fox.

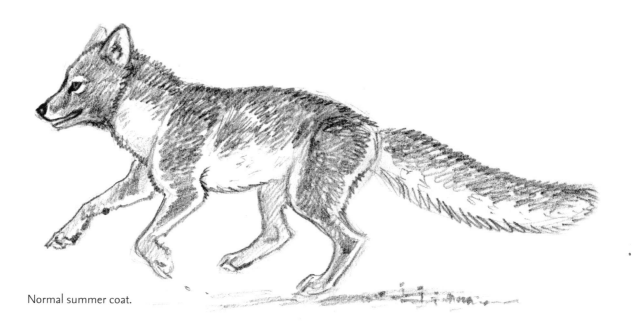

Normal summer coat.

HOW TO DRAW A GRAY WOLF

IN THIS DEMONSTRATION I BLOCK IN BASIC SHAPES with pencil then switch to pen and ink. If you have trouble with the anatomy of the gray wolf, try to spend some time with its domesticated cousin, the dog. Obviously a husky will look more wolf-like than a poodle, but even the latter can help you put together the pieces of the anatomy puzzle. Make some quick sketches of the dog in a similar pose, then refer to them when you return to the drawing.

1. First, draw five evenly spaced vertical lines. The space between the two lines on the left is one head-length. Draw a head shape between them, including a circle for the head and a rectangle for the muzzle. Then, in the section just to the right, draw a square that is slightly deeper than one head-length. This is the chest. Make sure that the top line of the chest square lines up with the bottom of the head circle.

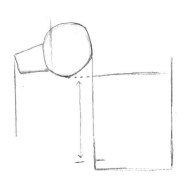

2. Continue the line of the back to the next vertical line and draw an oval for the hip/rump. Fill out the neck, then round out the chest area, indicating the sweep of the belly, and connect the back of the neck to the shoulders. Draw a slightly tapered, one-head-length rectangle for the front leg. Draw an oval for the hind foot and a slightly larger one for the front foot. Draw parallel lines to indicate the hind leg. Go back to the head and add the features. Continue to define the hind legs. Add width to the back of the neck and draw a ruff of fur, from the front to the back of the ear and to the bottom of the throat, allowing that area to "fluff" out a bit. Draw the tail and indicate the toes with sideways-slanted V-shaped marks.

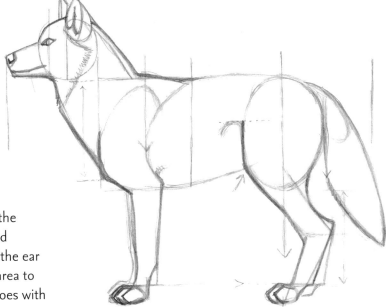

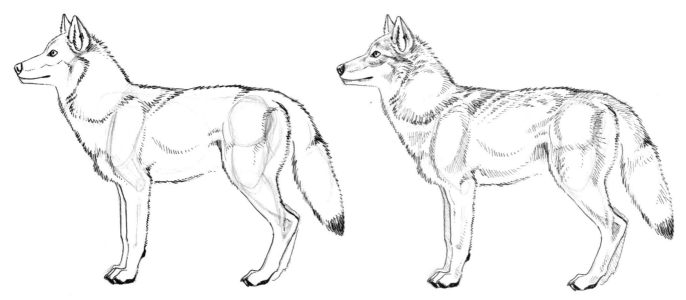

3. At this point I would lightly erase most of the lines or transfer the drawing to another sheet of paper. Still using a pencil, define the wolf and indicate its fur patterns and facial details. Using a pen this time, ink over the main features of the wolf and indicate major fur patterns. If it helps, you can use a pencil (very lightly) to block in muscle groups and bone joints to help you visualize bulges, "fluffy" areas, depressions, and shadows on the body.

4. With a smaller diameter pen, continue defining the fur, using pen strokes pointing in the direction of hair growth. Here I added some darkness to the nose, leaving highlights, and added a shadow to the top part of the wolf's eyeball, connecting the wolf's pupil to the dark shadow and leaving a small highlight to add "life." I have toned in some of the shadow areas like the paunch of the stomach where it meets the hind leg and the back of the shoulder.

5. Now go back with the larger pen and add depth to the fur, crosshatching and shading. Create almost vertical strokes that are aligned back-to-belly, or top-to-bottom, on the tail, on the neck, and any other especially furry area where the tips of the hair are closest to and pointing toward the viewer. This technique gives the effect of a parting in the hair and it is where you would see the undercoat the most.

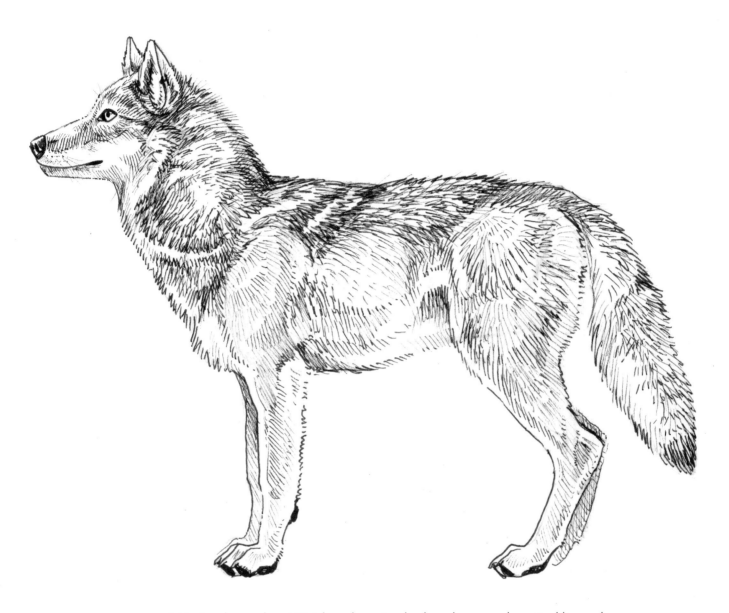

6. You're almost done! Finish up by going back to those nearly vertical lines where the hair parts and the undercoat shows. Using a smaller pen again, make short strokes that flow front to back horizontally, adding the final dimension to the fur and its general direction. Go back to the head and finalize the details of the face and ears. Add whiskers and shade under the lips. Add more shading and strokes and emphasize markings where needed. Be sure to shade the hollow in the heel of the hind foot and to leave some white space (in this case I left the lightest areas and the ones closest to the viewer the most "white").

WILD CATS

WILD CATS are well-known for their grace and beauty. Just as with dogs, artists who wish to draw wild cats have a great reference available all around them: their subjects' domesticated relatives! Study domestic felines to gain insights into cat behavior, poses, and movement. Most wild cats are agile climbers that can move easily up a tree or across a steep boulder-strewn canyon. They are among the most carnivorous mammals and have few predators other than humans. Three members of the family Felidae are featured here: the small, stub-tailed bobcat, the similar but taller lynx with its lush, silvery fur, and the powerful mountain lion. Several other wild felines, such as the ocelot and the jaguar, are native to North America, but only these three are found in significant numbers.

THE HEAD

Cats have round heads with short muzzles. They feature prominent eye sockets for keen night vision and the ability to judge three-dimensional space. Their hearing is good, but as their short muzzles attest, their sense of smell is not their most highly developed feature. When drawing cat faces, especially when they are facing forward, remember to keep things rounded.

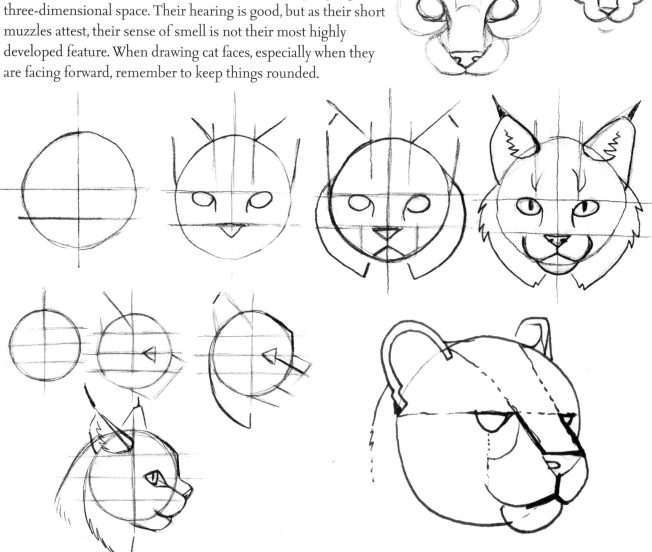

EYES: Like dogs, cats have eyes that are somewhat slanted and almond-shaped, and the eyes are very prominent in the head. Bobcats and lynx have vertical pupils like a domestic cat, while mountain lions have round pupils. Pupils dilate according to light, and vertical pupils may appear large and rather "fat" in low light or appear as mere slits in greater light. Cat eyes tend to be a golden-yellow color, but sometimes hint at green.

Bobcat or lynx eye (TOP) and mountain lion eye (BOTTOM).

EARS: Cat ears tend to be somewhat rounded, upright triangles. A bobcat or lynx's ears are more pointed, while a mountain lion's are more rounded. Bobcats and lynx are well-known for their distinctive "tufted" ears. The "ear pocket" is especially noticeable on a cat ear due to its upright position and often somewhat short hair.

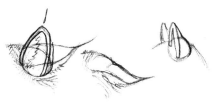

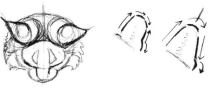

Cat ears are also very expressive and can be flattened completely down on the head or perked upright in curiosity. There is often a noticeable hairline extending between and almost "connecting" the two ears at the point where they are the closest together on the head.

NOSE: Cat noses are basically triangular with C-shaped nostrils that flare out to the sides. They tend toward a pinkish-orange color.

THE BODY

Wild cats hunt their prey by stalking within range and pouncing. This activity reflects in the build of their shoulders and hindquarters, which are muscular and thick—ready to pounce and leap with great power from a stationary position. Attaching the front and back legs is a long and flexible spine that gives cats a distinctively "slinky," supple look. Keep in mind that while a cat may be long in body, it is usually rather narrow in width—"no wider than its whiskers" as I've heard it said.

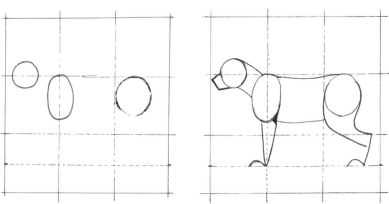
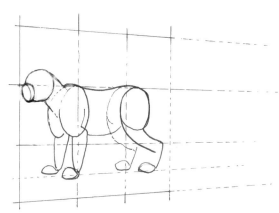

Some basic proportions to keep in mind while drawing a wild cat.

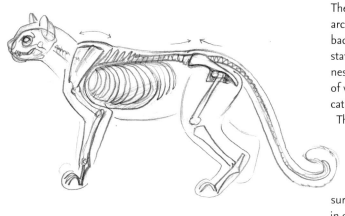

The spine of a cat can arch in tension or sway back in a more relaxed state. This expressiveness of the torso is part of what makes any wild cat register as "cat."

The tail is an extension of this expressiveness, and even the short tail of a lynx or bobcat can be surprisingly effective in conveying mood.

FEET: Cats walk on the tips of their toes like many mammals and have visible paw pads to grip surfaces. Their feet and toes are very soft and rounded in appearance, hiding needle-sharp claws that can be extended out or retracted inside hard sheaths of skin. The ability to retract their claws allows cats to keep them sharp: ready for attack, defense, or tree-climbing.

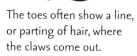

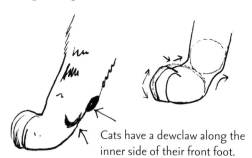

Front foot.

Cats have a dewclaw along the inner side of their front foot.

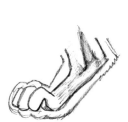

Hind foot.

The toes often show a line, or parting of hair, where the claws come out.

LEGS: Wild cats have long, strong, and flexible legs, which are similar to wild dogs' legs in structure, but on the thick side. Their front shoulders are powerful and their long shoulder blades are often prominent and expressive. These shoulder blades often create a "hump" above the shoulder in certain body positions. The hindquarters are pronounced as well and the hips often jut out above the line of the backbone.

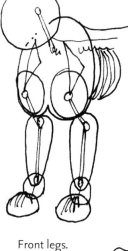

Front legs.

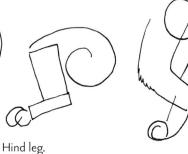

Hind leg.

TAIL: Cat tails are fairly simple. They are furry (but not thickly furred) extensions of the spine. The bobcat and lynx have short, twitchy tails and the mountain lion possesses a long tail that acts well as a counter-balance when running. More details can be found in each cat species section.

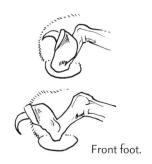

FUR & TEXTURE

Muscles of steel and claws that shred come cloaked in a soft package. In winter, the fur is especially long and the tufts on the ears and ruff on the jaws (if present) are well-defined. Northern cats' coats are thicker. Thanks to constant "cat baths," cat fur usually stays fairly neat. Bobcat and lynx hair has a darker undercoat, much like dog hair. A mountain lion's hair layers are harder to see.

A cat's head has several distinctive tracts of hair that affect the look of its face.

WILD CATS IN MOTION

Cats are creepers, leapers, and pouncers. They have a lithe, slinky way of moving that combines grace and power. The way the shoulders and hindquarters move influences a cat's posture. Its spine and hide are loose and flexible. Felines are often noted for a walk that involves moving two legs on the same side of the body forward together, but that isn't exactly true—there is a slight difference in timing as they move. Pay attention to the shoulders and hips as you draw cats in action.

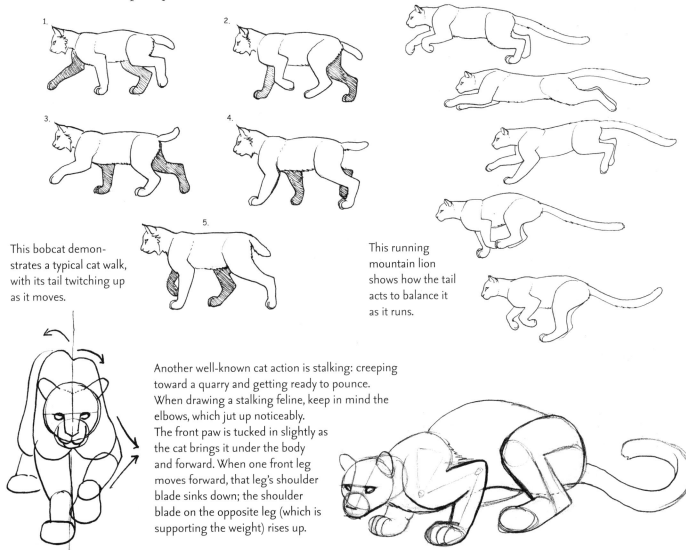

This bobcat demonstrates a typical cat walk, with its tail twitching up as it moves.

This running mountain lion shows how the tail acts to balance it as it runs.

Another well-known cat action is stalking: creeping toward a quarry and getting ready to pounce. When drawing a stalking feline, keep in mind the elbows, which jut up noticeably. The front paw is tucked in slightly as the cat brings it under the body and forward. When one front leg moves forward, that leg's shoulder blade sinks down; the shoulder blade on the opposite leg (which is supporting the weight) rises up.

CANADIAN LYNX

LYNX CANADENSIS

THE LYNX IS A SECRETIVE CAT of cold snowy regions and dark northern forests. It has huge paws that act as snowshoes, enabling the cat to move easily on snow that many other animals would flounder in. The lynx is well-known for its interdependence with its main prey, the snowshoe hare. Large numbers of hares lead to large numbers of lynx, while a decline in hares causes a decline in cats too.

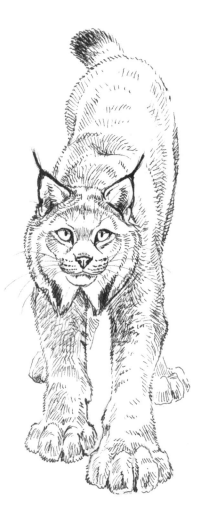

THE HEAD
The head of a lynx is much like a bobcat's, but a little thicker and broader. The muzzle is slightly heavier. Be sure to include the lynx's long, distinctive cheek ruffs.

EYES, EARS, AND NOSE: Lynx eyes tend to be a pale yellow to yellowish-green. They have elliptical pupils like a bobcat's. Around their eyelids, they have white markings fringed with darker markings. These markings are not as distinctive as on a bobcat. A hallmark of the lynx is its very long, showy ear tufts. The rims of its ears are marked with black, and the dark marking extends about halfway down the back of the ear. The lynx has a typical cat nose.

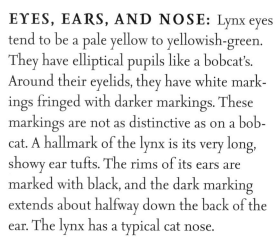

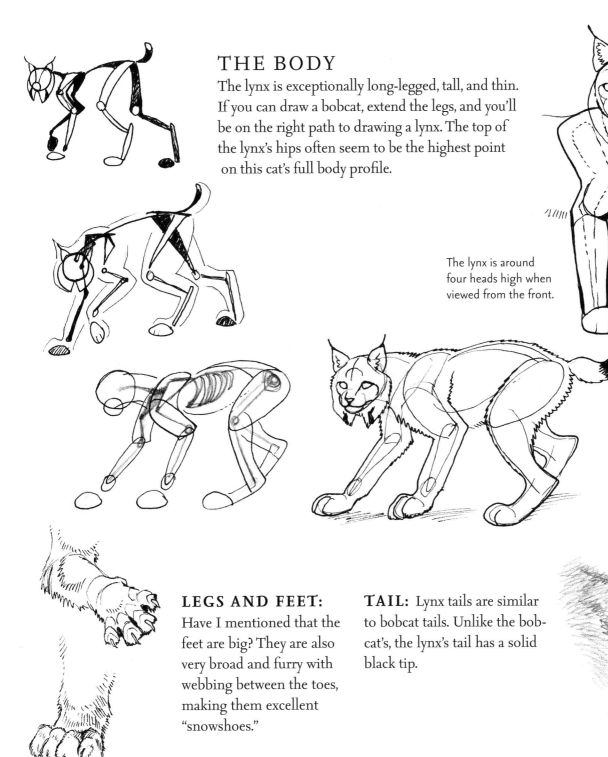

THE BODY

The lynx is exceptionally long-legged, tall, and thin. If you can draw a bobcat, extend the legs, and you'll be on the right path to drawing a lynx. The top of the lynx's hips often seem to be the highest point on this cat's full body profile.

The lynx is around four heads high when viewed from the front.

LEGS AND FEET: Have I mentioned that the feet are big? They are also very broad and furry with webbing between the toes, making them excellent "snowshoes."

TAIL: Lynx tails are similar to bobcat tails. Unlike the bobcat's, the lynx's tail has a solid black tip.

COLOR MARKINGS

Lynx and bobcats can be confusingly similar at times, but while bobcats are generally a brownish color, Canadian lynx have a lush silvery coat with some tan or rust. They are also less spotted, usually having only a faint suggestion of spots, or a mottled look, on most of their body. Some spotting may occur around their legs and belly. Remember to include the big black spots on their cheek ruffs.

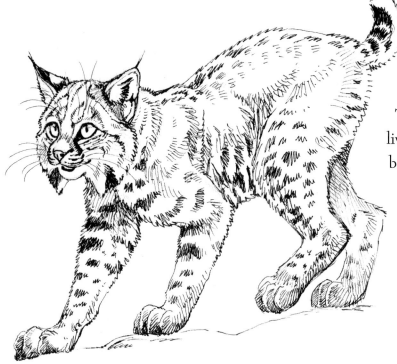

BOBCAT

Lynx rufus

THIS WIDESPREAD LITTLE FELINE certainly lives up to its other name, "wildcat." Bobcats can be scrappy and tough fighters when called for, but would rather be left alone to live out their solitary lives in peace and quiet. They are masters of stealth and their spots and stripes provide excellent camouflage. As a result they may be common in an area but rarely seen.

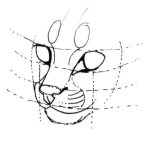

THE HEAD

The bobcat has a typical cat head with a short muzzle and big eyes. Its prominent cheek ruffs fluff out from just below its ears and flatten out to a large tuft on either side of its jowls.

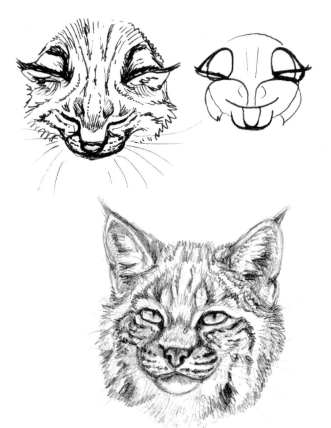

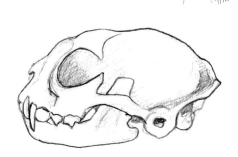

EYES, EARS, AND NOSE: Bobcats often have large, wide eyes relative to their face, but a big northern bobcat may have comparatively small, slanted ones. A bobcat's eyes are generally golden , sometimes with hints of green. Bobcats have elliptical pupils, like those of a housecat, which contract in sunlight. Bobcat ears are very distinctive. They feature dark tufts of hair on their tips, believed to possibly help with hearing or perhaps to accentuate expression. The backs of the ears are dark with a white spot in the middle of each. The bobcat has a typical feline nose.

THE BODY

The bobcat is built much like a hefty, stubby-tailed house cat. Its shoulders and hips are usually prominent, as in all cats, but its backside generally has a curved, ready-to-pounce posture.

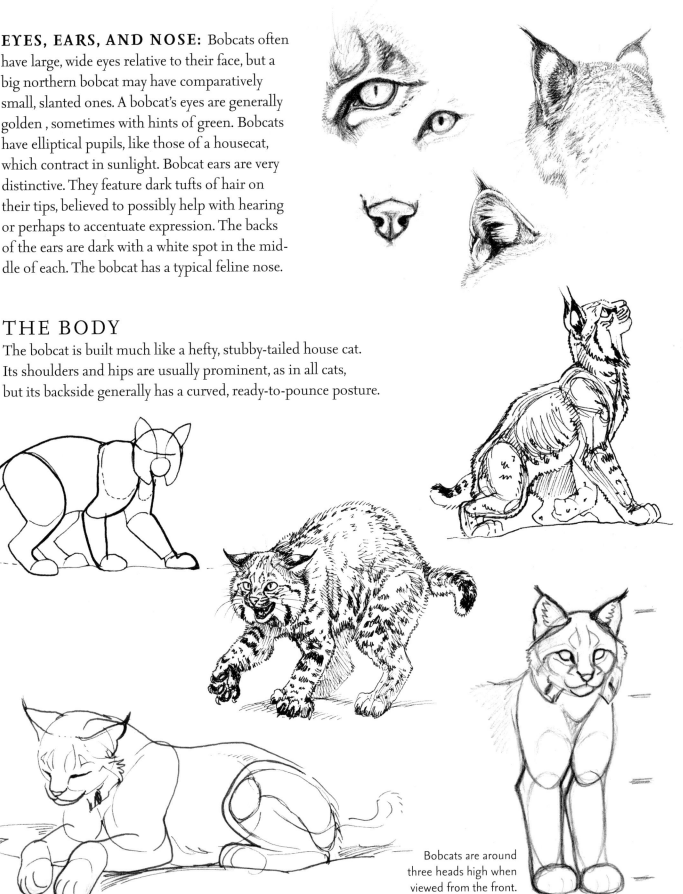

Bobcats are around three heads high when viewed from the front.

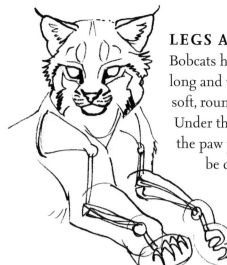

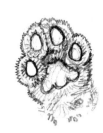

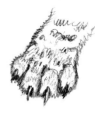

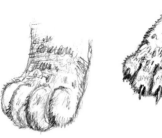

LEGS AND FEET:
Bobcats have strong, fairly long and thick legs with soft, rounded paws. Under the foot and near the paw pads the feet can be dark-colored, as if the cat just stepped in mud.

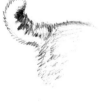

TAIL: The short tail of the bobcat is white underneath and on its very tip. The top of the tail is the same color as the body color, with two or three large black bands and various black spots starting from the white tip of the tail.

Despite being short, the bobcat's tail is very expressive and may be raised or lowered at will.

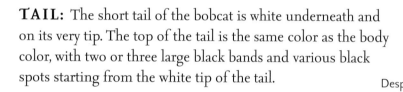

COLOR MARKINGS
Bobcats vary in markings, and some individuals are more heavily spotted than others, but basic patterns stay the same. When drawing a bobcat's spots, remember the three-dimensionality of your subject and think of how that marking wraps around its legs and body.

Bobcat fur is very soft.

Bobcats also exhibit heavy spotting along their spine.

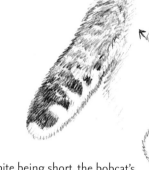

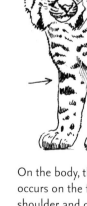

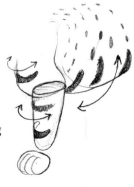

On the body, the most heavy spotting and striping occurs on the front chest and legs, below the shoulder and on the belly.

The facial pattern usually includes black marks along the whisker bases, eyebrow markings, and two stripes extending from the sides of the eyes and down to the cheek ruff.

MOUNTAIN LION

PUMA CONCOLOR

ALSO KNOWN AS COUGAR, PUMA, CATAMOUNT, and by ever more names, the mountain lion is the second biggest cat in North America after the jaguar. The mountain lion is a tawny-coated cat of wild places that is rarely ever seen by humans. Its combination of big cat strength and feline grace makes it a popular subject for wildlife artists.

THE HEAD

Lions have a large, blocky head with thick, powerful jaws. The hair tracts and shape of the skull create an almost "sculpted" look, especially since the hair is short and so much of what lies underneath shows through.

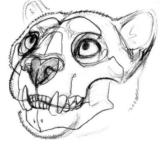

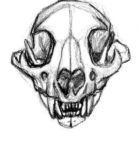

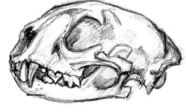

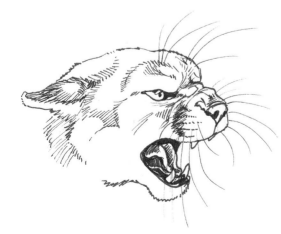

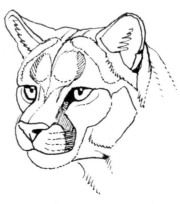

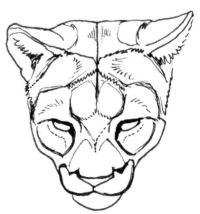

EYES, EARS, AND NOSE: Mountain lions generally have golden-yellow eyes, but they range in color from yellow-green to yellow with blue-gray around the pupil. Their pupils are round, not elliptical like the other cats'. Lion ears are a bit rounder in appearance than a bobcat's or lynx's. They are generally dark in the back but sometimes have a lighter area at the base. The nose is a typical triangular cat shape, rounded almost to a heart shape.

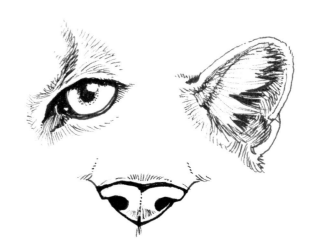

THE BODY

The mountain lion is a lithe, supple, and strong stalker and leaper, built to bring down deer and elk. Thick hindquarters hint at the power of this cat's leap. A long tail balances the front of the body. When viewed from the side, the head appears rather small compared to the rest of the body.

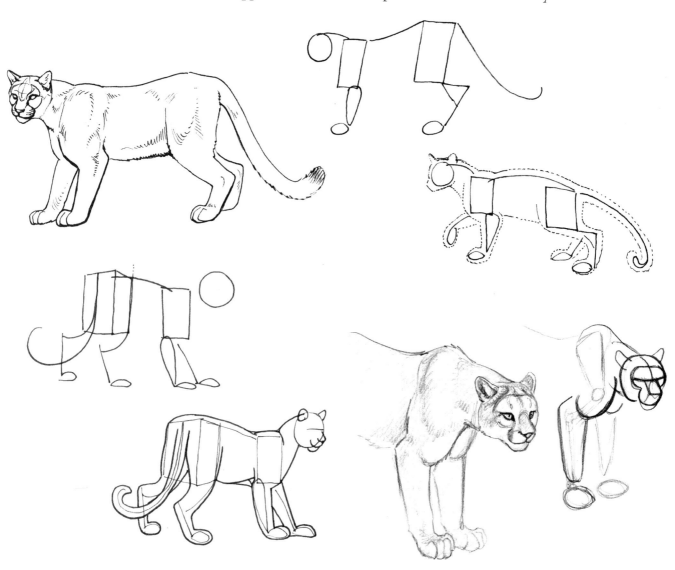

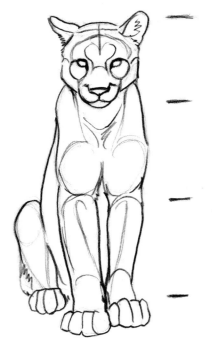

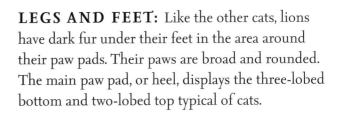

LEGS AND FEET: Like the other cats, lions have dark fur under their feet in the area around their paw pads. Their paws are broad and rounded. The main paw pad, or heel, displays the three-lobed bottom and two-lobed top typical of cats.

The mountain lion is around three and a half heads tall from the front, although that depends on the individual and variables like maturity.

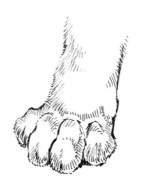

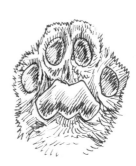

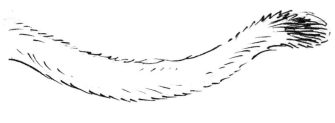

TAIL: The mountain lion's tail is its key distinguishing feature. Mountain lion tails are long with a dark tip, but no tuft like that found on an African lion. The tail works almost as a fifth leg, adding balance.

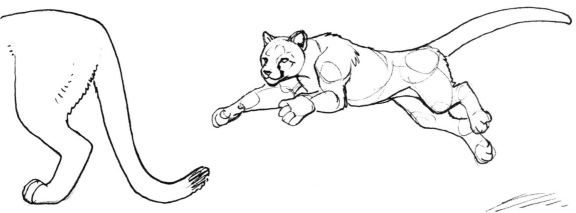

COLOR MARKINGS

The mountain lion's former scientific name, *Felis concolor*, means "cat of one color," and it is indeed mostly a tawny golden brown. The undersides are lighter than the backside, and there are dark markings under the feet, along the roots of the whiskers, the backs of the ears, and on the tip of the tail.

HOW TO DRAW A MOUNTAIN LION

A MOUNTAIN LION MAKES FOR A GOOD BEGINNER SUBJECT because of its short hair. In this demonstration I used pencil to depict a mountain lion in a seated posture with its elegant tail curved out to the side. Think "power," "grace," and "rounded forms" as you work on this project.

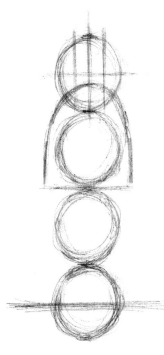

1. Begin by drawing four circles of the same size stacked on top of each other and put a ground line halfway through the bottom circle. Draw a plus sign or crosshairs centered on the top circle. Add two vertical lines, one on each side, to divide the top circle into evenly spaced fourths. Draw an upside-down "U" starting just below the crosshairs and ending below the second circle. Cap this off with a straight line.

2. Add slightly slanted eyes and a "blocky U" nose shape between them. From the body add two lines curving down and ever-so-slightly inward toward the ground. Indicate the inside legs. Add a triangular nose and the ears, keeping a broadened heart shape in mind. Add shoulder humps, using half-circles, where the legs attach to the body. For the top of the paws, add another straight, horizontal line where the outer leg lines meet the fourth circle. Draw a U-shape for the muzzle, two lines for the mouth, two ovals above the eyes, and a straight line between the inner ears. Add the hind leg. Draw in the toes, letting the lines splay out a bit from the top, and a hind foot, putting its top line a bit lower than the top line of the front feet, which are closer.

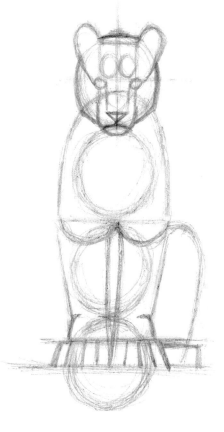

3. Add the inner ears and the toes for the hind paw. Then do some fine-tuning, which is very subtle but will add a lot to your drawing. Hint at the musculature by adding a faint "dent" above the shoulders. Add the rump to the hind leg. Add a tail. Block in the features of the face, keeping a rounded look in mind. Pinch in the outside ears where the "ear pocket" will be. Define the "heart-shaped" nose and the eyes. Add a small hint of the hind leg and foot on the other side.

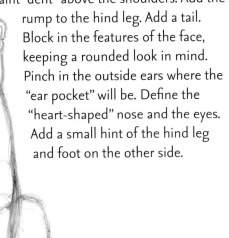

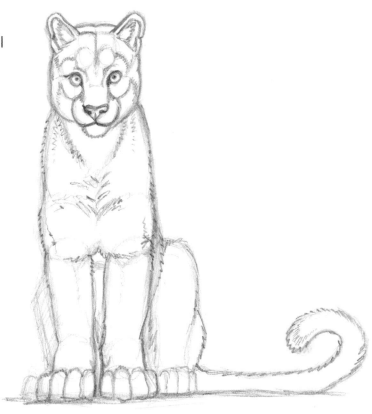

4. Now clean up your drawing, or transfer the image to a new sheet of paper. At this stage, I use a 2B pencil to begin laying down the final drawing. Define the outlines and major hair direction lines. Begin shading in some of the dark markings.

5. Now begin adding fur details. Use short strokes in the direction of the hair. In the case of very short fur, such as along the nose, you may want to shade with just the side of your pencil, leaving visible strokes only for areas with longer hair (comparatively), such as the chest. Go back and continue adding fur strokes and shading. Darken the belly and continue to indicate fur texture along the chest and shoulders. Fine-tune the facial markings and shade all the "planes" around the head. Add the whisker markings and define the inside of the ears. Lightly shade the neck under the jaw to make the jaw (and head) pop out a bit from the neck. Add creases to the fur along the tail.

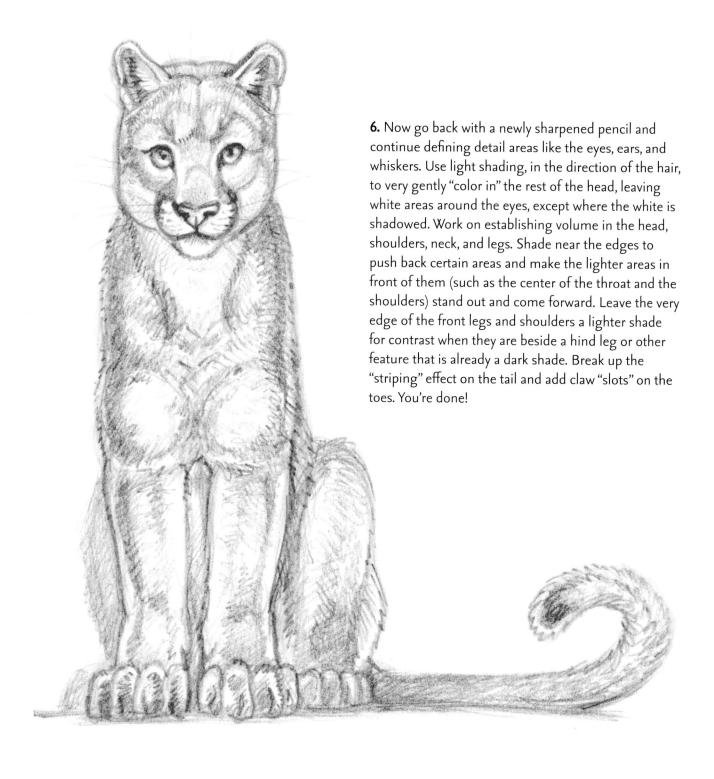

6. Now go back with a newly sharpened pencil and continue defining detail areas like the eyes, ears, and whiskers. Use light shading, in the direction of the hair, to very gently "color in" the rest of the head, leaving white areas around the eyes, except where the white is shadowed. Work on establishing volume in the head, shoulders, neck, and legs. Shade near the edges to push back certain areas and make the lighter areas in front of them (such as the center of the throat and the shoulders) stand out and come forward. Leave the very edge of the front legs and shoulders a lighter shade for contrast when they are beside a hind leg or other feature that is already a dark shade. Break up the "striping" effect on the tail and add claw "slots" on the toes. You're done!

WEASELS & THEIR RELATIVES

are members of the family Mustelidae, a distinctive and diverse group of animals that have adapted to a variety of habitats. Many members of the weasel family, including ferrets and minks, have long, slinky bodies adapted to squeezing down rodent tunnels in search of food. Others members of the clan, such as the badger, have abandoned the long and sinuous body shape for a more compact or powerful one. Many carry a reputation for ferocity, and there is no doubt that many members of the weasel tribe can hold their own in a fight, even with much larger animals. However, they can also be playful, inquisitive, and fun to watch as they go about their daily business. There are so many members of this family that narrowing them down was a challenge. Skunks, now grouped in their own family, Mephitidae, are included in this section because they were once part of Mustelidae.

THE HEAD

Weasel heads are generally broad, with a large space between the low-set ears. The head, including the muzzle, is usually somewhat oval- or egg-shaped. The features of the head, such as the eyes and ears, are often small to medium in size.

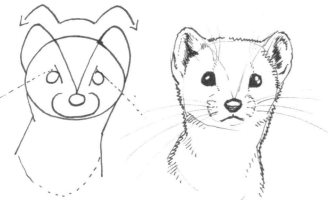

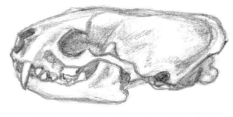

Members of the weasel family, such as this mink, tend to have extremely long brain cases. It is important to provide adequate mass and length behind the eyes and ears of a weasel in order to achieve a correct "look."

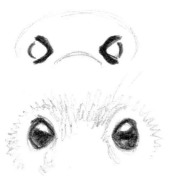

EYES: All members of the weasel family have dark, beady, and, usually, small eyes. One important feature to keep in mind is the broadness of their heads and the subsequent width between the eyes. Weasels and ferrets have round pupils.

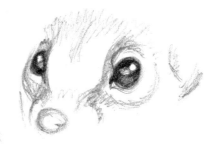

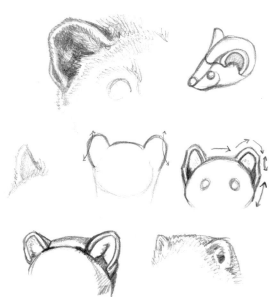

EARS: Weasel ears are a somewhat blocky C-shape, are usually set low and far apart, and have "ear pockets" (see page 13). They are rounded but sometimes have slightly pointed tips, which may tilt back a little toward the back of the head. The exact shape of the ear seems to vary by individuals and species, but if you capture the broad, semi-rounded, low-set effect, the ear should look about right.

NOSE: The nose tends to be small on most members of the family, but badgers and otters have somewhat more prominent noses. A short-tailed weasel's nose is shown here.

THE BODY

Many members of the weasel family, such as weasels and ferrets, have exceptionally long, slinky bodies. Others, such as the badger and the wolverine, have abandoned the long and sinuous body shape for a more compact or powerful one.

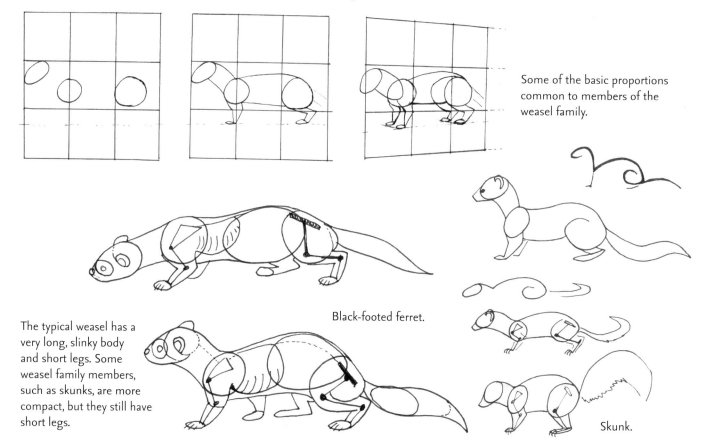

Some of the basic proportions common to members of the weasel family.

The typical weasel has a very long, slinky body and short legs. Some weasel family members, such as skunks, are more compact, but they still have short legs.

Black-footed ferret.

Skunk.

FEET: Weasels have rounded paws that are usually quite furry, making the toes indistinct at times, but the claws tend to show up fairly well. Weasels have five toes on each paw—the middle three usually stick out farther than the outer two.

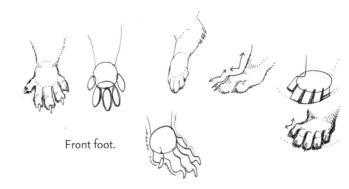

Front foot.

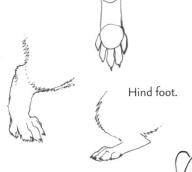

Hind foot.

LEGS: The short legs are important features to capture when drawing members of this family. Weasels tend to have very round haunches. They often stand on their toes with their heels off the ground, but sometimes they stand flat-footed.

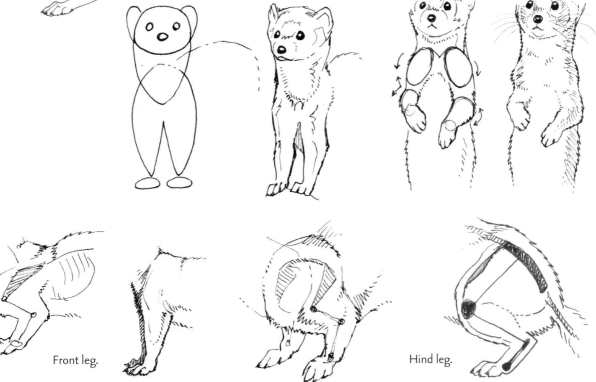

Front leg.

Hind leg.

Hind leg.

TAIL: Members of the weasel tribe tend to have long, tapering, and somewhat bushy tails. There are some dramatic exceptions, however, including the long, flattened tail of the otter, the short tail of the badger, and the elegant plume of the skunk.

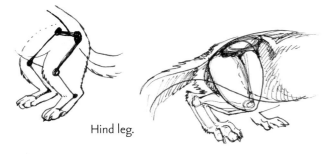

FUR & TEXTURE

Weasels are well-known for their soft, luxurious fur. Most people are familiar with mink stoles or the fact that the winter pelts of the short-tailed weasel (ermine) adorned the robes of kings. Most members of the weasel tribe have this kind of silky fur. Keep in mind that the fur is usually rather short, soft, and has a silky sheen to it. Some weasel species display a fairly solid hair coloration from base to tip, and most lack the dramatic color variation of other kinds of mammals.

Mink fur.

WEASELS IN MOTION

With their long bodies and short legs, weasels have a distinctive way of moving. They are reminiscent of furry slinky toys as they scoot across the landscape! Weasels often move by leaps and bounds, hunching their bodies, then stretching them out. They seem to be in constant motion, heads bobbing and paws twitching. They can walk, but are just as likely to move by bounding along effortlessly. Weasels also sometimes stand on their hind legs to get a better view of their surroundings. Other members of the weasel clan that possess shorter and stouter bodies tend to move through the world in their own way. Wolverines have a tireless gait that carries them for miles at a time. Badgers and skunks shuffle along, not usually in too much of a hurry.

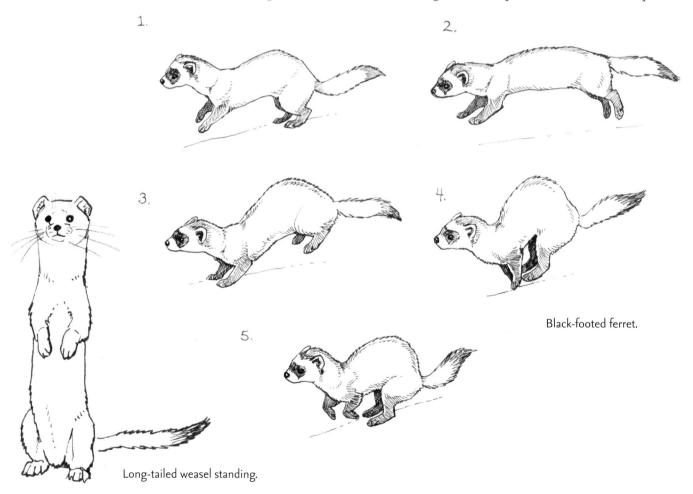

Black-footed ferret.

Long-tailed weasel standing.

LONG-TAILED WEASEL

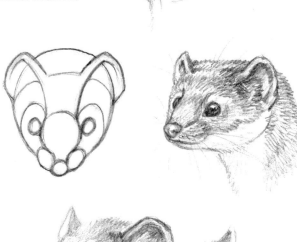

MUSTELA FRENATA

THERE ARE THREE SPECIES OF WEASELS in North America, all of which are fairly similar to each other. At around 7 inches long, the least weasel (*Mustela nivalis*) is the world's smallest carnivore. Next in size is the short-tailed weasel (*Mustela erminea*), also known as the ermine (the name for its white winter coat). A little larger than the short-tailed weasel is the long-tailed weasel. This relentless bundle of energy is capable of taking down rodents and rabbits larger than itself. The long-tailed weasel is inquisitive and alert as it explores every nook and cranny in its endless search for food.

THE HEAD
Weasels have very broad heads with low-set ears and a rounded muzzle.

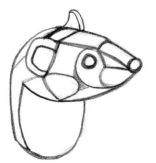

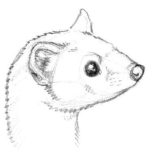

EYES, EARS, AND NOSE: The weasel's eyes are dark, beady, and wide-set. The ears are small and rounded. The nose of a weasel juts out a little bit farther than the rest of its muzzle.

THE BODY

As discussed in the family description, weasels are well-known for their long, slinky bodies and short legs.

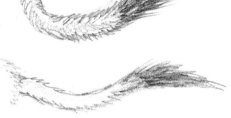

LEGS AND FEET: Weasels have short legs and rounded feet.

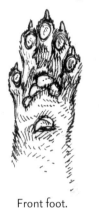
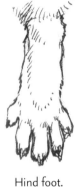

Front foot.　　Hind foot.

TAIL: As its name implies, the long-tailed weasel has a long tail. The tip is black and may appear slightly bushy.

COLOR MARKINGS

The long-tailed weasel, like other weasels, is usually brown on the top and white or yellowish below during the summer. In the more southwestern parts of its range, it may have a dramatic white or yellowish spot between its eyes, and the light fur on its throat may extend high up its cheeks. Individuals show a lot of color variation. The boundary between the light and dark areas may be smooth, or it may be somewhat patchy and mottled. In the northern parts of this weasel's range, it turns completely white during the winter except for its dark eyes, nose, and tail tip.

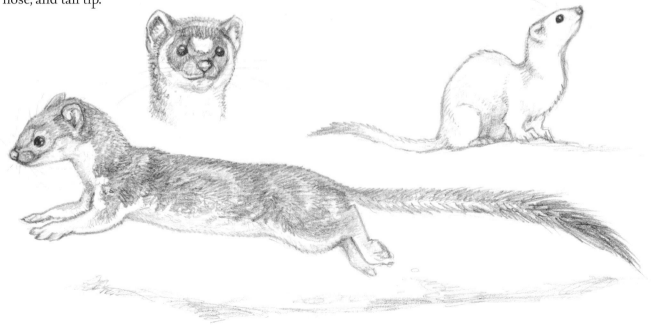

AMERICAN BADGER

Taxidea taxus

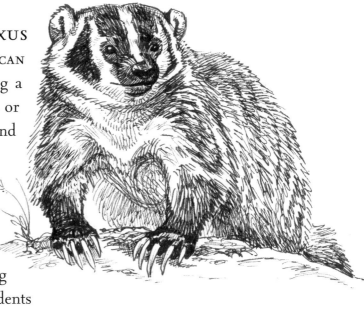

THE STOCKY, BROAD-SHOULDERED NORTH AMERICAN BADGER has a well-deserved reputation for being a formidable fighter able to ward off mountain lions or even bears on occasion. It shuffles along the deserts and plains, digging into the ground in search of rodents or shelter. The badger is sometimes part of an interesting partnership. Coyotes and badgers can be observed hunting ground-dwelling rodents together. As the badger digs, the presence of the coyote keeps many rodents underground, increasing the badger's success rate. The coyote catches any rodents that try to make a break for it.

THE HEAD

The badger has an extremely broad, wide head with ears placed far apart from each other.

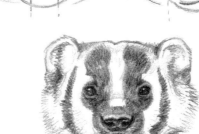

EYES, EARS, AND NOSE: The badger's eyes are small and dark, with round pupils. The ears are low-set but noticeable. The nose usually appears darker than in some of these illustrations, which are lightened to show details.

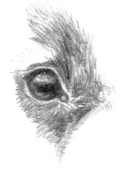

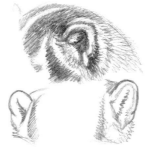

THE BODY

The badger's body is stocky, flattened, and broad: built for power, not speed.

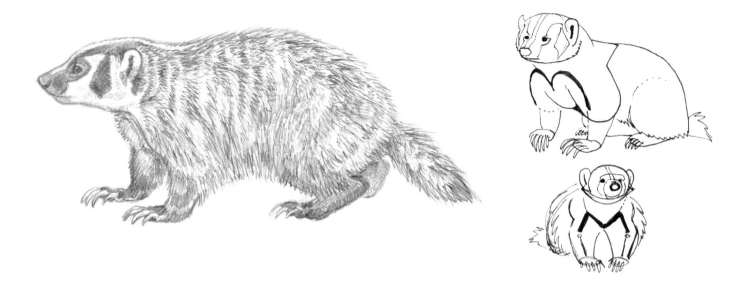

LEGS AND FEET: The badger's legs are short and powerful, and the front feet have exceptionally long claws.

TAIL: The badger's tail is very short and may be bushy or somewhat scruffy-looking.

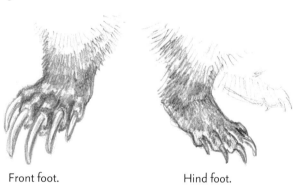

Front foot.　　　　　Hind foot.

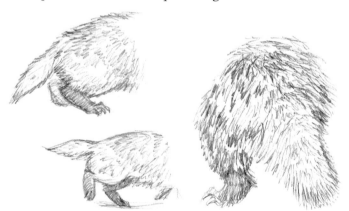

COLOR MARKINGS

The distinctive-looking badger has a white face with a some-what U-shaped dark brown marking and dark brown cheek patches. Parts of the ears and the paws are dark brown. The fur is coarser than that of some weasels but still has a softness to it. It is very grizzled in appearance, comprising of alternating bands of black, white, and tan. The base of hairs is buff, which shows up most clearly along the sides and rear.

RIVER OTTER
LONTRA CANADENSIS

IT'S HARD TO FIND SOMEONE who does not like the playful, energetic otter. This water weasel is superbly adapted to its aquatic environment and moves through it with ease. A resident of Alaska, most of Canada, and parts of the continental United States, the river otter swims through marshes, rivers, and lakes in pursuit of fish. It would seem to be in search of a good time, as well, as it repeatedly slips down muddy banks just to run up and slide down again!

THE HEAD

The river otter has a very broad, long, and rounded head with small, low-set features. The muzzle is very wide and its whiskers are prominent. Note the relatively small size of the face compared to the rest of the skull, especially when viewed from the side or above.

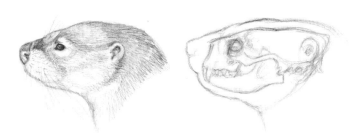

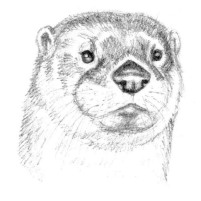

EYES, EARS, AND NOSE: The river otter's ears, like most of its features, are small and streamlined. Its ears and nostrils are valved to keep out water while swimming. The nose is quite large and somewhat spade-shaped. The top of the nose, above the nostrils, extends up to a point above the base. The fur rimming the dark nose sometimes appears lighter colored, creating an area of contrast.

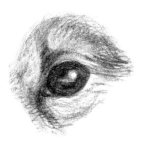
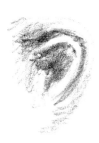
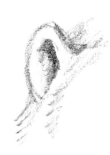

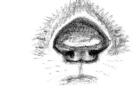

THE BODY

The otter has a very streamlined and sinuous body, perfect for its underwater escapades. The head, body, and tail all flow together.

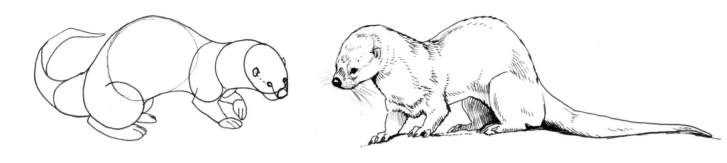

LEGS AND FEET: Otters have webbed feet, a reflection of their aquatic lifestyle.

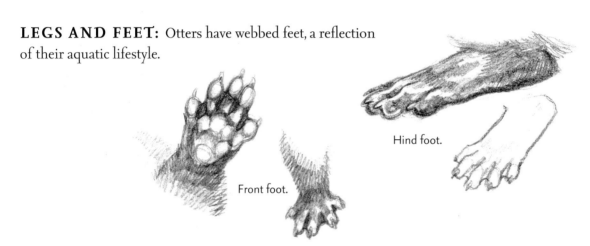

Front foot.

Hind foot.

TAIL: The river otter's tail has a thick base that tapers to a pointed tip. It is slightly flattened and functions as a rudder to help the otter swim.

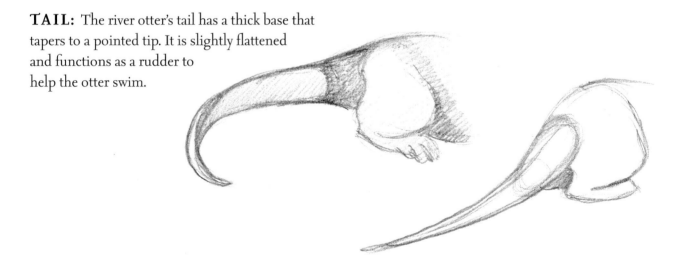

COLOR MARKINGS

River otters are mostly brown, with lighter throats and bellies. Their hair is short, dense, silky, and soft. The otter spends a lot of time grooming its fur to keep it buoyant in the water.

STRIPED SKUNK

Mephitis mephitis

Found throughout the U.S. and most of Canada, the striped skunk is a familiar animal to many people...perhaps a little too familiar, in some people's opinions! Once you have smelled the stench a skunk is capable of producing, you won't forget it, nor will you tend to seek out an encounter with the animal—which is exactly what the skunk wants. It's really a relatively peace-seeking critter: It has a powerful defensive weapon but would prefer not to use it if it doesn't have to. Not a bad way of living.

THE HEAD

Until recently, skunks were considered members of the weasel family, and this close relationship shows in their head structure. They have the broad face, low-set ears, and small facial features of the weasel clan.

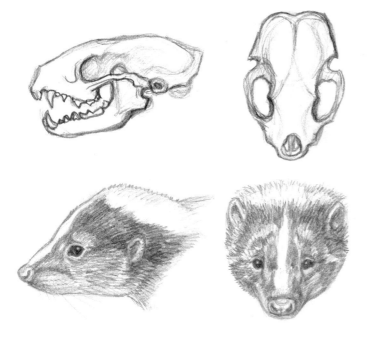

EYES, EARS, AND NOSE: The striped skunk's eyes are small and beady, and its ears are not very noticeable. The nose is broad and may range in color from black to a muddy pinkish-brown.

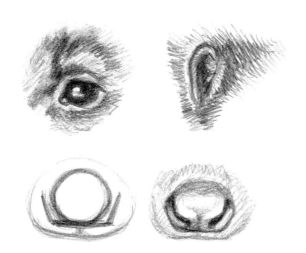

THE BODY

The skunk is not as specialized as many weasels; it is more of a generalist, which is reflected in its body shape. It doesn't need to be in a hurry, given its unique ability to defend itself, so its relatively compact body shuffles along on flat feet as it searches the ground for plant or animal food items, such as small rodents, invertebrates, and eggs.

LEGS AND FEET: The skunk's feet are flat with long claws. Its legs are not long, but they are not quite as short as those of some members of the weasel family, either.

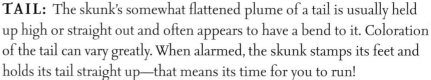

Hind foot.

Front foot.

TAIL: The skunk's somewhat flattened plume of a tail is usually held up high or straight out and often appears to have a bend to it. Coloration of the tail can vary greatly. When alarmed, the skunk stamps its feet and holds its tail straight up—that means its time for you to run!

COLOR MARKINGS

While most animals are colored to blend into their habitat, the skunk's dramatic black-and-white coloration serves to warn potential predators that this animal doesn't need to hide. The striped skunk is mostly black, with a white V-shaped mark extending from its neck down its body and through its tail.

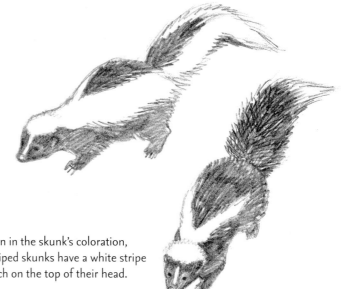

There is a lot of individual variation in the skunk's coloration, as shown here. However, most striped skunks have a white stripe on their forehead and a white patch on the top of their head.

OTHER MEMBERS OF THE WEASEL FAMILY

WEASELS AND THEIR KIN ARE A DIVERSE AND VARIED TRIBE, from the acrobatic spotted skunk to the tool-using sea otter. There are too many to include all in this book, but here is a quick look at some other species.

PINE MARTEN

MARTES AMERICANA

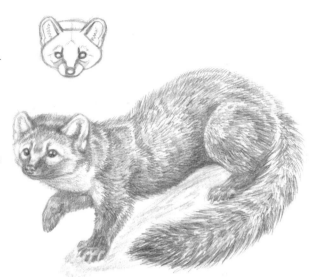

The pine marten is a creature of the high, cold northern forests, and its plush, silky coat reflects this habitat. It has fairly large ears and eyes for a weasel and possesses a light-colored, foxy face with a dark muzzle. Its body is long with a fairly bushy tail. The fur is dark brown but the throat may be an intense orange. The marten dashes along the ground and through the treetops in search of red squirrels and other rodents.

WOLVERINE

GULO GULO

This very powerful animal is capable of driving a bear or mountain lion away from its kill! Wolverines travel tirelessly over vast territories (up to 1,000 square miles), searching for food they can kill, scavenge, or steal. They are usually solitary except during mating season. The wolverine has an almost bear-like appearance and shaggy, brown fur. The wolverine usually has a dark face, a light-colored forehead, and a light stripe circling around its sides and rear.

BLACK-FOOTED FERRET

MUSTELA NIGRIPES

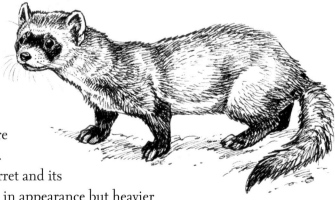

This inquisitive and distinctive member of the weasel tribe may be North America's rarest mammal. It lives on the open plains, feeding largely on prairie dogs, and this specialization almost meant its demise as prairie dogs were systematically wiped out through most of the western U.S. Now, through the efforts of some dedicated people, the ferret and its prey are making a comeback. The ferret is very weasel-like in appearance but heavier set. It is light golden-brown with a black mask around the eyes and, no surprise here, black feet.

HOW TO DRAW A RIVER OTTER

IN THIS DEMONSTRATION IN PENCIL, I show more of my personal approach to drawing, starting at my natural beginning point and going on from there. In order to understand where I am coming from as I start this demonstration, you may want to try some of the other step-by-step tutorials in this book before attempting this one. This drawing is also a good example of the techniques I use to draw wet fur, which are a little different than those I use for dry, fluffy hair. Wet fur has a slicker and darker appearance with more contrasting highlights.

1. Having an idea already in mind, I sketch a rough drawing and focus on the design aspect. Do the shapes flow and do they have a pleasing pattern and balance? This is especially important for a drawing of the streamlined and fluid otter. Note how the otter is twisting back to look at the viewer. Its visible, closer hind foot and the farther front foot are both on the horizon line, which is about the same distance from the viewer. The closer front foot juts out and down from that horizon line, coming closer and adding three-dimensionality to the animal.

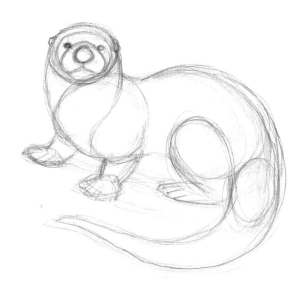

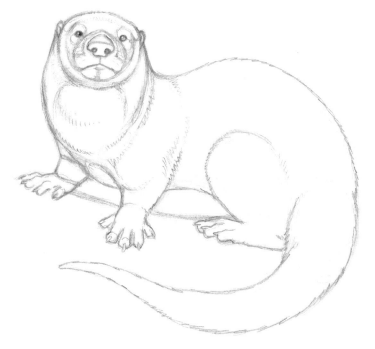

2. At this point, I work on refining the concept and making sure the form is believable. I begin to put in the lines and connections between the legs, the neck, and other parts of the anatomy that I will need later. I begin to define the nose, eyes, and toes. This is where I finalize the outline and details. As I put the final outline on the otter, I make sure to keep a sense of weight, volume, and anatomy, while beginning to indicate fur. I also define the lower lip, jaw, and toes.

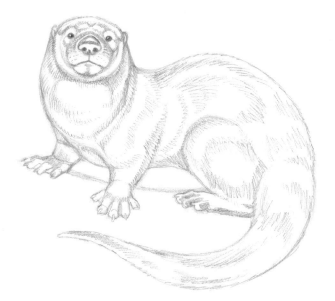

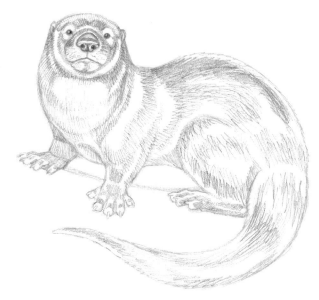

3. Now I begin to shade the body and define the bulges and hollows of muscles and overlapping forms. Note how I kept the thick oval base shape of the tail in mind, while not overemphasizing it. This underlying shape helps to indicate the thickness there. I also add shadows directly behind the toes to help them "pop" out. I then add whisker follicles and details of the eye and nose.

4. I continue shading. Keep in mind that to convey the look of wet fur, it is important to keep high contrast areas where glistening highlights snake their way through darker sections. Areas where the fur is compressed, such as where the hind leg presses against the otter's side, will be darker, while areas that angle out will usually have a highlight somewhere that follows the curve of the muscles.

5. Another thing to keep in mind when drawing damp or wet fur is its "spiky" look. In wet fur, the hair clumps together and spiky points are prevalent. Note the V-shaped spikes on this drawing indicating clumps of wet fur. Keep in mind that really wet, "just out of the water" fur slicks back and smoothes out. Note that this critter's outline is smooth and sleek, not "fluffy." The head of this otter is the least wet part of its body; the animal probably kept its head out of the water most of the time while it was swimming recently.

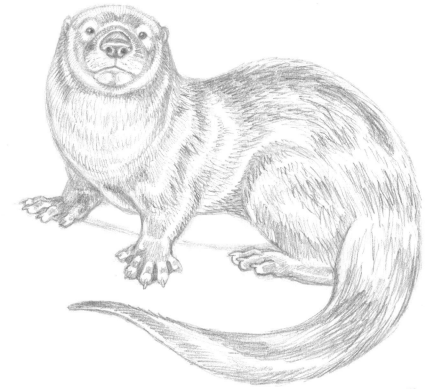

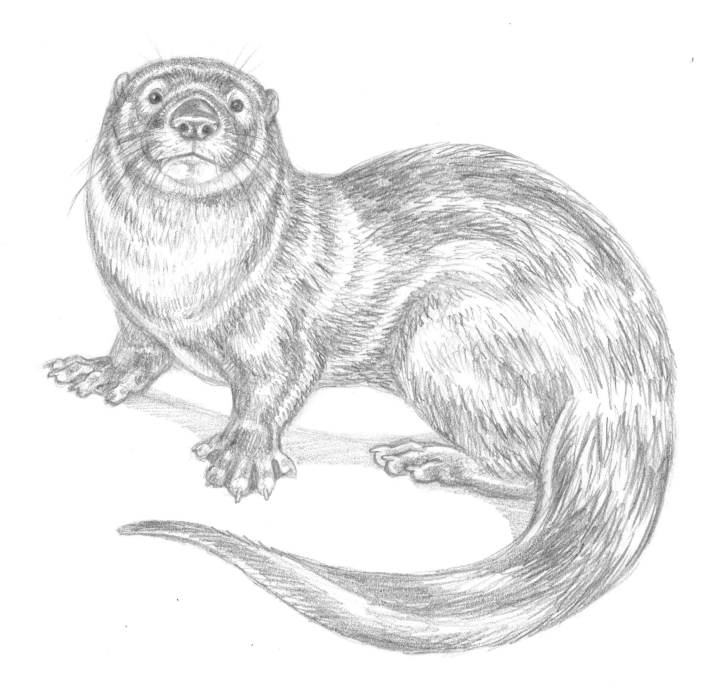

6. The final step is to go over the drawing and continue to add details and shading where needed. I darken several areas but try to keep the throat and jawline light. Note that I leave a light sheen next to the dark area. I work down the whole body, adding definition and hair detail. The tail is shaded in broadly below the base, with a minimum of hair detail, because the hairs on it get shorter and less defined toward the tip. I darken the top of the nose, shading on one side and leaving the other lighter for a sense of volume and shadow. Finally, I add whiskers, an important part of any otter's face!

BEARS

BEARS hold a special place in the human psyche, due not only to their large size and sharp claws, but also to their sometimes human-like appearance. Bears can stand on their hind legs, or sit much like a human would. There are three members of the family Ursidae found in North America: the black bear, the brown, or grizzly, bear, and the polar bear. The all-white polar bear is pretty easy to spot, but how do you tell the difference between a black and a brown bear? There's an old woods saying I've heard that advises you to climb a tree. If the bear climbs up the tree and eats you, it's a black bear. If it knocks the tree over and eats you, it's a brown. While there is some truth in that old saying, you may want to know of a less painful way of discerning the species.

THE HEAD

One of the keys to successfully drawing a bear is conveying the thick, broad nature of its head. Bears have a normally proportioned, somewhat narrow face set inside a massive head. Be sure to show the broad forehead by keeping the distance between the ears wide. It is also important to remember that there is a broad space between the ears and eyes of a bear. I used to have some trouble making my bears look like bears and not some kind of dog or cat until I learned to get the broadness of the head correct.

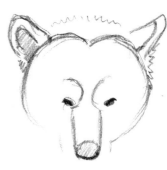

EYES: Bear eyes are dark, rather small, and almost beady-looking compared to the massiveness of their heads. In fact, their dark eyes can sometimes be hard to discern from the rest of their face! The eyes have round pupils and brown irises. Sometimes, when glancing to the side, the whites of their eyes show. Some individual bears, especially brown bears, have prominent brows above their eyes.

EARS: Bears have small to medium, upright, rounded ears that are spaced far apart. Ear detail is often hard to see because of the shaggy hair.

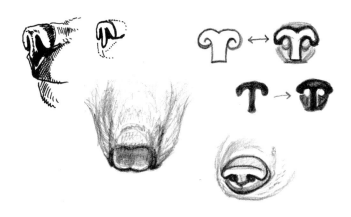

NOSE: Bear noses, when viewed from the front, remind me of a mushroom slice. They are a prominent, arched T-shape with a fleshy pad below the nostrils. The top edge of the "mushroom" sticks out some from the middle of the nose.

THE BODY

Bears have a solid, somewhat chubby appearance, with large, powerful hindquarters, broad, flat-footed paws, and shaggy fur. Their hind legs are fairly straight and stand directly under their hips, rather than extending farther back and behind like most animals. Bears are built for power but can be surprisingly fast, equally able to rip into a car to search for food as to run down an elk calf.

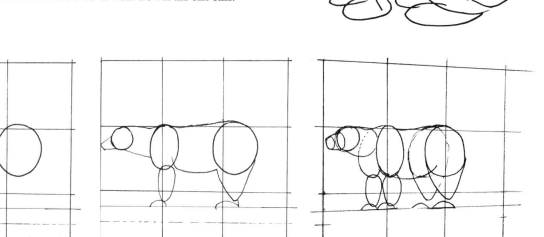

A grid can help you visualize a bear's body build.

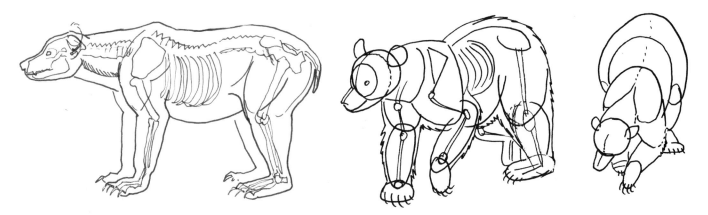

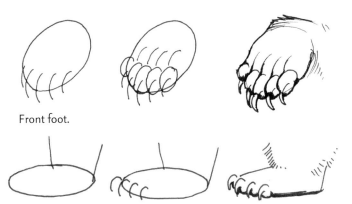

Front foot.

Hind foot. Remember that a bear's hind foot is flat and that the heel touches the ground.

FEET: Bears are flat-footed. Their heels and palms touch the ground, much like humans on all fours, and they leave a human-like footprint (except for those claws!). Their paws are broad, and their toes are small compared to the main pad. Shaggy fur can obscure the detail of the toes sometimes, but the long, somewhat curved claws are always visible.

LEGS: Bears have rather straight, muscular, and powerful legs. Their front legs are similar to those of other carnivores, except for the front foot, which is laid flat on the ground—palm, toes, and all. A bear's hind legs are more human-like than those of most mammals in that they stand nearly straight, instead of extending back and behind the hips. The already bulky legs are covered with long, shaggy fur, which adds to their thick appearance.

One very important thing to remember about a bear's front legs: A bear is slightly "pigeon-toed"— its front feet have a tendency to point inward a little.

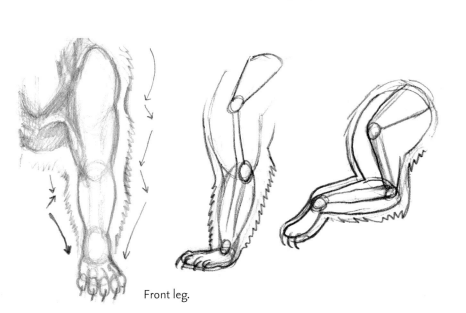

Front leg.

Hind leg.

TAIL: Bears have very short and stubby tails, which are often obscured by hair.

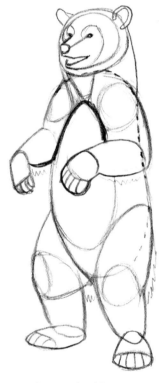

FUR & TEXTURE

Bear fur is very long and shaggy. During the cold months of the year, it can become exceptionally thick and take on a glossy sheen as it ripples with the bear's movements. Understanding what is going on underneath a bear's fur is critical, since the hair tends to obscure so much of the actual anatomy.

BEARS IN MOTION

Bears have a rambling, shuffling walk that could lead one to think that they are slow and clumsy—until the bear starts to run. Brown bears have been known to outrun horses for a short distance! As a bear walks, its front feet tend to point inward. The head is often kept at a low angle.

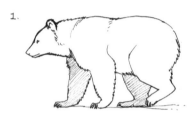

1.

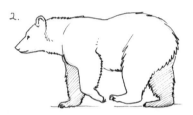

2.

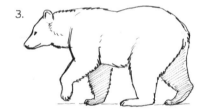

3.

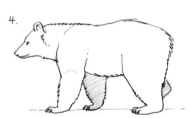

4.

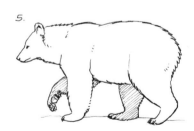

5.

When a bear stands on its hind legs, usually to get a better view of its surroundings, we take notice. A standing brown bear or polar bear towers over the average human being. Bears can't maintain this posture for long; their knees don't lock when standing like ours do, so the legs aren't completely straight and the bear tires.

Another intimidating sight is that of an angry, growling bear. Some key things to remember when drawing such an animal is that the nose tip draws back, while the lips may still reach out. The top of the bear's muzzle wrinkles up, but the cheeks of the bear don't distort as much as, say, a dog's do.

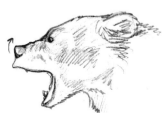

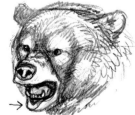

BLACK BEAR

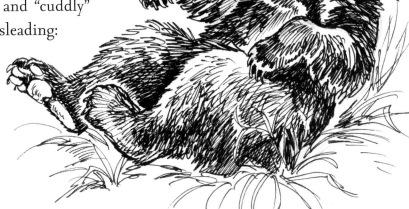

The well-known black bear is widespread and adaptable. The smallest North American bear, it is the basis for the beloved "teddy bear," and, indeed, black bears can charm us with their almost human-like antics and "cuddly" appearance. This charm can be misleading: The black bear is also an unpredictable wild animal with claws and teeth, and it knows how to use them! Best enjoyed from a distance, black bears are a rewarding subject for artistic endeavors.

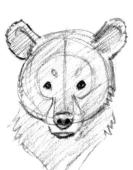

THE HEAD

The black bear's head is fairly streamlined. In a profile view, its "eye stop," or the junction of the forehead and muzzle, is generally not as pronounced as a brown bear's. The muzzle is straight or slightly down-turned and the eyes are small.

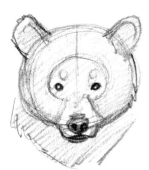

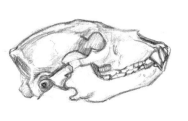

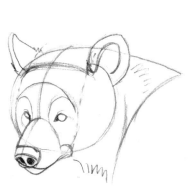

If you are having trouble depicting an older, more mature bear versus a young one, keep in mind the broadness of the head. A young bear (LEFT) has proportionately larger ears and a larger face. As it matures, the head gets thicker and the space between the ears and the rest of the face grows. An older bear (RIGHT) will have a face and ears that appear much smaller relative to its head size.

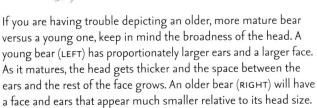

EYES, EARS, AND NOSE: The black bear's eyes are small, dark, and have a round pupil. The ears are upright and rounded at the top, and often seem to be slightly longer and narrower than the ears of other species. The nose is similar to that of other bears.

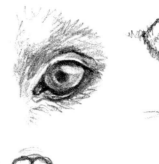
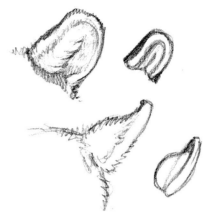

THE BODY

The black bear is a solidly built, muscular animal with fairly straight legs. It lacks the shoulder hump present on the brown and polar bears, and the hindquarters are the highest point on this bear's body. This bear's shuffling, almost clumsy walk and demeanor belie the fact that it is quite agile and very strong.

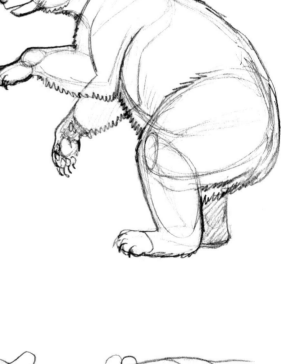

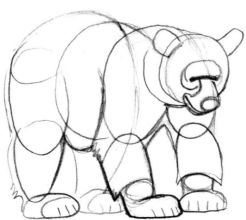

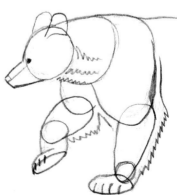

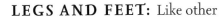
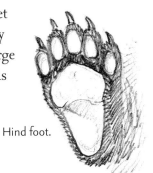

LEGS AND FEET: Like other bears, the black bear has flat and broad feet with long claws and shaggy hair that partially obscures the toe details. The front foot has a large palm pad as well as a smaller, round pad, which is found just above and behind it.

Front foot.

Hind foot.

TAIL: Black bears, as well as other bear species, have small, stumpy tails that are sometimes hidden by all that shaggy fur.

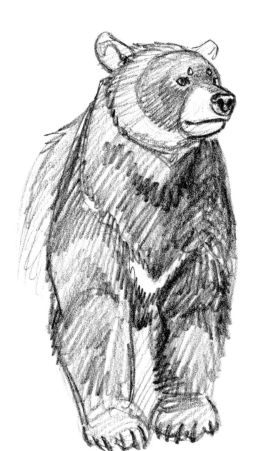

COLOR MARKINGS

Despite their name, black bears actually come in a wide variety of colors. Eastern bears are almost always black, while western bears exhibit a range of colors. The most common color is black, but there is also brown, blond, cinnamon, and even a "blue" or a white color that is found in some subspecies. Black-colored bears may have tan eyespots, a tan muzzle, and sometimes a white V-shape on the chest.

BROWN BEAR

URSUS ARCTOS

BROWN BEARS ARE IMPRESSIVE AND CHARISMATIC ANIMALS that demand respect, and get it, whether fishing for salmon in a stream, rolling over boulders in search of insects, or wrestling an injured caribou to the ground. There are two subspecies of brown bear in North America: the grizzly bear and the Alaskan brown, or Kodiak, bear. The grizzly bear has longer claws, is slightly smaller, and sometimes shows a "frosted," or grizzled, pattern on its coat, hence its name. Alaska brown bears are found only along coastal areas of Alaska and British Columbia, but grizzly bears are found over a wider area of North America.

THE HEAD

In profile, the brown bear usually features a much more pronounced "eye stop" than the black bear. The muzzle and nose generally have a scooped, upturned look to them. Viewed from the front, a mature brown bear's head is massive and almost heart-shaped, with a pronounced groove between the ears.

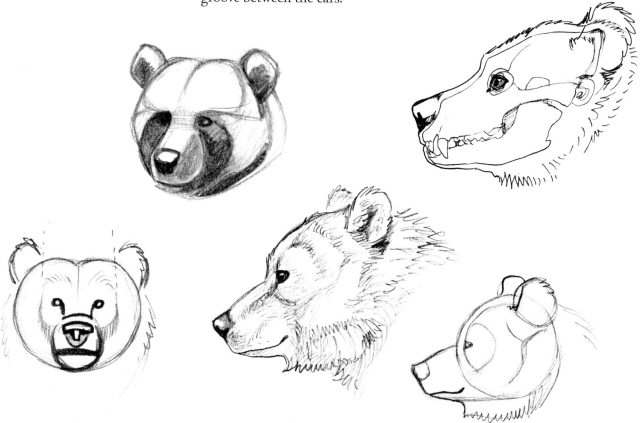

EYES, EARS, AND NOSE: A brown bear's eyes are similar to those of a black bear. Brown bears may have an especially pronounced, shaggy "eyebrow." Their ears are smaller and rounder than the ears of a black bear and are sometimes so shaggy that no detail can be easily discerned. The nose is similar to that of other bears.

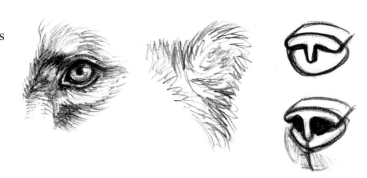

THE BODY

The brown bear has the typical bear build: bulky and powerful. It has a noticeable shoulder hump, which is generally the highest point of its body.

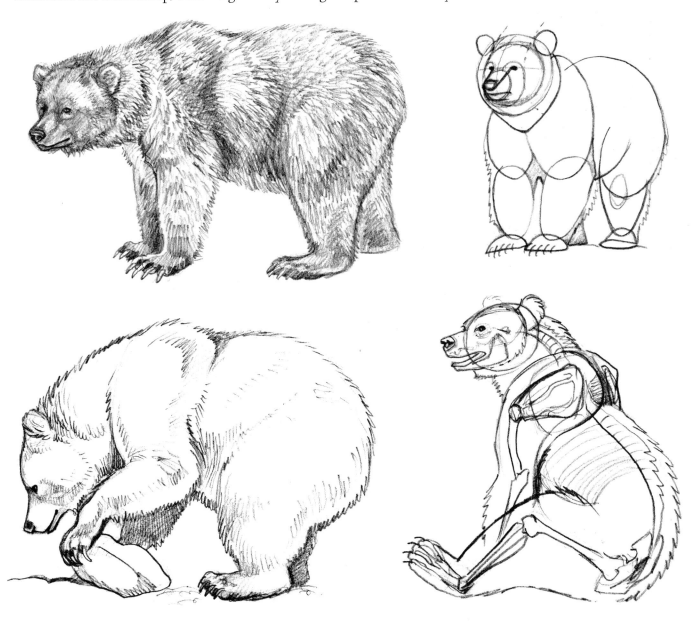

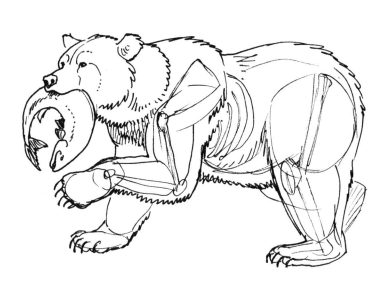

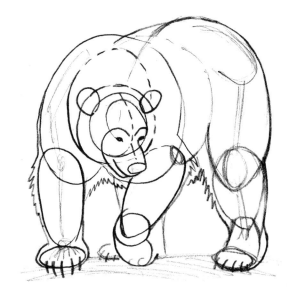

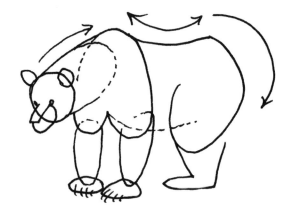

LEGS AND FEET: The brown bear's legs and feet are similar to those of the black bear. The grizzly bear subspecies has longer claws than the Alaskan brown/Kodiak bear.

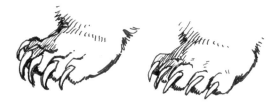

Grizzly (LEFT) and Alaskan brown bear (RIGHT) front paw.

TAIL: The brown bear's tail is very similar to the black bear's.

COLOR MARKINGS

Brown bears are indeed generally brown, although the color can vary in tone. Some grizzlies, called "silvertips," have light-tipped hair that creates a grizzled, or "frosted," look on their head, neck, shoulders, and back. The brown bear's legs can sometimes appear somewhat darker than its back.

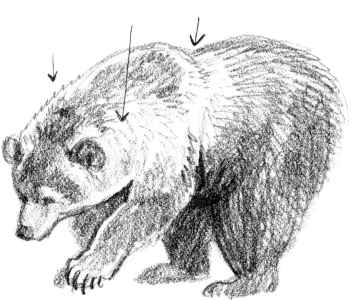

POLAR BEAR

URSUS MARITIMUS

THE POLAR BEAR IS KING, OR QUEEN, OF ALL IT SURVEYS. This all-white animal is the largest land carnivore on Earth, living comfortably in freezing temperatures and wandering the ice floes of the Arctic searching for seals. Most of what is true about drawing other bears is true about drawing polar bears, so this description will cover only what is unique about the Great White Bear of the North.

THE HEAD

The polar bear has a very streamlined head with a flat facial profile, suited to swimming. Its eyes are high on the head, and its small, rounded ears are set very low. The muzzle is slightly down-turned.

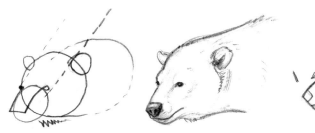

THE BODY

The polar bear's body is streamlined and narrow. It has a shoulder hump like the brown bear, but it is not quite as pronounced.

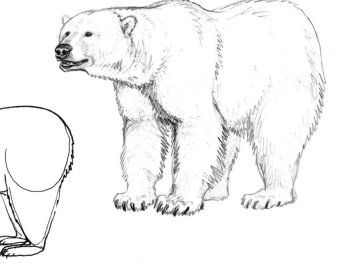

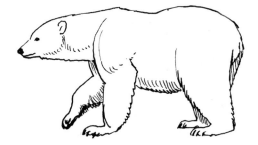

COLOR MARKINGS

The polar bear's thick, oily fur coat is entirely white or yellowish-white, broken only by the black of its eyes, nose, and claws. The muzzle may be slightly grayish or brownish.

HOW TO DRAW A BLACK BEAR

FOR THIS STUDY OF A BLACK BEAR I deliberately tried to keep the bear's pose simple. Bears are a satisfying subject to start with because of their rounded forms and shaggy hair, but can also be a bit tricky because that hair can obscure the bear's anatomy. This tutorial is done entirely in pencil.

1. First draw three circles to block in the most basic shapes for placement of the head, shoulders, and hips. Add an "action line" to connect the three. Draw two lines pointing inward to indicate the elbow and knee. Add points for the placement of joints and the pelvis.

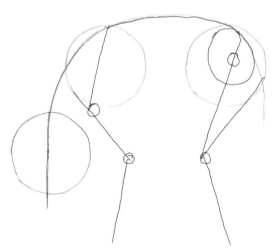

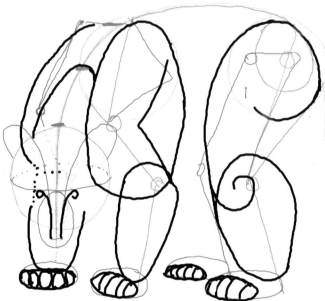

2. Add feet and continue "fleshing out" the shoulders and hips, keeping in mind that the bear is turned slightly toward you. Begin to block in the muzzle and the eye line. Continue to add features, such as ears and the nose. Indicate the toes and the eyes. Block in and define the legs and neck, remembering to keep the shapes broad, blocky, and rounded—bears are not sharp or angular.

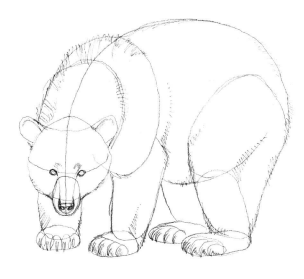

3. Continue to define the shapes on the bear, keeping a rounded effect in mind. To work toward the finished drawing, start to place details such as the eyes, claws, and nostrils.

4. Place some of the fur pattern on the bear, indicating areas of shaggy, overlapping fur. Continue to place fur patterns, keeping in mind the underlying muscle structure.

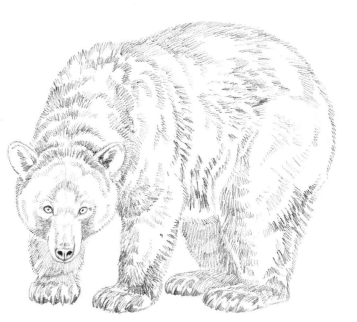

5. A lot of the work at this stage is getting pencil marks on the paper. Fill out the shape, but be sure to allow empty space along highlighted areas. The contrast between light and dark is important in defining shapes and volume, and keeping a dark animal such as this bear "readable." Go back and continue to shade in the bear. Allow your pencil strokes to follow the direction of the bear's fur as you shade and add volume. Darken the areas that you need to, but don't wipe out all the highlighted areas—they add a shine to the fur and depth to the bear.

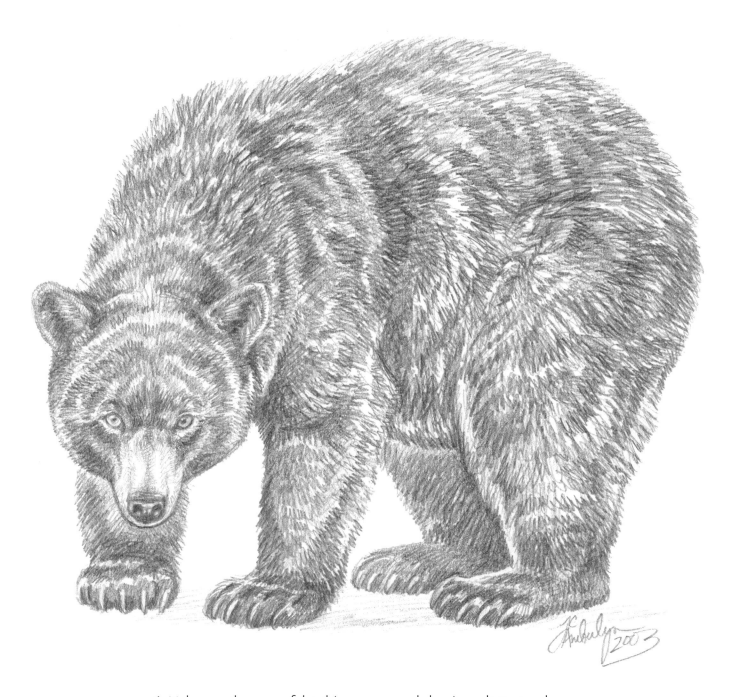

6. Make sure the areas of detail (eyes, nose, and claws) are distinct and defined. Add volume to the bear by shading in under the jawline, under the front shoulder, and anywhere else you need to add weight. Go over the fur, defining areas where the shaggy hair overlaps. In some areas, without much overlapping muscle such as the shoulder blade, the fur lies fairly flat. Do these areas with a minimum of detail and lots of shading. This is a good idea for two reasons: 1) These areas don't show lots of detail in real life. 2) Too much detail can make a drawing too "busy" and not as pleasing to the eye.

RACCOONS & THEIR RELATIVES,

the coatimundi and the ringtail, are members of the family Procyonidae. The common raccoon looks somewhat bear-like with its flat feet and its hunched and shuffling manner, but it sports a striking black mask and ringed tail. This attractive animal steals hearts—and your garbage. The raccoon's compact but strong body carries it wherever it needs to go, from the heights of treetops to the shorelines of rivers. The coatimundi, or coati, looks like a stretched-out version of a raccoon, while the weasel-like ringtail is more specifically adapted to pouncing and dashing among rocks and cliff sides.

THE HEAD
These features differ between raccoons, coatimundis, and ringtails, so look to the species accounts for details.

THE BODY
Remember, raccoons and coatimundis have an almost bear-like body, while the ringtail is somewhat reminiscent of a weasel. The drawings below show a raccoon.

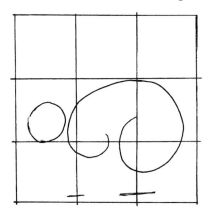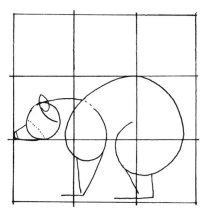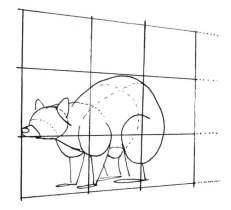

Some basic proportions to keep in mind when drawing raccoons.

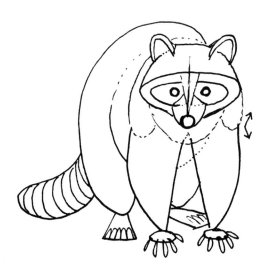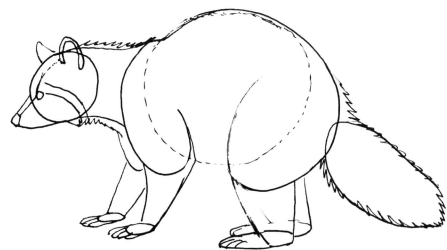

LEGS AND FEET: Raccoons have almost human-like paws. They feature five long, clawed fingers on a flat palm. The hind feet may be held flat like a bear or, especially if the raccoon is moving, may have the heel raised from the ground, with only the toes (and palm of the hind foot) touching.

The raccoon's front legs are skinny but strong, and the hind legs have thick thighs. The raccoon is capable of momentarily standing on its hind legs like a bear.

Front legs and feet.

Sometimes, there is a certain point on the legs where the thicker fur ends rather abruptly, and the legs and hands below that point feature much shorter fur. On the front leg, this area may be about midway between the hand and the elbow, and on the hind leg, it may be just above the heel.

Hind leg and foot.

FUR & TEXTURE

Raccoon fur is thick and woolly and makes the already stocky-bodied animal look even rounder than it is. A raccoon in its winter coat can be very shaggy and furry. It also has exceptionally loose skin: A raccoon can turn around in its skin, making it a formidable fighter that is hard to get hold of. The texture of the fur is slightly coarse with a soft undercoat.

Sometimes the fur shortens in length along the lower legs, near the paws, revealing true leg thickness.

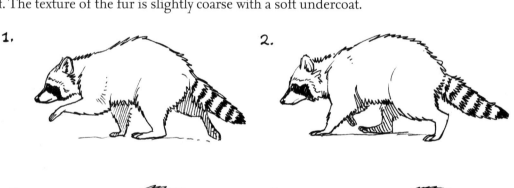

1.

2.

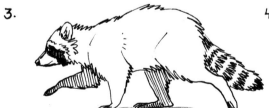

3.

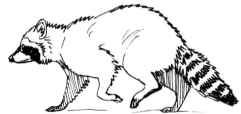

4.

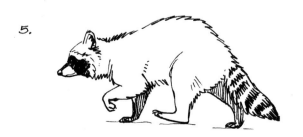

5.

RACCOONS IN MOTION

The raccoon has an ambling, shuffling gait much like a bear's. It generally walks flat-footed, with head pointed slightly down and an occasional swagger. The coati has a similar walk, while the ringtail bounds along in a more weasel-like manner.

RACCOON

The raccoon provides a familiar and furry face in the suburban night almost anywhere it is found. Widespread and adaptable, it seems little fazed by humanity and seems to thrive despite, or perhaps because of, humans and their ways. Many a campground has been visited by these "bandits," and many of their almost human-like footprints have been left behind as evidence of their nocturnal visits. Raccoons have a soft, rounded, and fuzzy appearance and a curious nature, but are strong and vicious fighters if provoked.

THE HEAD

A raccoon's head is broad, with a pointy, medium-sized snout, upright and somewhat rounded ears, and beady eyes.
The profile of a raccoon's muzzle is tapered: The nose sticks out slightly from the upper jaw area, and the upper jaw sticks out slightly from the lower jaw. It has a facial ruff and a distinctive black-and-white mask.

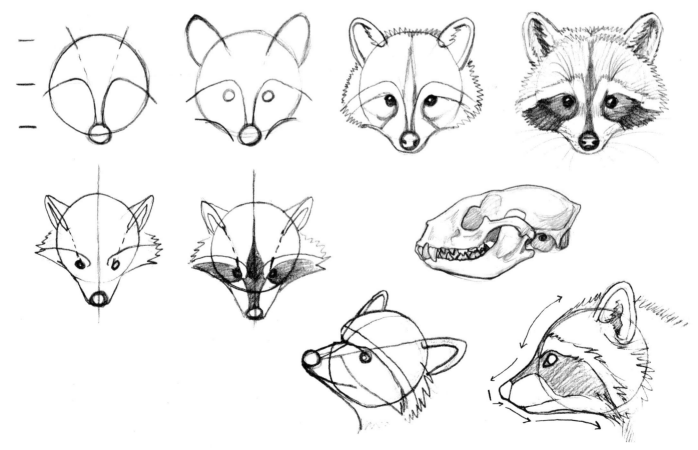

EYES, EARS, AND NOSE: The raccoon's eyes are small, dark, and beady. There is a small stripe extending above the eye where the "eyebrow" whiskers are. The ears are upright and may appear more rounded or more pointed depending upon the angle from which they are viewed. The front has a distinctive white rim and the back is white-tipped with a base the same color as the body. The nose has a slightly upturned look to it and features a wedge that runs down the middle.

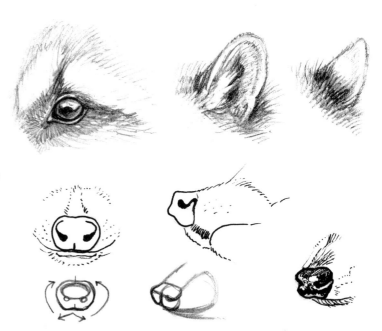

THE BODY

The raccoon has a hunched, almost bear-like body, with fairly thin forearms and thick thighs. Its fur makes it look even chubbier than it is.

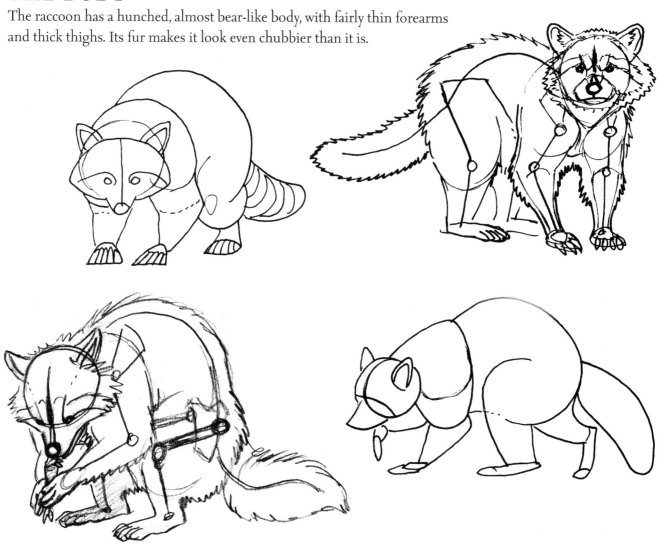

LEGS AND FEET: The paws, or "hands," of a raccoon look almost human-like—five slender fingers extend from a fleshy palm. Generally, the palm and undersides of a raccoon's fingers and hand are dark and hairless, while the topside is a lighter color and has short hair. However, if muddy or wet, the entire hand appears dark.

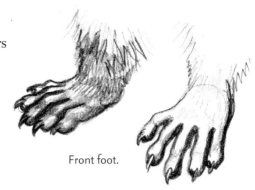

Front foot.

Hind foot.

TAIL: The raccoon has a medium-length, bushy tail with five or six black rings, including the black tip. The ring closest to the body is often thinner than the others. Remember that while the raccoon has a furry tail, it isn't quite as long as, say, a red fox's. Tail bushiness varies depending on the season of the year and the individual.

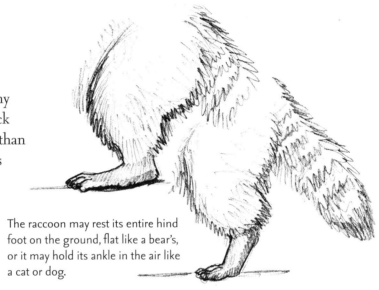

The raccoon may rest its entire hind foot on the ground, flat like a bear's, or it may hold its ankle in the air like a cat or dog.

COLOR MARKINGS

The basic color markings on a raccoon are distinctive and obvious. It has a black "mask" and a ringed tail. There are other details, however, which require more examination. The black mask is rimmed with white and interrupted by black stripes extending up the eyes, creating a white "eyespot" effect. The wideness of the black band on top of the muzzle and between the eyes varies from individual to individual. This black band extends up above the mask, creating a small black stripe that travels up the head and between the ears, where it fades.

The body of the raccoon is a gray-brown, salt-and-pepper color, and its base tail color is often lighter and tanner than most of the rest of its body. The fur is soft and thick, but somewhat coarse, and features a dark woolly undercoat with long hairs going from white to black on the outside.

COATIMUNDI

Nasua narica

The coatimundi, or coati, is a relative of the raccoon found from the tropics of South America to just inside the southern boundary of the United States (in Arizona and New Mexico). Females travel in matriarchal troops of ten to twenty, foraging for fruit, lizards, and other food. The males are solitary much of the year. This almost monkey-like omnivore has a very long nose and tail and bold black-and-white patterning on its head.

THE HEAD

A coati's head is defined by its nose. The head features black, beady eyes, small, rounded ears, and tapers into a long snout.

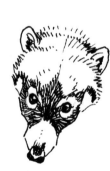

EYES, EARS, AND NOSE: The coati's eyes are small and dark with a white eye ring. It has a black stripe running up from its eye like a raccoon does. The ears are small, rounded, and have large white tips with dark bases on the back. From the top, the actual nose of the coati is narrow at its base, then it flares out and generally has an upturned appearance. The nose is extremely flexible and can be bent up, down, left, right, etc. The lower jaw appears shorter (on the live animal) than the upper jaw or nose.

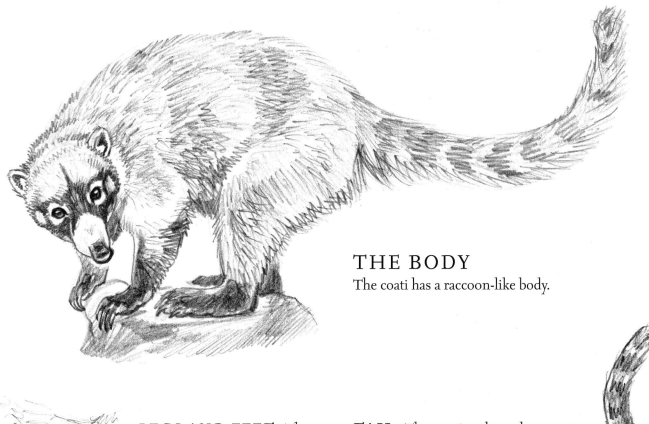

THE BODY
The coati has a raccoon-like body.

LEGS AND FEET: The feet of a coati are thicker-toed than a raccoon's and have prominent claws.

Front paw.

TAIL: The coati's tail is as long as its body. It is thicker at the base and thins as it extends toward the tip. It is usually striped, but the stripes range from distinct, to subtle, to nonexistent.

COLOR MARKINGS
The coloration and marking of coatimundis vary. Coatis are brownish, ranging from a blondish-brown to a dark brown. They usually have dark faces with white muzzles and eye-spots, as well as a spot on their cheek and a spot just past their jowls. Their ears are white inside, and that white may extend down onto their neck, shoulders, and forelegs. The bottoms of their legs are dark.

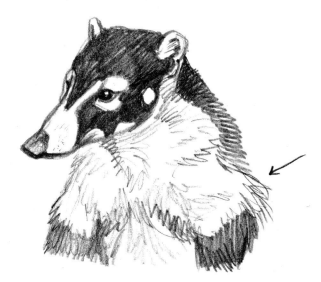

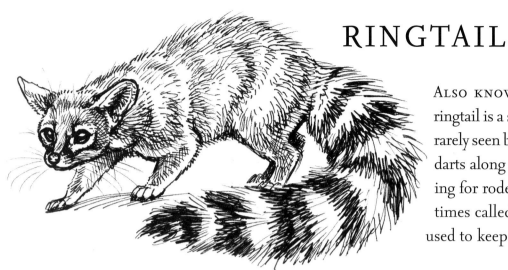

RINGTAIL

Bassariscus astutus

Also known as the cacomistle, the ringtail is a small, nocturnal creature that is rarely seen by people. This attractive animal darts along rocks and cliffs at night, hunting for rodents and other prey. It is sometimes called "miner's cat" because miners used to keep ringtails as pets and mousers.

THE HEAD

The ringtail has a foxy face, enormous eyes and ears, and a petite, often light-colored nose. White rings circle its eyes, adding to their prominence.

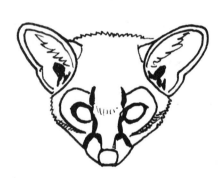 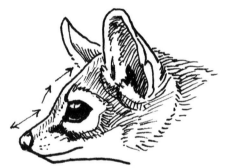

EYES, EARS, AND NOSE: The ringtail's eyes are large and dark. Their eyelids are rimmed with dark hair, then outlined in white, and they feature the black stripe above the eye that the raccoon and coati share. Ringtail ears are larger and longer in comparison to their head than a raccoon or coati. They appear rounded on the tips if viewed from the front and pointed if viewed from the side. They are often thinly haired inside and are white-tipped behind. The nose is small and usually somewhat pinkish-brown in color.

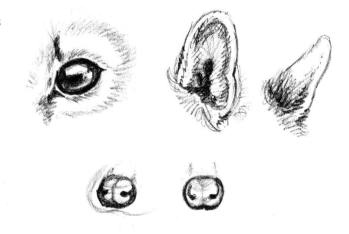

THE BODY

The ringtail has a long, slinky body reminiscent of a weasel's, but not quite as thin.

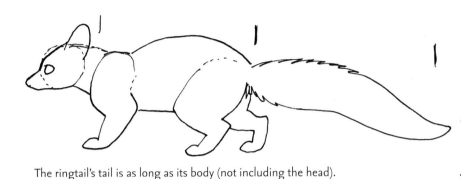

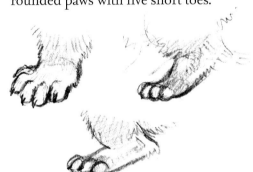

The ringtail's tail is as long as its body (not including the head).

LEGS AND FEET: The ringtail has small, rounded paws with five short toes.

TAIL: The tail of a ringtail is quite showy, hence its name. The tail is as long as its body, although a young ringtail's tail may appear longer in proportion. It is marked by very distinctive black and white rings that flare slightly outward from the center, creating a V-shape from a side view. The black rings are interrupted by white on the very bottom of the tail.

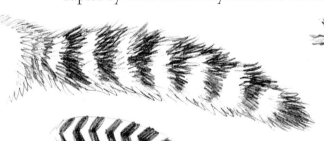

COLOR MARKINGS

The ringtail has the aforementioned white eye rings and black and white tail rings. There are also black markings on the side of the muzzle and up between the eyes. The overall body color is a brownish-gray to buckskin color, ranging from dark brown guard hairs on the back to a whitish pattern underneath the body and throat. The undercoat is gray.

HOW TO DRAW A RACCOON

FOR THIS DRAWING OF A COMMON RACCOON, I decided to do a portrait, concentrating on showing how I work with the details of the eyes, ears, and nose. I find the eyes to be the most important piece of a drawing: If the eyes look flat and lifeless, so will the rest of the drawing. I used a pencil lightly in the beginning, then applied it more heavily at the end to bring out the contrast of the raccoon's distinctive markings.

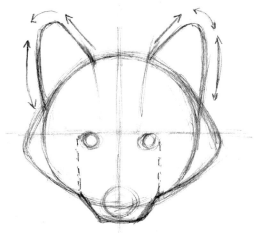

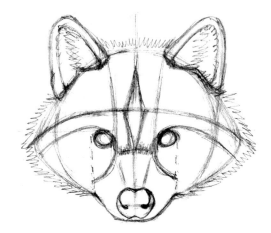

1. Draw a circle with crosshairs centered inside it. Block in eyes, nose, and cheek ruff. Use a slightly outward-curved line above the top inner corners of the eyes to indicate the inner side of the ears. Block in ears and muzzle.

2. Add the raccoon's mask and define ear rims. Block in a cross section of the nose as shown, using the circle of the head to help guide you. Define the nose, adding nostrils and delineating the wedge on both the top and bottom. Add a diamond shape between the eyes. Block in the white rim above the black mask, curving it gently on the front of the face and sloping it more sharply as it falls away. Block in the black stripe on top of the muzzle as shown. Begin to indicate more of the fur around the head, giving the raccoon a full ruff and fur "behind" its ears.

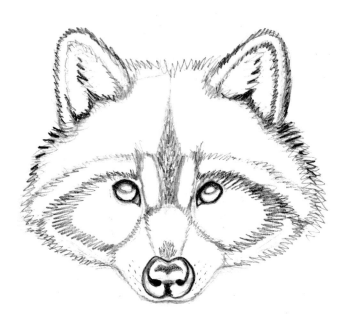

3. Clean up the drawing or transfer it to a new sheet of paper. Begin to block in the finished lines and show details of the fur patterns. Add whisker bases to the muzzle and tear ducts to the eyes. Put highlights in the eyes and make sure they are rimmed on top with black. Add shadow to the wedges of the nose and the inner ears. For variety, use some zigzag strokes and some straight ones to indicate hair partings.

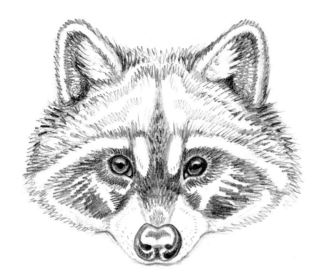

4. Continue shading, using a variety of strokes. I used a short "curly-Q" stroke to indicate the short, compact hair inside the ear. Add pupils to the eyes, and break up the highlights, keeping in mind a bright horizon reflected in these eyes—one that is broken up by trees and vegetation. Add more fur, shading the inner ears, defining hairs around the ears and ruff, and darkening the mask and stripes. Shade in the eyes, allowing the bottom rim to remain slightly lighter (to add shininess). Shade around the eyes, but let the eyelids retain just a smidge of white space so that the eyes remain "readable" and don't blend in with the mask.

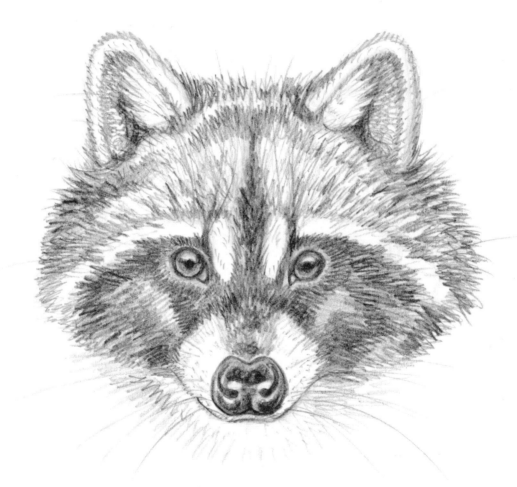

5. Darken the mask with long, broad strokes and add tone to the rest of the fur. Add small lines to indicate hair in the white areas. Shade the nose, making some areas darker than others to show depth or contrast. Go over the fur and try to create a sense of layered hair clumps with tips and bases. Let other areas "breathe" and don't try to get too many details. Add whiskers. In areas that are too straight-lined, like the mask and its rim, break up the outline with black strokes. Add a few strokes to indicate a throat, and thus body, so that the head looks less like it's just floating in space. Finally, sharpen some of the highlights on the nose to give it more of a moist, "alive" effect.

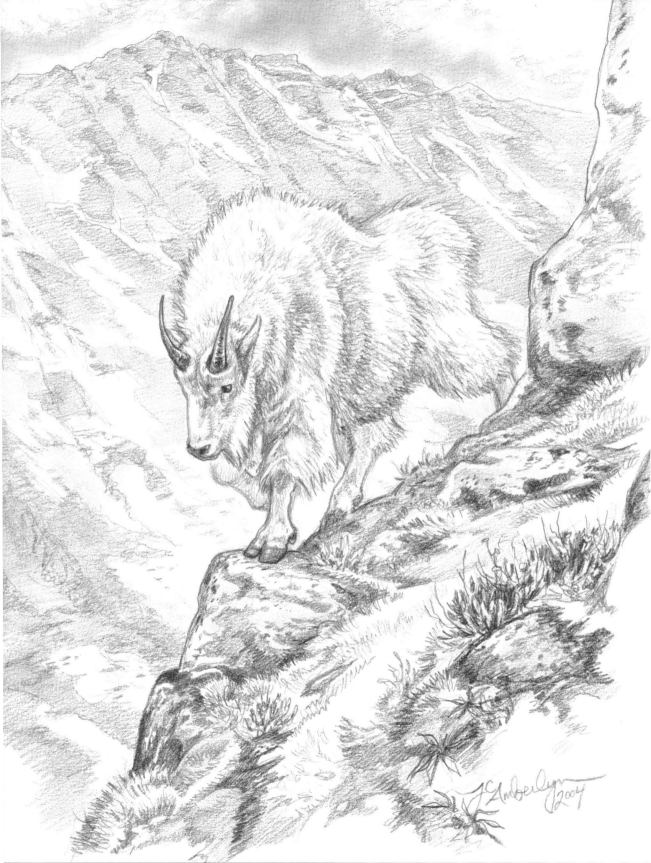

HOOFED MAMMALS

Hoofed mammals, or ungulates, have long captivated the human imagination. Their likenesses appear on the ancient caves of Lascaux in present-day France, and petroglyphs in North America feature hoofed mammals in abundance. Hoofed mammals were an important food item to human beings for many millennia, and their impressive headgear probably caught our eye as well.

The subject of hoofed animals often leads to thinking about horns and antlers. Antlers are grown and shed each year in an annual cycle of renewal. Horns grow throughout the animal's life and, with a few exceptions, are never shed. Horns are made of keratin, the same substance as human nails and hair. Antlers are essentially extended bones. In most species, only males carry antlers. Of the horned animals, females usually carry small horns while males have larger and more massive ones. Males use their horns and antlers to battle for mates. Females use their headgear less frequently and mostly for defense. However, females, and males as well, can use their sharp hoofs skillfully. Hooves are basically hardened toenails that allow hoofed mammals to run quickly over many kinds of terrain.

This section features several members of the deer family, ranging from the sometimes diminutive white-tailed deer to the largest Alaskan moose. Mountain sheep and goats are covered together because of their similar adaptations to mountainous habitats and the fact that people sometimes confuse the two. This section also includes some hoofed species that didn't quite fit into the other categories, including one hoofed mammal with no horns or antlers—the pig-like collared peccary. Pronghorns are swift runners of the open plains, and bison and musk-oxen round out the section in their own solid, powerful way.

THE DEER FAMILY

includes some of the most celebrated and successful members of the large mammal world. The grace of the deer, the power of the moose, and the haunting bugle of the bull elk speak to the imagination. These animals have long been a quarry of humankind, and we seem fascinated by their alertness, their vitality, and, especially, their antlers. These antlers they carry are grown each year, used in autumn breeding battles, then shed to grow again. In this chapter we will examine the major North American species of the family Cervidae, including three species of deer (genus *Odocoileus*), and the elk, the moose, and the caribou.

THE HEAD

The muzzle of a deer seems like one long extension of the face. Deer possess eyes on the sides of their head, which pick up movement from a large radius around them—helpful to a prey animal!

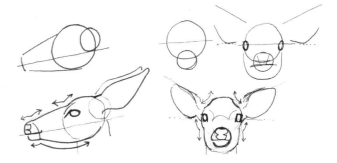

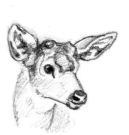

ANTLERS: Usually only male deer (bucks) have antlers. Antlers are made of bone, but do not have a hollow marrow inside. They grow from the frontal skull plate and are shed annually. While growing, antlers are covered with soft hair called "velvet" (because that is what it feels like). At this sensitive stage, bucks try to avoid contact to their growing antlers. The tips of velvet antlers have a rounded appearance. Once growth is complete and the antler hardens, the skin dries and the animal rubs the velvet off, sometimes leaving temporary strings of skin. Newly polished antlers assist the buck in its fights for dominance and access to female deer (does). As the season wears on, in some deer, once fresh, brown antlers fade into white, bleached bone. Finally, bucks shed their antlers and the cycle begins anew. You cannot tell a deer's age by the number of points on its antlers.

The bases of the antlers extend from the top of the skull and create a pair of surface knobs (pedicels) that are always visible.

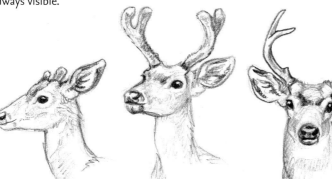

Black-tailed deer buck showing the cycle of antler growth.

It helps to think of antlers as circling around an invisible ball. They grow from the head, the main beams curving outward and then often back inward. The points that branch off are called tines. There are usually brow tines that jut out a few inches above where the antlers attach to the head.

EYES: Deer eyes are generally brown with horizontal, elliptical pupils. The whites of their eyes may show, for example, if they are alarmed. The eyeballs are large and bulge out of prominent sockets on the sides of the head, and there is a pronounced gland just in front of the eye.

EARS: Deer ears range from medium-size to large and have a rounded appearance with a tip that may point slightly upward at times. The ears are nestled on rounded bases and can be swiveled around to catch the sound of danger from any direction. The exact shape of the ear differs depending on species, subspecies, or individuals.

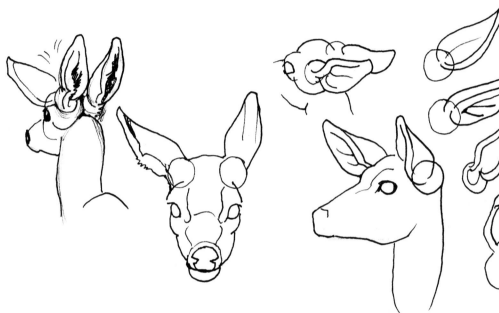
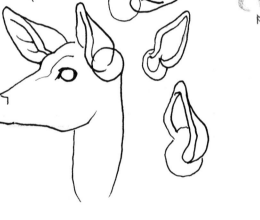

NOSE: Deer noses feature a wedge-shaped, bare, moist nose pad interrupted on either side by the nostrils. Short, dark hair and whiskers surround the nose pad. The lower jaw features a dark spot on either side of the chin and sometimes a small dark stripe coming up from the center of the jaw to the lip's edge.

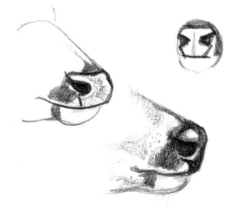

THE BODY

In general, members of the deer family tend to have long, graceful, and muscular bodies. They may also have a somewhat "boxy" shape that contrasts with their slender but strong legs.

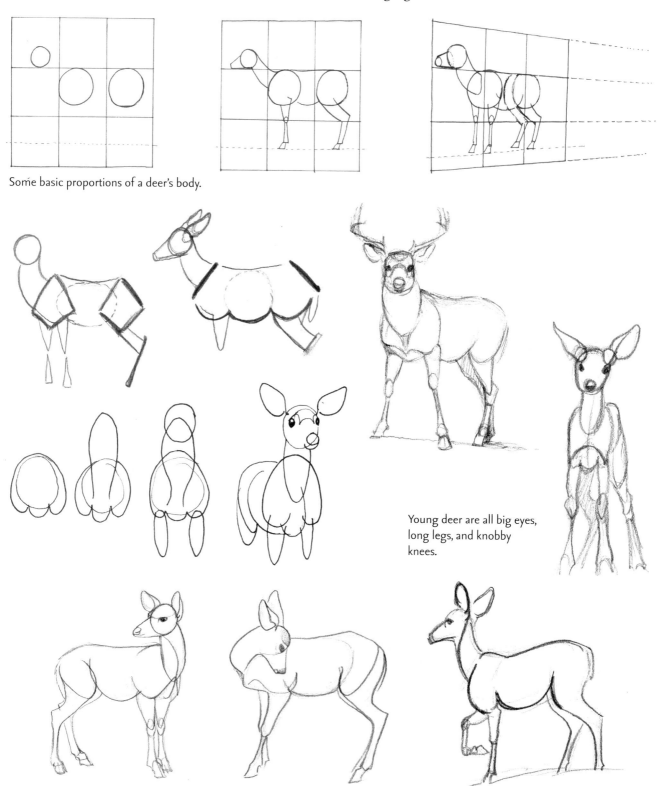

Some basic proportions of a deer's body.

Young deer are all big eyes, long legs, and knobby knees.

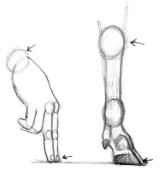

Human hand (LEFT) and the front foot of a deer (RIGHT).

FEET: Members of the deer family have two large main toes and two much smaller, stiff vestigial toes above and behind them called dewclaws. All four toes end in hooves. Basically, a deer's hooves are similar to a human's fingernails, but more developed. On the front foot, their "wrist" is a large joint in the middle of the leg. The "hand" begins from there and extends down to the toes and fingernails (hooves). The hind foot is also much longer than ours, with the heel, or "hock," much farther from the toes.

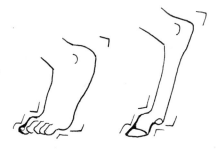

Human foot (LEFT) and hind foot of a deer (RIGHT).

HOOVES: Hooves are dark and hard and made of keratin, as are our fingernails. The bottom of the hoof is almost convex with a hollow area inside. Hooves are usually trimmed by wear, but deer in areas of soft ground, like swamps, may have very long hooves.

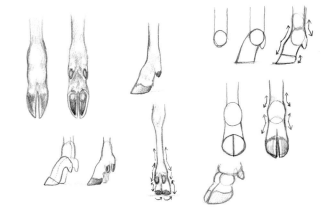

LEGS: A deer's legs are very long, thin, and delicate-looking, which is deceiving because they can carry a deer strongly and swiftly away from danger. The top half of both the front and hind legs can look thin from the front but are wider from a side view. The long hind legs are ready to launch into flight at a moment's notice. On the hind leg, note how pronounced the ankle, or hock, is, and note the hollow area between the bones and tendon.

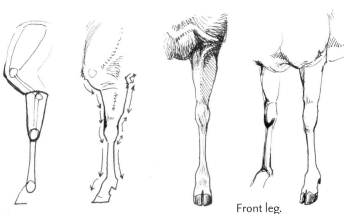

Front leg.

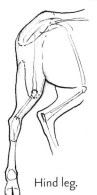

Hind leg.

TAIL: Tails in the deer family differ by species (hence some of the species names, such as white-tailed deer) and will be discussed in greater detail in the individual species descriptions. Overall, most deer have small to medium-size tails that are slightly flattened on top and bottom and are wider on the sides. A deer's tail serves as a signal and as a fly swatter!

FUR & TEXTURE

Deer hair changes, sometimes dramatically, from season to season. During the summer, the hair is solid, dense, and reddish-colored (sometimes very red), while during the winter, it is hollow, brittle, and grayish-brown. The two coats are called the "summer red" and the "winter blue" coat, respectively. The winter pelt contains an undercoat of soft, fine hair that provides winter insulation. In general, the base of the hairs is light gray in color, extending to the color of the body and ending with a small whitish area that is tipped with dark brown to black. Some of the color markings on deer may differ depending on whether they are in summer red or winter blue: for instance, in the summer some deer (especially whitetails) may have a dark area on the top of their muzzle, which is not apparent during the winter.

Note the difference a short summer coat (LEFT) or a thick winter coat (RIGHT) makes in the appearance of this mule deer doe.

BRISKET: One area on a deer's body that may be confusing to someone attempting to draw a deer is the chest, or brisket, area. The reason for this is that the hair coming up from under the deer's front legs points forward, toward wherever the deer is facing, while the rest of the deer's hair flows backward. Where the different hair directions meet you sometimes see a very defined line called the brisket. Brisket hair patterns vary by individual, but here is a generalization of some common traits. Note how the lines often (but not always) meet in the center.

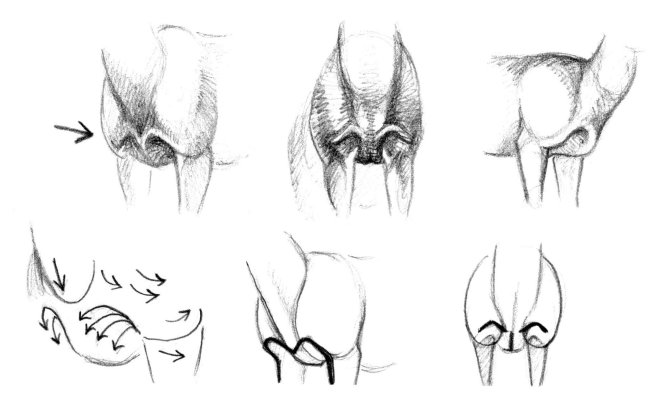

DEER IN MOTION

Deer are very mobile animals. They travel their territories, sometimes covering long distances, such as during the mule deer's winter migration. While their walk cycles look similar, different deer species have different ways of running. White-tailed deer are runners. They are adapted to forests and flatlands, and engage in a rollicking, galloping run to put as much distance between themselves and their predators as quickly as possible. Mule deer, on the other hand, live in rough, broken terrain, and use a means of escape called "stotting." When a muley stots, its hooves move in unison and leave and hit the ground at the same time—making the deer look something like a four-legged pogo stick. This stotting behavior allows the deer to move through rough ground, cover obstacles easily, and change course quickly to throw off predators. Black-tailed deer stot, as well, but not as often as mule deer. The other members of the deer family have running gaits that are a little like the whitetail's; they don't stot.

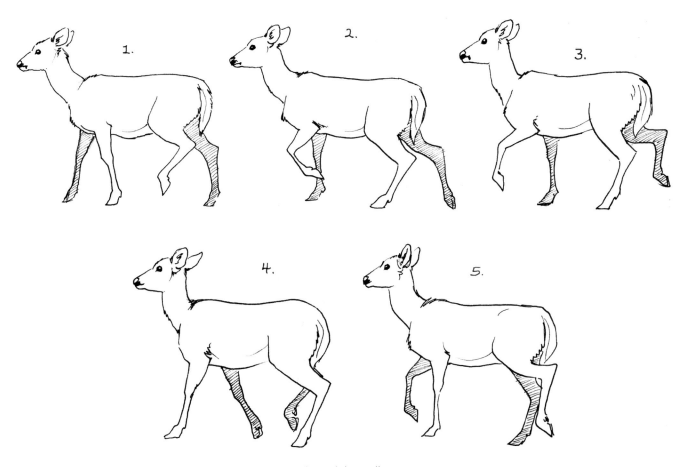

Whitetail doe walking.

MULE DEER

ODOCOILEUS HEMIONUS

THIS STOCKY, SHOWY DEER with the big antlers is a familiar sight to many westerners and the visitors of national parks in the West. The mule deer, or "muley," is named for its ears—so big that they reminded someone of a mule. The muley's manner of jumping away like a pogo stick, combined with its large, wide antlers and a distinctive white rump patch make this an impressive, memorable deer.

THE HEAD

Muleys have a somewhat blocky head, compared to some other species such as the white-tailed deer. Their muzzles may be comparatively short and pale and have a "roman nose" appearance and, of course, their ears are very large. They usually have a blackish-brown forehead patch (especially bucks).

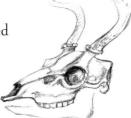

Buck skull.

Doe head.

ANTLERS: Mule deer antlers arise from a single beam that divides into two other beams from which tines (points) may grow. The brow tines are usually small. Mule deer antlers are usually brown in color. Muleys are capable of growing very large, showy antlers, and unusual (called non-typical) antlers are not uncommon. Some geographic areas seem to harbor an especially large number of bucks with large or non-typical antlers.

Normal antler formation.

← PALMATION

← "CHEATER" TINE

Abnormal, or "non-typical," antler formation, showing some common abnormalities.

← DROP TINE

EYES, EARS, AND NOSE: The mule deer's eyes are large and dark, and are usually surrounded by a white "eye ring." Don't forget the very distinctive black patch between the eyes on the forehead area. Note the pattern of black and white markings on the ears. Mule deer have a white nose ring that may extend up their snout.

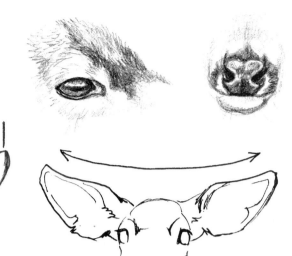

Depending on the individual, a mule deer's ears, from a side view, are about the same length as the space between the corner of its lips to the back of its head.

From a front view, the ears hang comparatively low, sweeping from one side to the other—perhaps due to their weight.

THE BODY
The mule deer is on the stocky side compared to other deer. It is a powerful and compact deer.

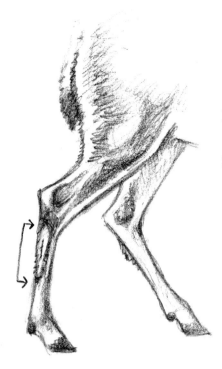

LEGS AND FEET: Long, strong, sinewy, and thin legs carry this deer across rough terrain effortlessly. Mule deer have a large, approximately 5-inch-long, metatarsal gland on the hind leg.

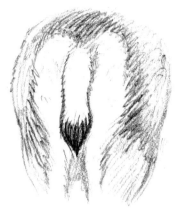

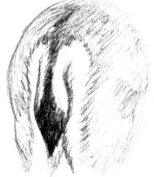

Mule deer (LEFT) and California mule deer (RIGHT).

TAIL: Muley tails are white and rope-like with black tips. They are surrounded by a large white rump patch with hairs that can be flared and raised in alarm. On the western edges of their range, mule deer interbreed with blacktails, creating the "California mule deer" subspecies, which is perhaps most often encountered by people in Yosemite National Park in California.

COLOR MARKINGS

The muley is a dark-bellied deer with a white face, white rump patch, and a dark patch on top of its head. Mule deer tend to be dark brown or gray in the winter, sometimes with reddish legs, and are reddish-brown in the summer. Mule deer have a dark belly that may show a little white toward the rear end. They may have a faint dark stripe down the back of their neck or along their spine. Mature bucks may have an almost all-white face.

Cross section of mule deer hair.

WHITE-TAILED DEER
Odocoileus virginianus

Perhaps our best-known deer, the whitetail, or white-tailed, deer is a graceful, abundant creature of field, plain, and forest. Named for its habit of lifting up its tail as it runs away, it flashes its white banner as a signal to alert other deer to danger and to help fawns follow their mothers. It is the oldest deer species in the Western Hemisphere, and one of the most successful.

THE HEAD

Whitetails have a more elongated head than the mule deer, although this can vary: A northern whitetail's head tends to be more heat-conserving and stocky in build than that of other deer, while southern white-tails may have very long muzzles indeed. Their ears are smaller than a muley's.

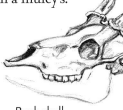

Doe head. Buck skull.

ANTLERS: Whitetail antlers are made up of one main beam with tines arising from it and a brow tine that can be longer than an inch and quite noticeable. Antlers from different regions may have different "looks" to them. For instance, the main beams of some southern deer's antlers seem to point farther upwards than those of many other whitetails.

EYES, EARS, AND NOSE: The eyes and nose of a whitetail are similar to those of a mule deer, but the ears are much smaller and rounder than a muley's. Edges of ears may be almost entirely brown.

A whitetail's ears, from a side view, are about the same length as the distance between the front corner of its eye and the back of its head. Size can vary greatly, however, and desert-dwelling whitetails may have much larger ears.

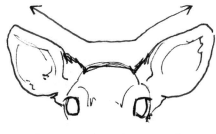

From a front view, whitetail ears are often "perkier" and tilted upward more than the ears of many mule deer.

THE BODY

A whitetail's body is often long compared to other deer.

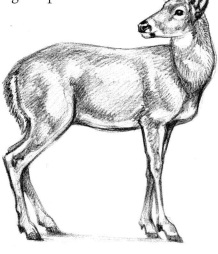
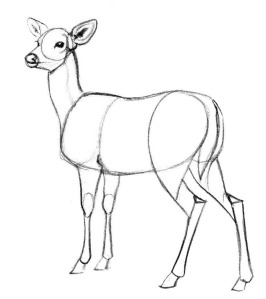

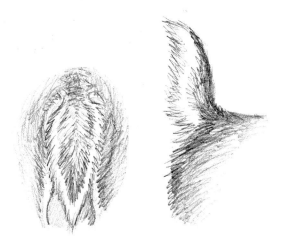

LEGS AND FEET: Remember to include the small, 1-inch-long, white metatarsal gland when drawing a whitetail's hind legs.

TAIL: Sometimes held aloft when running away and kept tucked down at other times, this deer's tail is bushy but usually somewhat flattened. Some tails are medium-length, while others are very long. The top of the tail is brown like the rest of the body. Sometimes there is a darker tip. There are white fringes and the underside is white.

COLOR MARKINGS

Whitetails are generally brown with white bellies, eye rings, and nose rings and white on the insides of the ears, the insides of the legs, and the underside of the tail. During the summer they can be especially reddish-colored.

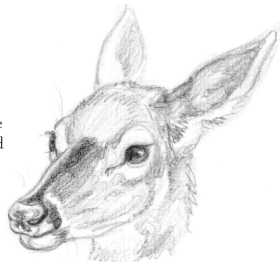

The top of the muzzle of summer deer is darkened.

BLACK-TAILED DEER

ODOCOILEUS HEMIONUS

BLACKTAIL, OR BLACK-TAILED, DEER are found on the western coast of North America. Although still considered subspecies of the mule deer, new DNA research indicates that blacktails may in fact be descended from whitetails and that much later a combination of black-tails and whitetails gave rise to the larger and showier mule deer. This isn't a total surprise to those (the author included) who have always thought that blacktails look and act like a white-tailed deer in many ways.

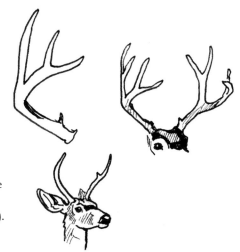

THE HEAD

There are two blacktail deer subspecies: the Columbian blacktail (O. h. *columbianus*; found over much of the deer's range) and the Sitka deer (O. h. *sitkensis*; found in parts of Alaska and Canada). Blacktails may have antlers like a muley or a whitetail. Typically a mature buck will have three or four tines per side and short to almost non-existent brow tines. In some areas, older blacktails may grow only "fork horns" (two-point antlers) or simple (very long) spikes.

The Columbian blacktail (TOP LEFT) is thinner and has a longer muzzle and larger ears, while the cold-climate Sitka (BOTTOM LEFT) has extremely small ears and a short muzzle (and is more compact overall).

THE BODY

The blacktail is somewhat blocky. The metatarsal gland on the hind leg is around 2½ to 3 inches long. As its name suggests, the black-tailed deer usually has a black- or brown-topped tail with white underneath. The blacktail's tail is between the muley's and whitetail's in size—not a lot longer than a mule deer's, but bushier. Blacktails have a small white rump patch.

COLOR MARKINGS

Blacktails can be very dark brownish-gray in winter and very reddish in summer. They have white eye rings and their nose rings sometimes extend up the snout. Sitka blacktails often have two white patches on their throat.

ELK

Cervus canadensis

Also known as "wapiti," this large member of the deer family is typically thought of as an animal of rugged western mountains, but it is actually comfortable in a wide variety of habitats. Elk hold a special place in the heart of many westerners, who love to hear them "bugle," or call out a high, ringing challenge, during the breeding season in the autumn. Very social animals, elk tend to be found in herds. There is a similar animal found in Europe called the red deer.

THE HEAD

The elk's head is broader and longer than a deer's, making the features look smaller.

Elk bull skull.

ANTLERS: Male (bull) elk have antlers that sweep back and upward. A large bull commonly has six tines on each antler. Two of these tines lie close to the head base and usually point forward, or nearly forward. The rest are found higher up the antler.

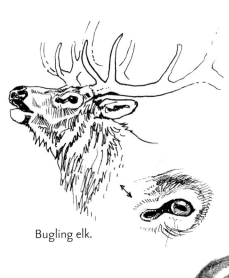

Bugling elk.

EYES, EARS, AND NOSE:

Elk have eyes like deer. They also have a very pronounced, distinctive gland in front of each eye. The gland duct opens when they yawn and when the bulls bugle. Note in the skull drawing on the previous page how pronounced the gland area is.

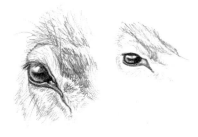

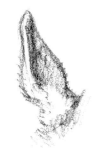

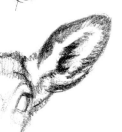

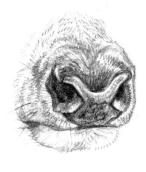

THE BODY

The elk is built like a deer, but heavier. Think of the big animal "table" effect discussed on page 12. The neck may be hidden in a mane of hair, so blocking in the anatomy of the neck underneath first can help give it definition.

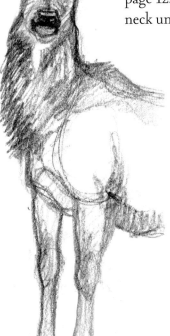

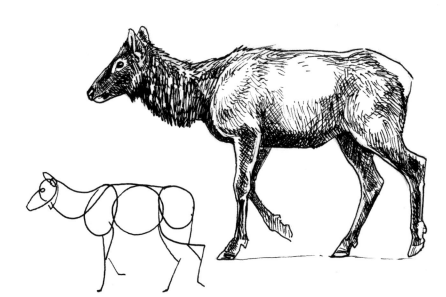

LEGS AND FEET: The elk's legs are strong and slender and somewhat straighter than a deer's. Elk are large, powerful animals and their leg muscles show it.

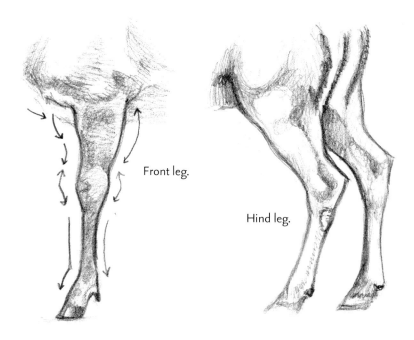

Front leg.

Hind leg.

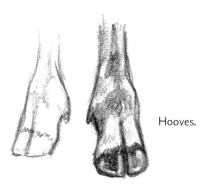

Hooves.

TAIL: Elk have very stumpy tails surrounded by a light tan-colored rump patch rimmed with dark brown. The brown color extends down from the rump and continues down the legs.

COLOR MARKINGS

The elk is an animal of contrasts. It has a pale brown body with a dark head, neck, and (often) legs. The color of an elk is richest in winter when the coat is longer, and the legs are more likely to be dark then. A small line down the very top of the back can sometimes be somewhat darker than the sides. The tan-colored rump patch is rimmed with a darker brown. There is also some tan coloring around the eyes and jaw and the inside of the ears. During the summer, elk turn a more reddish color similar to deer.

MOOSE

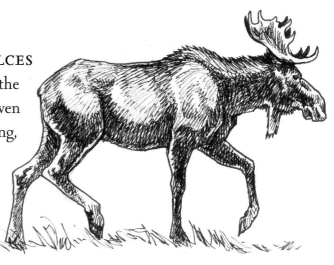

This impressive animal is the largest member of the deer family. Moose may appear somewhat ungainly, or even clumsy—until they move. When a moose comes charging, even a grizzly bear might have second thoughts about standing its ground! The wide, dish-like antlers, bulbous nose, shoulder hump, and dewlap on the chin make this a very distinctive animal. It is also found in Europe, but called an "elk" there!

THE HEAD

The underlying structure of a moose head is deer-like, but the overhanging nose can present a challenge to draw. Think of their heads as similar to a snow shovel—broad and flat on top. Moose have straps of skin, called dewlaps, hanging from their jaws; dewlaps vary in length and shape.

ANTLERS: Male (bull) moose have heavily palmated antlers; they are wide and dish-like and sweep backwards and up. There are some skinny tines along the edge, especially on the front and outer sides, and sometimes on the back end.

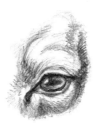

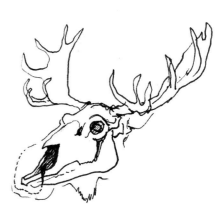

EYES, EARS, AND NOSE: The eyes and ears are similar to those of deer and elk. The nose, however, is very distinctive. It is bulbous and hangs down a bit. The top is flat and there is no distinctive nose patch as in deer and elk.

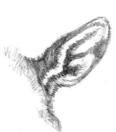

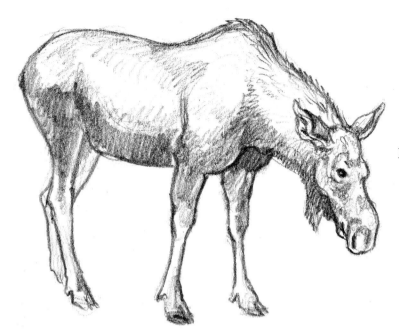

THE BODY

Moose are built to be able to plow through deep snow as easily as possible. They have long legs, big hooves, and massive and muscular shoulders. Be sure to include the distinctive shoulder hump.

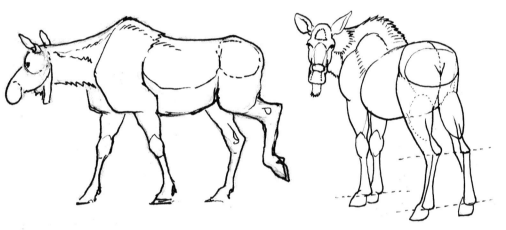

LEGS AND FEET: Moose have very long legs. They are big animals and carry a lot of weight, so their hind legs are straighter than a deer's.

TAIL: Moose tails are very small and stumpy.

COLOR MARKINGS

Moose are a very dark brown color in general. They have very dark bellies and slightly lighter sides. Different subspecies of moose may vary in color. For instance, the Alaska-Yukon moose tends toward a very dark or even black body color. Some moose have white on their legs below the wrist and heel joints.

118

CARIBOU

RANGIFER TARANDUS

THIS ARCTIC NOMAD is a North American version of the reindeer of Christmas fame! Caribou travel in large herds, participating in migrations that resemble the great animal migrations of Africa. They bring life, interest, and food to people in the Arctic and other cold northern areas.

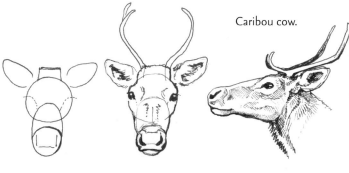

THE HEAD
Caribou have a very blocky, rectangular head with a prominent nose.

Caribou bull skull.

Caribou cow.

ANTLERS: Caribou are unique among the species in the deer family in that the females (cows) often have antlers, albeit small ones. Males (bulls) grow much larger antlers that have a sweeping C-shape. They have flattened brow tines, and often one antler (but not usually the other one) will have a second brow tine. Tines may grow from the semi-palmated areas on the top and bottom and from one spot on the back of the main beam. Different subspecies grow variations on this theme.

EYES, EARS, AND NOSE: A caribou has small, dark eyes and ears that are very small and heat-conserving. Its nose is a little bit like a cow's nose in its broadness and is mostly furred.

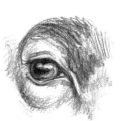

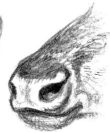

THE BODY

The caribou is solid and rectangular-bodied with a shaggy white neck and large feet.

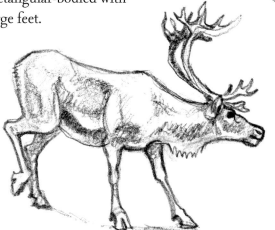

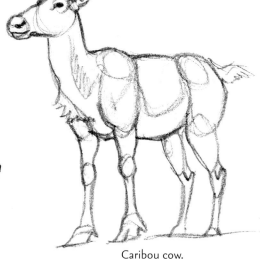

Caribou cow.

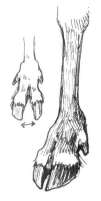

LEGS AND FEET: A caribou's foot is furry and wide. The hooves spread out, and the animal can spread them out even further for traction if needed.

TAIL: A caribou's tail is like a small, short version of the white-tailed deer's tail. The caribou sometimes raises its tail like a whitetail, too.

COLOR MARKINGS

The color markings of caribou vary greatly, even within a herd. In general, however, they have dark faces with white necks and a brownish body with some white on it, and often a light streak behind the shoulders. They have small white rump patches. Caribou hair, as might be expected, is very thick, soft, and warm, but slightly brittle.

Caribou sometimes have very dark face markings.

HOW TO DRAW A MULE DEER

FOR THIS PORTRAIT OF A MULE DEER BUCK, I used Strathmore smooth bristol paper and Berol Prismacolor pencils in the following colors: white, black, dark brown, medium warm gray, sand, burnt ochre, and bright blue violet. Be sure to use good paper when attempting to work with colored pencil. If you don't want to deal with the antlers, draw a doe instead. Just make sure the distance between her ears is shorter and that her ears are slightly "perkier." She should also have a thin neck, since only bucks in rut (breeding season) have swollen necks like the one in this demonstration.

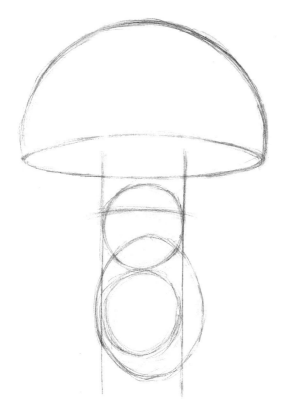

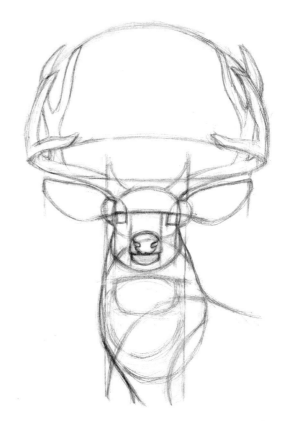

1. First block in the basic drawing in pencil. It may look like a mushroom at this point, but trust me! Draw a circle for the head and block in a "halo" for the antlers, adding a "mushroom top" for the tines. Draw lines for the "mushroom stem" on either side of the head circle. Add an oval for the neck, making sure it's a bit longer than one head-length. The buck's neck will be angling off to the viewer's right, so lean the oval that way. Add a slightly bent line on the head circle for the eyes.

2. Slim the sides of the head. Using the eye line as a guide, add a T-shape. Put in a circle for the muzzle and define the nose and eyes. Add lines for the neck and shoulders and add details on the antlers. Measure about one head-width on either side of the head and mark the outer edges of the ears. Block in the ears and ear butts. The outermost tip of the ear is a flattened curve, which dips back toward the head in a deeper arc, coming back up slightly before meeting near the eye.

3. Finalize the line drawing. Finish up the antlers. Add definition to the eyes. I added a tear to this buck's ear to indicate that he's lived a little—little details like that can add interest and individuality to your drawings. Flatten the top of the nose pad. Finish the ears, nose, neck details, and markings. If you would like, transfer the drawing to a new sheet of paper to start working in colored pencil.

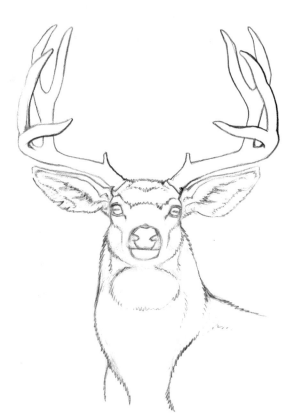

4. Erase as needed, making sure the original pencil lines are soft and light. If the pencil line is heavy, it will smudge and smear with the colored pencil. Lightly trace the outline with a dark brown colored pencil. The lighting in this picture is soft and overcast, with a slight, subtle shadow. The light is coming from the deer's right so go over the buck's antlers and darken the line a bit on the antler's left side (viewer's right side), especially on the parts of the antler "closest" to the viewer.

5. With the dark brown pencil, begin filling in some space, keeping hair direction in mind. Begin filling in the antlers, leaving a narrow white border on the (viewer's) right edge to allow for reflected light. Keep the tips of the tines white. Use your darkest strokes on the tines closest to the viewer in order to make them look more dramatic—and closer. Fill in the darker areas of the nose and eyes, adding a shadow on the inner corners of the eyeballs.

HOOFED MAMMALS

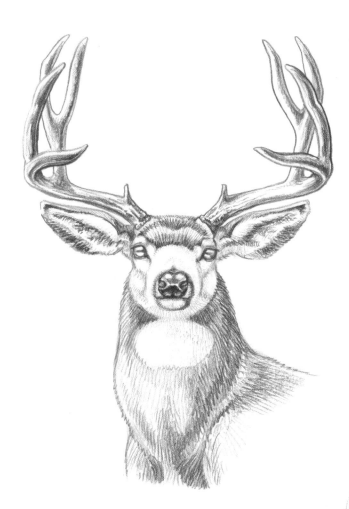

6. Now add more color. The "underpainting" of dark brown will help unify what comes later. Use a medium warm gray pencil to build up shadow areas. Define the eyes, eyelids, and nose, keeping reflected light and highlights in mind. With the bright blue-violet pencil add a blue undertone. It is important to use this color lightly! This blue may be reflecting the deep shade of a forest or cold, wintery snows. Think of the deer's environment as you draw. Proceed to gently shade in blue in the shadows and on the areas you had left white for reflected light.

7. Use the sand color to lightly add warmth to areas being hit by light. Add soft sand highlights to the antlers, ears, face, and neck. Then go back with the dark brown and rework and darken the brown areas on the deer and antlers. Make the tines "closer" to the viewer slightly darker than those farther away. Define the ears and nose and shade in parts of the eyes. Make sure the right eye's (on your left side) highlight is left pure white and sharp, and dull the highlight of the left eye because it is more in shadow.

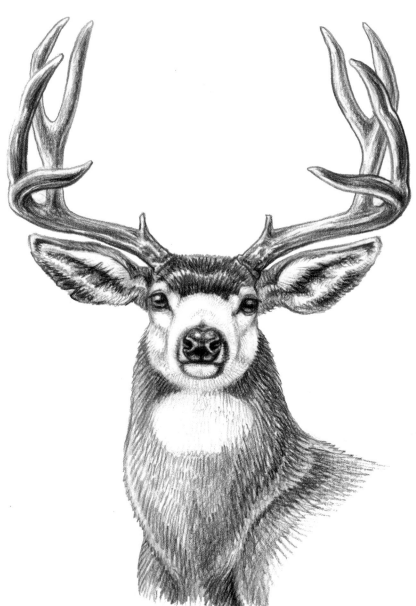

8. Now for the black! Try to keep it to a minimum and don't overuse it. Define the eyes, forehead, and antlers more. Darken the nostrils, leaving a little area inside them brown to indicate light still penetrating parts of the nostril and thus implying depth. Now use dark brown to work over the antlers. Fill in and solidify areas that still need work, darkening where needed. I left a light-colored "line" along the juncture of the neck and shoulder to give a sense of compressed hair overlapping more hair. Define more of the markings around the nose and jaw.

9. Use white to blend color on the lighter sides of the antlers, face, ears, and neck, and burnt ochre to achieve a richer tone throughout. Use medium warm gray and black to touch up and define any areas made dull with blending. Finish the facial details. At this point I would add a bit more burnt ochre and bright blue-violet. Add ochre to the "cheeks," to help make the white area surrounding the nose pop out more. Add blue subtly to the ear butts to push them back from the head. Sign your name and you're done!

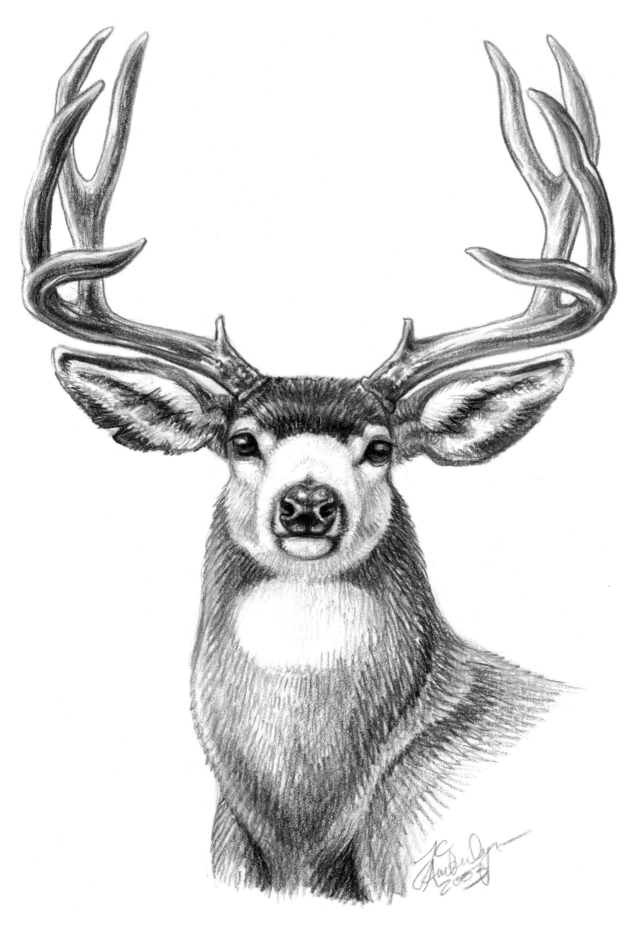

MOUNTAIN SHEEP & GOATS

are masters of their elements, and their element is air—or at least it seems that way. They prance about the highest, steepest mountain peaks with grace and surefootedness. They tread where their predators would fear to go. Their bodies are solidly built, with large feet and warm coats where needed. All members of their family, Bovidae, grow horns, but the sheep's horns are by far the most massive and impressive. Mountain sheep have a deer-like build but are stockier and their hooves are larger and bulkier. Mountain goats are actually not true goats, but more of a "goat-antelope," like the chamois of Europe and Asia. They are even more compactly built than sheep and are found in only the highest, coldest places in the western mountains where their distinctive snow-white coats serve as camouflage.

THE HEAD
Mountain sheep have heads similar to their domestic cousins—bulging eyes on the sides of their heads, an almost Roman nose, and small, rounded ears. Mountain goats are a lot less like their domestic namesakes, and have a very long snout and somewhat pointy ears. Both the mountain sheep and goats have an almost heart-shaped nose when viewed from the front and nostrils that curve out and up.

THE BODY
Mountain sheep have a blocky, compact body. The mountain goat is even more compact. The feet, legs, and tail of mountain sheep and goats are similar to those of a deer or any other hoofed animal. See individual species descriptions for more information.

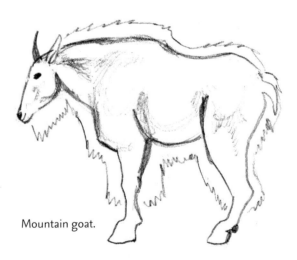
Mountain goat.

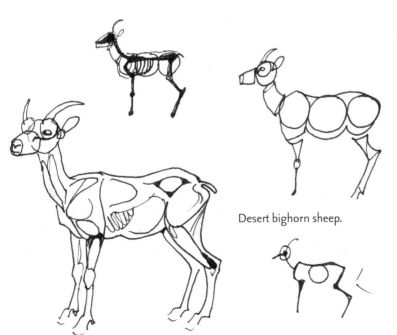
Desert bighorn sheep.

FUR & TEXTURE
Not surprisingly, the hair on these high-country animals is extremely thick and warm when needed. Mountain sheep do not have long, shaggy wool like their domestic cousins, but their hair does have a very woolly, thick undercoat. Mountain goats have exceptionally shaggy, warm, and somewhat woolly hair.

MOUNTAIN SHEEP & GOATS IN MOTION

Wild sheep and mountain goats have a locomotion that is similar to deer or most other hoofed mammals. They are just very good at doing it while running up a sheer cliff wall that would stop most other creatures!

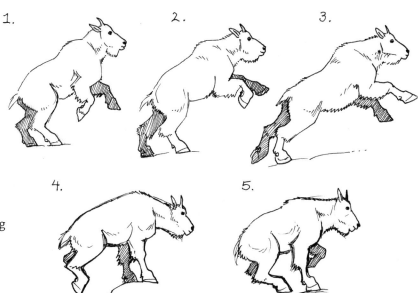

Mountain goat running up a mountainside.

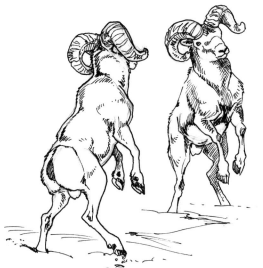

Rocky Mountain bighorns.

BUTTING HEADS: There is one action that mountain sheep are famous for: butting their heads during the breeding season, or rut. The male sheep (rams) will rush at each other and butt their horns together to determine who is the strongest. This crack of horns can be heard up to a mile away! Rams have thick, cushioned skulls and what appears to be a spongy sort of area just behind their horns—a built-in shock absorber. The rams first look each other over, perhaps even kicking at one another with a front leg. Finally, the two rams rear up on their hind legs, front legs held stiffly below. Then comes the charge and "crack"!

Desert bighorns: gesture sketch (TOP), blocking out the basic action (MIDDLE), and the final drawing (BOTTOM).

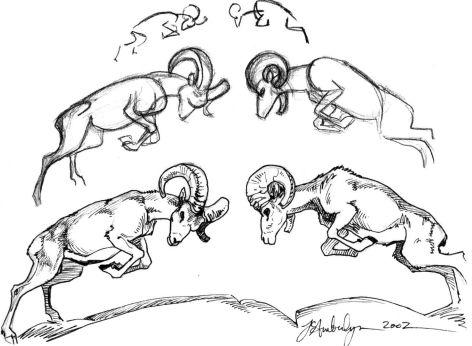

BIGHORN SHEEP

OVIS CANADENSIS

THE APTLY NAMED BIGHORN SHEEP is an animal adapted to rugged extremes and its sturdy, solid build reflects this lifestyle. Its blocky hooves and slender but strong legs carry it nimbly across ridges, rocks, and sheer cliff faces, seemingly without a care in the world. There are two types of bighorn sheep: the hefty, cold-country Rocky Mountain bighorn and the lanky, desert-dwelling desert bighorn subspecies (O. c. nelsoni).

Desert bighorn.

THE HEAD

Mountain sheep have heads shaped much like their domestic cousins'. Their large eyes are placed on the sides of their head for good peripheral vision. Their muzzle is slightly Roman-nosed and fairly long, but not as long as that of some other hoofed mammals.

"Blocky" is the best word to describing wild sheep, especially Rocky Mountain bighorns. Desert bighorns have longer muzzles and more slender heads in comparison.

Rocky Mountain ewe (LEFT) and young ram (RIGHT).

HORNS: A dominating feature of the male bighorn sheep's head are his horns. Basically a sweeping C-shape, they start out very thick at the base, especially from the front to the back. Very pronounced, rough ridges ripple all the way down the length of the horns, but are the most ragged at the base. These "growth rings" enable one to guess the ram's age. Their horns are made of the same stuff as our nails and hair—just much harder!

The bighorn's horns are incredibly heavy. They start out as "buttons" on a young lamb and grow continuously throughout the sheep's life. A ram grows much bigger, heavier horns than an ewe. By the time they reach six to eight years of age and have a full curl, most bighorn ram's horn tips begin to show signs of wear, called "brooming." It appears that rams deliberately try to rub or knock off the tips! Perhaps they get too heavy, or the ram begins to find his eyesight impaired, or both?

Rocky Mountain ram.

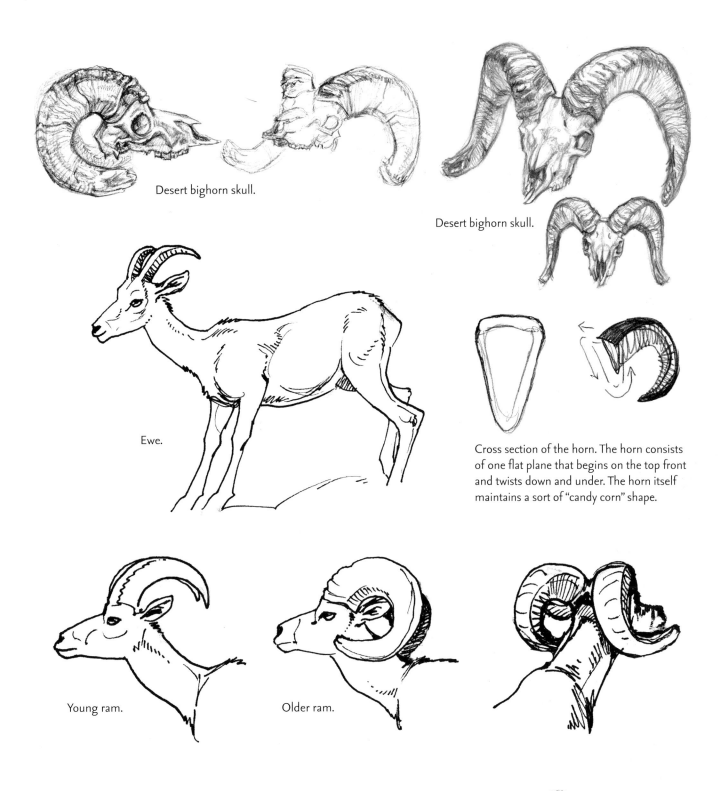

Desert bighorn skull.

Desert bighorn skull.

Ewe.

Cross section of the horn. The horn consists of one flat plane that begins on the top front and twists down and under. The horn itself maintains a sort of "candy corn" shape.

Young ram.

Older ram.

EYES, EARS, AND NOSE: Bighorns have large, somewhat expressionless eyes with horizontal, elliptical pupils. Their irises are a golden brown. The ears tend to be small and rounded. A desert bighorn's ears are longer and larger than a Rocky Mountain bighorn's. The nose is somewhat heart-shaped.

Rocky Mountain bighorn's ear.

THE BODY

If any animal lends itself to a study of blocky geometric shapes it's the bighorn sheep. Not only does it have the sweeping horns but also a blocky back, broad white belly and rump patch, and sturdy, large-jointed legs.

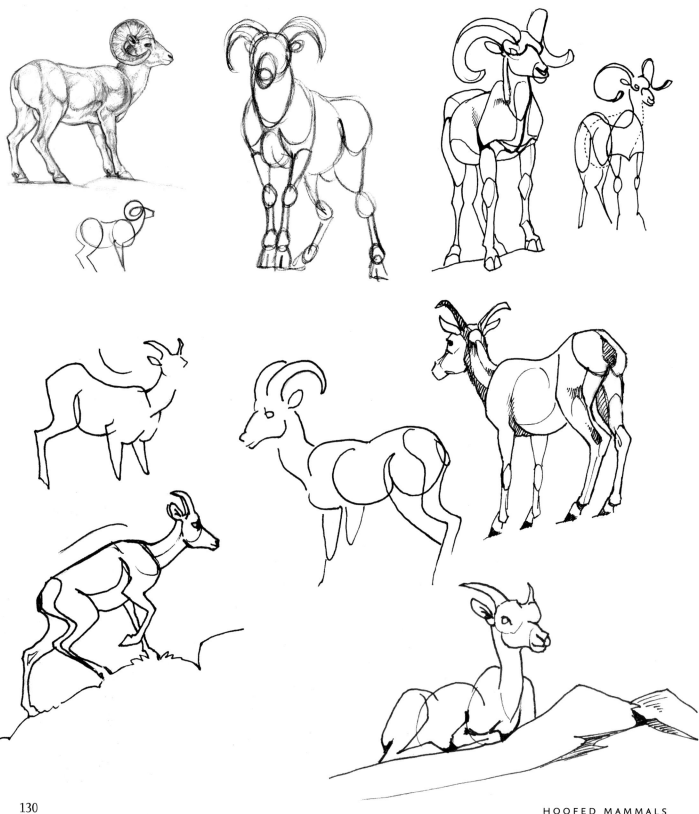

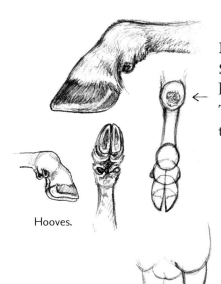

Hooves.

LEGS AND FEET: Bighorns have thin but strong, large-jointed legs. Sheep sometimes have knobby patches on their front "knees" where the hair has been rubbed off from lying down or other contact with the ground. Their large, blocky hooves are hard on the tips but softer underneath and toward the back, creating a suction effect that helps them grip rocky surfaces.

Front legs.

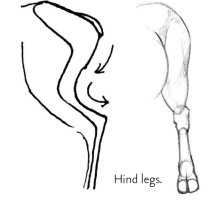

Hind legs.

Desert bighorn tail.

TAIL: A bighorn's tail is short, stubby, and usually a dark brown color, which creates almost a bull's-eye effect against its white rump patch. A desert bighorn has a slightly longer tail than a Rocky Mountain bighorn.

COLOR MARKINGS

Bighorns are the same grayish-brown color as their rocky environment. Rocky Mountain sheep tend to be darker in color than desert sheep. There is some individual variation and some sheep are darker than others, even in the same herd. A dark desert bighorn is sometimes referred to as "chocolate." The horns of a desert bighorn have a yellowish tint, while a Rocky Mountain sheep's horns are often a slightly darker color. Another prominent feature is the big white rump patch, which is interrupted by a dark stripe leading up from the tail to the back. The white belly extends from the rump all the way to where the front legs attach. The legs are mostly the same color as the body with a thin white stripe extending down the rear-facing sides. There is also white around the muzzle and inside the ears.

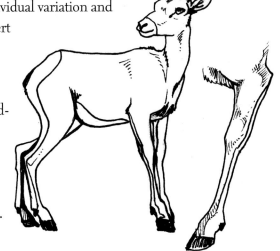

THINHORN SHEEP

OVIS DALLI

MOST OF WHAT IS TRUE for drawing bighorn sheep can be applied to thinhorns as well. The thinhorn sheep include the snow-white Dall's sheep (O. d. dalli) and the dark-bodied and white-faced Stone's sheep (O. d. stonei), both animals of the Far North. They are similar in appearance except for color, and a bit reminiscent of a desert bighorn's horns attached to a Rocky Mountain bighorn's body—only their thinner horns flare outward even more than do the desert sheep's.

Dall's sheep.

THE HEAD

Thinhorn sheep have the same blocky head shape as bighorn sheep, with smaller ears. Their horns are more slender than a bighorn's, as their name implies, and their horn tips sweep much more outward from their head. They also tend to show less evidence of "brooming," or the breaking off of the tips of their horns, than do bighorns.

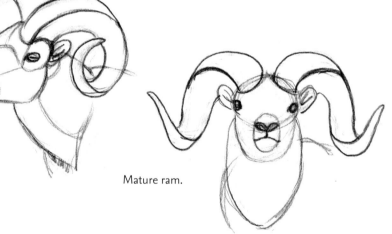

Mature ram.

Young ram.

COLOR MARKINGS

The Dall's sheep is entirely white except for its eyes, nose, horns, and hooves. Its eyes are lighter brown than a bighorn's, but from a distance may appear dark contrasted with the white hair of the face. The horns are a golden brown color. The Stone's sheep ranges from gray to black. Its body has dark and light markings similar to a bighorn's, but with more contrast. Its legs may appear very dark or black except for where the white stripe extends down the rear-facing side. The dark areas near the belly may appear black. This sheep has a distinctive white or light gray face and head. The intensity of color markings varies.

MOUNTAIN GOAT

OREAMNOS AMERICANUS

MOUNTAIN GOATS ARE SNOW-WHITE, unique-looking creatures that live only on the highest, most remote mountaintops. Not truly a goat, they are more of a "goat-antelope," like the chamois of Europe or the serow of Asia. They display amazing agility and surefootedness on some of the steepest, most rugged terrain on earth.

THE HEAD

Mountain goats have heads that are sort of a blocky oval shape, with long muzzles and a pair of dagger-like blackish horns. Both sexes possess a "beard," which is actually an extension of the throat mane. The length of the beard varies, due to both individual variation and whether the animal is in summer or winter coat.

Young adult goat.

HORNS: It can sometimes be difficult to distinguish between the horns of the male, called a billy, and the female, called a nanny. A billy's horns tend to be thicker and have larger bases. The horns sweep back gently and are slightly ribbed but much smoother overall than a bighorn sheep's.

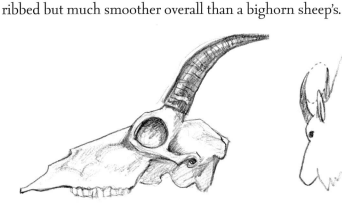
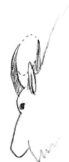
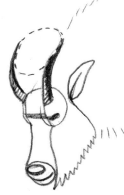
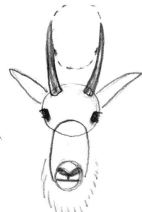

EYES, EARS AND NOSE: Mountain goats have horizontal, elliptical pupils much like a mountain sheep's. Their eyes are a dark brown color, but often appear "black" from a distance in contrast to their white fur. Their ears are long and pointed and often seem a little bit "droopy." The nose is somewhat heart-shaped, like a sheep's.

THE BODY

The mountain goat has a distinctive, hunchbacked shape. It is compact, blocky, and built to conserve heat. It is also built perfectly for rock-climbing! Mountain goats are perhaps even better adapted to rock-climbing than sheep are; they have narrow bodies and a very compact shape, which takes up less space on a narrow ledge. Their thick hair conceals a lot of their anatomy and, when starting a drawing, it can help to block out the form hidden underneath all that fur.

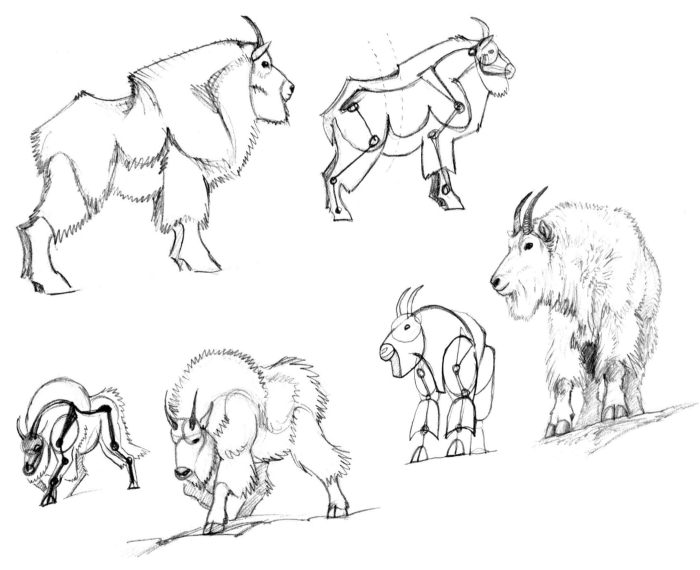

LEGS AND FEET: The relatively short and stocky legs of the mountain goat are half hidden under shaggy fur most of the time. The really long hair ends at about the knee (on the front leg) and hock (back leg) joints of the goat. The hooves are large and blocky and, like the mountain sheep's, they are hard-tipped with rubbery soles for a suction-like grip on rocky surfaces.

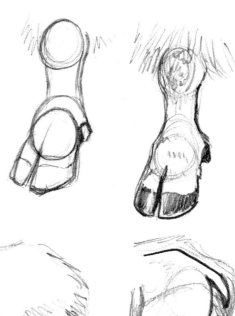

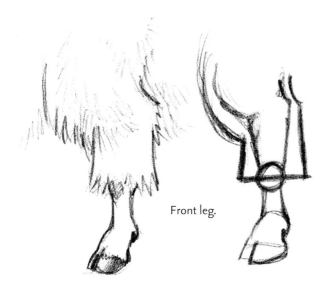

Front leg.

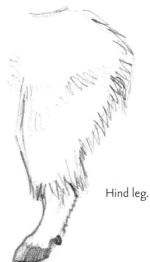

Hind leg.

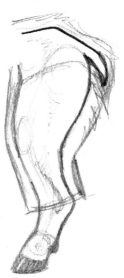

TAIL: The tail of the mountain goat is short and, because it blends in with the thick hair around it, not very visible most of the time.

COLOR MARKINGS

The mountain goat is pure white, except for its eyes, nose, horns, and hooves, which are a blackish color. The hair sometimes has a yellowish tint to it, and billies, in particular, will sometimes paw dirt on themselves during the rutting season. The mountain goat's hair is woolly, thick, and shaggy, keeping it warm. During the summer, a goat's hair will shed in chunks, creating a very ragged appearance.

HOW TO DRAW A DESERT BIGHORN SHEEP

THIS SLIGHTLY MORE ADVANCED DRAWING in pen and ink shows a desert bighorn ram quartering toward and above the viewer. Be careful not to overdo the pen strokes and make the head and horns darker than the rest of the body.

1. First block in the major parts of the body, using slightly squashed ovals for the forequarters and hindquarters and a slightly smaller circle for the head. Make sure the body measurements equal out as shown.

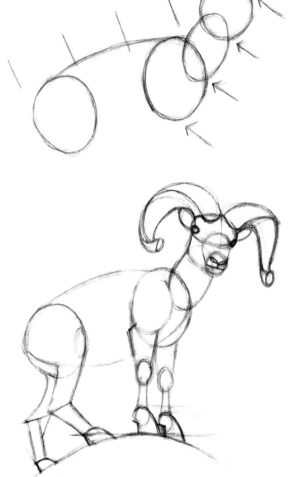

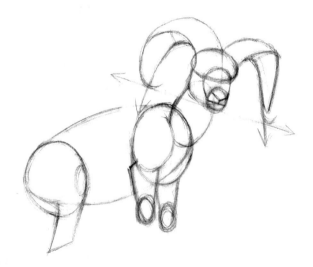

2. On the top half of the head, rough out an oval to indicate the eye area. Add the top of the muzzle, the curve of the neck, and the base of the horns. Make sure the eyes bulge out a bit from the rest of the head. On the far side of the head, "cut away" some of the head under the eye bulge, as shown, to add to the bulge effect and to narrow the head. Add the top part of the front legs and the nearest hind leg. I added a circle to indicate where the knee is—blocking it in can sometimes help one visualize the leg's positioning better.

3. Rough in the ram's nose, mouth, eyes, and ears. Indicate the elbow and knees—letting them jut out as needed. Work on the legs, adding the rest of the front and hind legs. Make the new parts of the front legs narrowest just below the knees and widen them as you go down. Add the "wrists." Be sure to indicate the dewclaws above and behind the hooves. Finish up shaping the horns by defining the tip ends and the top, flat part of the horns where they extend from the base. Indicate the ground under the ram's feet.

4. Add the jawline and begin adding ridges, growth rings, and "brooming" to the horns. Add details to the head. Begin blocking in the final shape of the body, adding definition to the legs and the chest area. The hip bone should jut out slightly from the back's outline. Add the tail, hooves, genitals, and dewclaws. Clean up your drawing or transfer it to a clean sheet of paper.

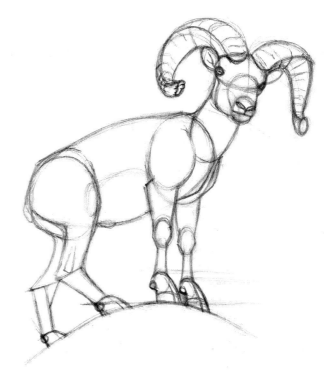

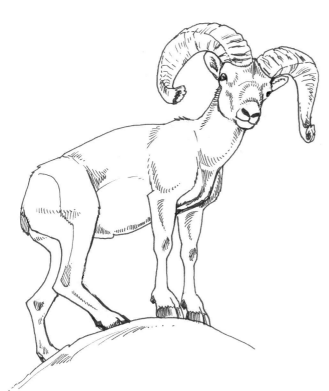

5. Trace the outline. Use a dotted line to differentiate the top of the horn from its side to soften the effect. Begin inking in hair and volume. Add ribs to the horns, following the shape as you do so. Add a scuffed area to the knees. Put in the pupils and "color" the hooves.

6. Continue inking. Use your strokes to fill out and suggest the form. Many of the forms that make up the sheep's body will have a domed appearance due to the viewpoint of looking up at the sheep. Use your line strokes to suggest this. For instance, this "doming" is easily visible on the top half of the ram's front legs and the line dividing his brown sides from his white belly.

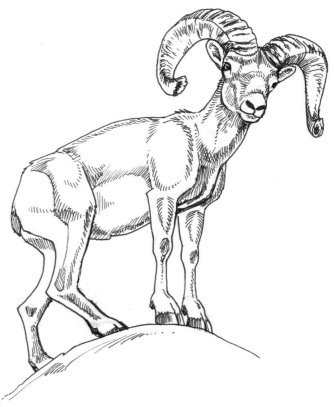

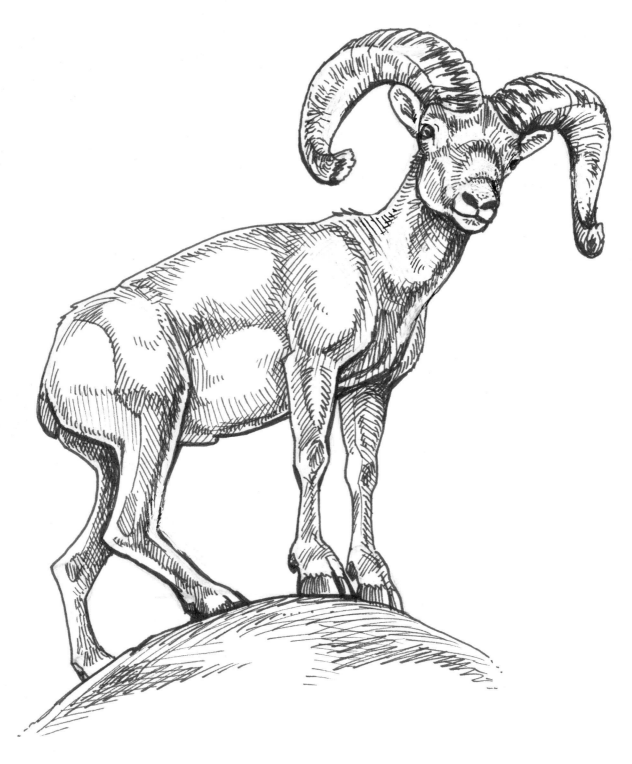

7. Now, the finishing touches. Use your pen strokes to indicate and fill out the form, using cross-hatching when needed. Darken the shadowed areas. Be sure to leave areas on the head, neck, and front shoulders light enough so that your animal stays balanced and not too dark in the front half. To add a nice sense of weight, thicken your lines on the undersides of the animal, including the bottom areas of the horns, joints, hooves, etc. Shade the rock the ram is standing on and you're done!

PRONGHORN

Antilocapra americana

The pronghorn, often called the pronghorn antelope, is not a true antelope at all, but it is the last surviving member of a once diverse ancient family, Antilocapridae. These unique and beautiful animals have branched horns, hence their name, which are partially shed each year. Living out in the open plains, their eyesight is excellent and their speed makes them the fastest land mammal in North America.

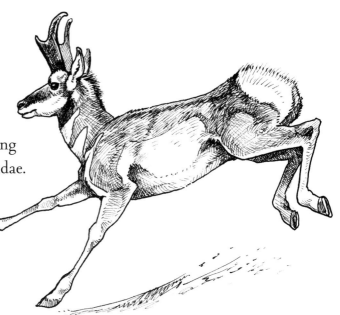

THE HEAD

Pronghorns have deer-like heads, with very large eyes and eye sockets that bulge from each side of their head. They may possess a small mane, or crest of hair, on the back of their head and neck.

HORNS: Both sexes can have horns. The horns of the female (doe) are small spikes, if they are present at all, while the male (buck) grows much longer, pronged horns. Underneath the visible horn sheaths is a spike-like base, which is part of the skull. The base is permanent, but the horns shed annually.

The horn tips grow up, pointing backwards and slightly inwards, creating almost a heart shape when viewed from the front.

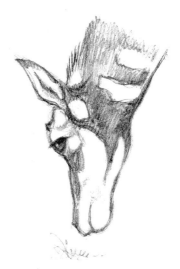

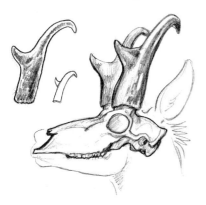
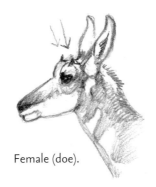

Female (doe).

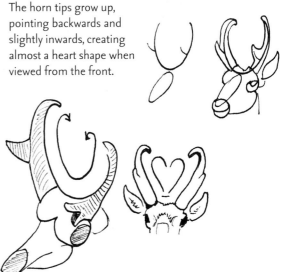

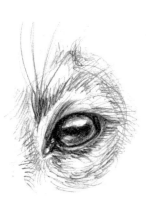

EYES, EARS, AND NOSE:
Pronghorns have large and dark eyes with horizontal pupils and heavy eyelashes. The ears are long, thin, and have an upturned tip. Pronghorns have a small, somewhat T-shaped nose pad set between two flaring nostrils.

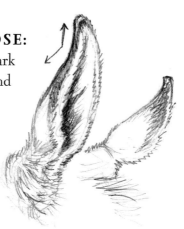

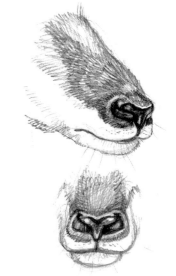

THE BODY

The body of a pronghorn is basically deer-like. They have long, thin, but strong legs capable of running long distances and a wide chest holding large lungs.

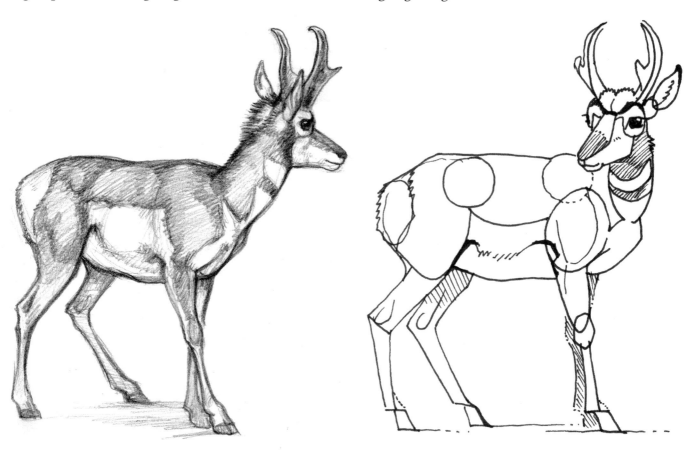

LEGS AND FEET: Pronghorns differ from most of the other hoofed mammals in this book in that they do not have any dewclaws, otherwise their legs and feet are similar to those of other members of the deer family.

TAIL: The tail of a pronghorn is small, at least somewhat tan-colored, and surrounded by a snowy white rump. Pronghorns can flare the hair on their rump patch, creating a white orb that is visible for long distances.

Relaxed rump patch.

Flared rump patch.

COLOR MARKINGS

Pronghorn hair is hollow and very brittle and areas on a pronghorn's body that get rubbed and moved about a lot often seem to show a lot of wear and tear. This is especially evident along the corners of the mouth and the sides of the body where the legs attach—there is often a line in the hair behind the front leg and in front of the hind leg.

Pronghorns are very colorfully marked, featuring a tan body with white patches on the throat, ears, ear bases, muzzle, top of head, legs, belly, sides, and rump. The two distinct white bands on the throat may or may not be attached by a small band of white in the center. Sometimes the pronghorn's dark brown mane has a white base. Other darker areas include the top of the nose and the tips of the ears. Male pronghorns are marked similarly to females except for an additional dark brown to black throat patch, cheek patches, and a darker nose. The horns of both sexes are brownish-black.

Male (buck).

Female (doe).

MUSK-OX

OVIBOS MOSCHATUS

THIS RELIC OF THE ICE AGE makes itself at home in the Arctic. It is not exactly an ox, being more or less something of an intermediary between oxen and sheep (with which it belongs in the family Bovidae). Musk-oxen are covered with long, thick hair that billows as it moves, like the ripples in a dress. Musk-oxen are famous for their defensive maneuvers: When threatened, a herd will gather into a circle, heads and horns facing outwards, while the young calves are protected in the center.

THE HEAD

A musk-ox's head is long-faced like a cow's and is covered with dense, shaggy hair except for the muzzle area, which has a shorter coat. The muzzle area is also largely white, creating contrast between its horizontal oval shape and much of the rest of the darker head. The only other area of any real contrast on a musk-ox's head are its horns.

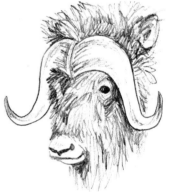

Female (cow). Male (bull).

HORNS: Both males and females carry horns, with the mature male's horns being much heavier and thicker. A male, or bull, musk-ox's horns meet at the center of the head and form a broad "boss" of white. A female, or cow, musk-ox's horns do not meet at the center, but there is a swath of white hair between the horns, which can lead to confusion for human observers from a distance. A young bull may look much like a cow, but both young and old bulls also usually have dark tips on their horns.

EYES, EARS, AND NOSE: The musk-ox's eyes are small and the nose is cow-like, but much furrier. The musk-ox's ears are small and pointed.

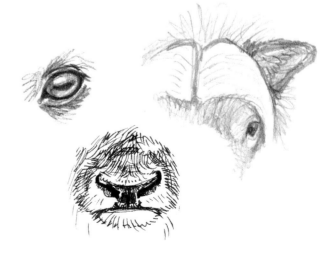

142

THE BODY

Musk-oxen have very strong, stout bodies built for heat conservation. However, very little of their anatomy usually shows under all that hair!

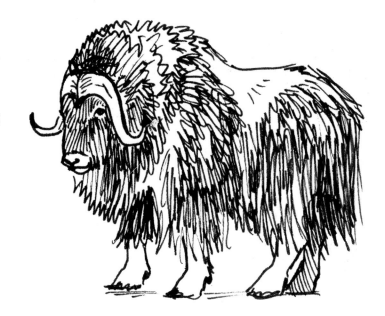

LEGS AND FEET: Musk-oxen have broad, cow-like hooves and short, thick legs covered in hair. The really long hair from the body usually drapes over the upper part of the leg and ends at about knee (front leg) and hock (back leg) level.

COLOR MARKINGS

Musk-oxen are basically dark brown, with white markings on the muzzle, horn bases, legs, and on the top of their back. They have thick, extremely long, and warm fur that hangs over their bodies and ripples with their movements. Their luxurious underwool, called qiviut, is highly prized by native weavers.

BISON

BOS BISON

THE BISON, also sometimes called a buffalo, is an icon of the American Wild West. This herbivore, which once numbered in the millions and was a vital part of the prairie ecosystem, was reduced to less than a thousand individuals by 1900. Fortunately, measures were taken in time to stop the complete extermination of the species, and today bison are still part of the landscape. There is a smaller, less shaggy bison found in Europe.

THE HEAD

Bison have cow-like heads and horns. Their shaggy, heavy hair tends to obscure much of their head shape, however. Male bison have much shaggier hair than females, including a longer, heavier "beard."

Male (bull). Female (cow).

HORNS: Both male and female bison have two small horns. The horns are similar to a cow's and are grayish in color.

EYES, EARS, AND NOSE: The bison's eyes, ears, and nose are somewhat cow-like.

THE BODY

The largest terrestrial mammal in North America, the bison is cow-like, with a shaggy head, front legs, and shoulders. Males are shaggier than females. Time of year also determines the heaviness of the coat. Bison feature a prominent shoulder hump, which is further accented by their shaggy hair.

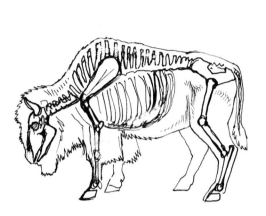 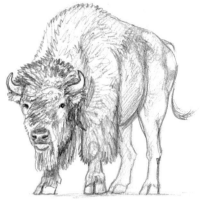 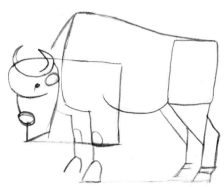

LEGS AND FEET: Bison legs are strong and sturdy. The front leg is covered down to about its "knee" area by shaggy hair, then smoothes out. When drawing the hindquarters, be aware of the bison's prominent hip bone. Bison have two hooves and two dewclaws per foot, like many hoofed mammals.

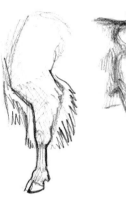 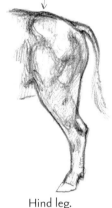

Front leg. Hind leg.

TAIL: The bison's tail is rope-like with a tuft of hair at the end.

COLOR MARKINGS

The most noticeable thing about bison hair is the contrast of the long, thick hair on the front half of the body and the much shorter hair on the back half.

This drawing shows the general areas of long and short hair, with the long hair shaded the darkest. The crosshatching on the shoulder area indicates the area on a bison that may be heavily furred or may be smooth like the sides and rear—it depends on the individual and the time of year.

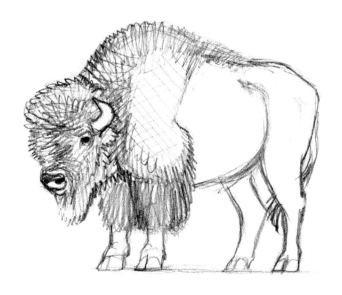

COLLARED PECCARY
Pecari tajacu

THE COLLARED PECCARY, otherwise known as a javelina, is a pig-like mammal of the southwestern United States. It is very distantly related to pigs. Peccaries are social creatures, living in herds and visiting established feeding, bedding, and watering sites within their territory. The peccary has a vicious reputation, perhaps because it looks a bit like a wild boar, but the real animal would usually rather run than fight. Peccaries can "bristle," or erect the long hairs on their back to look larger, as the one here is doing.

THE HEAD

The peccary's head is similar to a pig's, with an oval snout that extends ahead of the lower jaw and is flattened at the end. Peccaries have four tusks (two each on top and bottom) that range from about 1 to 1½ inches, but they don't usually protrude outside the mouth when the animal is relaxed.

The upper and lower tusks constantly rub against each other, creating a smooth, flattened surface where they make contact. Looking at the skull, one can see how the lower tusks rest against the top jaw.

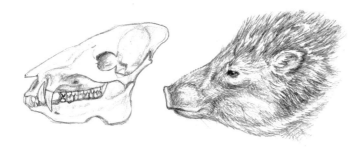

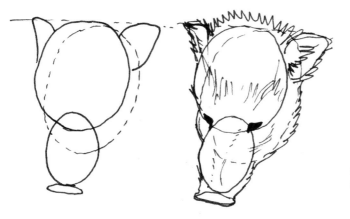

EYES, EARS, AND NOSE:

Peccaries have small, dark eyes with round pupils. The nose is a flexible, pig-like snout. The ears are somewhat oval-shaped.

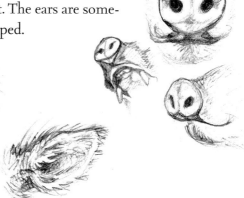

THE BODY

The peccary's head is huge in comparison to the rest of its body. The head and neck together comprise almost half the animal's length! The collared peccary gets its name from a light band extending around its body and behind its neck. Depending on the time of year, this "collar" may be very noticeable or it may be rather faded in appearance. Peccaries have short legs in comparison to their bodies and a tiny stub of a tail that is usually not noticeable. Peccaries also have a large scent gland on the back, about 7 inches above their tails, which they use for scent marking.

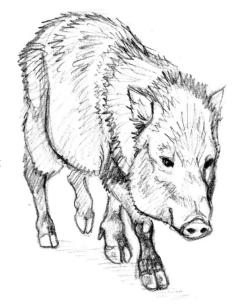

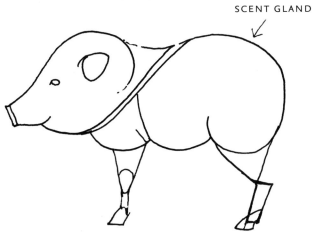

SCENT GLAND

LEGS AND FEET: Peccaries have short but sturdy legs. Their front "knees" are often knobby and hairless from kneeling and bedding in rough terrain. They have two dewclaws on their front feet, but only one dewclaw on each hind foot, located on the inside of the foot, toward the belly.

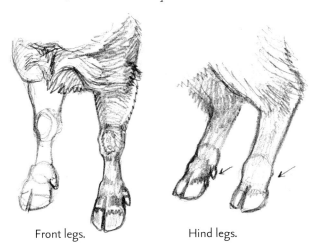

Front legs. Hind legs.

COLOR MARKINGS

Peccary hair is coarse, bristly, and somewhat brittle. The hairs are banded with brown and white, creating a salt-and-pepper brownish color that blends in very well with the environment. The hair tracts push down from the lower jaw and forward at the shoulder, meeting at the neck where the "collar" begins. The hair on a peccary's back/rump area, where its scent gland is located, is sometimes a little unkempt-looking due to frequent rubbing.

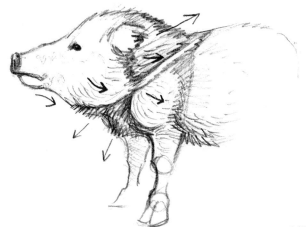

SMALL MAMMALS

SMALL MAMMALS SUCH AS mice, rats, squirrels, and rabbits are usually found in large numbers most anywhere, and yet they are often overlooked by people. These animals prefer things this way. All are food items on almost every local predator's dinner menu, and keeping out of sight is a wise strategy. In some cases, especially in urbanized areas where hunting is not allowed and natural predators are few, small mammals may be hard not to spot. In city parks and campgrounds, people may find themselves almost harassed by animals, such as tree squirrels, intent on being given a peanut! These animals display an amazing ability to adapt to the situation at hand and not only survive, but thrive!

Despite constant predation, these prey animals are able to keep replenishing their numbers. In fact, small animals often seem to influence their predators' numbers even more than their predators influence theirs! An abundant prey base means that a predator's offspring have a higher chance of surviving. If the population of rodents or rabbits crashes due to drought, severe winters, or other factors, so too does the number of their predators.

The small mammals covered here are just a few of the most notable or common rabbits, hares, squirrels, mice, and rats found in North America. There are many, many more. At the end of the section are descriptions of several "odds and ends": animals that are interesting and fun to draw, but not easily classified with others in this book. Here I've included several rodents, namely the beaver, the muskrat, and the porcupine, in addition to North America's only marsupial, the opossum, and the odd but interesting armadillo.

RABBITS & HARES are familiar animals of field, forest, and

bedtime stories found throughout most the world. Soft, "cute," and incredibly prolific, they are speedy and alert survivors in a world full of those who would eat them. Known for their bounding leaps and large, swiveling ears, the members of the family Leporidae add life to any landscape they inhabit. Covering all rabbits and hares is beyond the scope of this book, so the species profiles will examine the animals that I know the best: the desert cottontail (a rabbit) and its larger cousin the black-tailed jackrabbit (a hare). What is the difference between a rabbit and a hare, you may ask? Rabbits are born blind, naked, and helpless in a fur-lined nest, while the more precocious hares are born furred, with eyes open, and can run shortly after they are born.

THE HEAD

Rabbits and hares have oval-shaped heads with large, bulging eyes. Their nose is soft and round-looking and their ears are a defining feature. The muzzle is rounded but usually slender from the top and widening out at the cheeks.

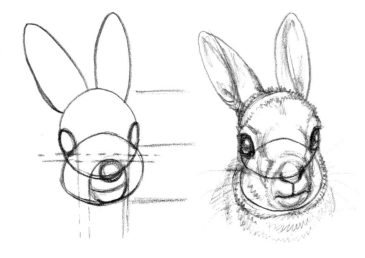

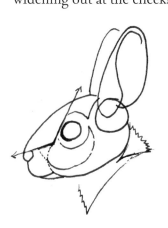

EYES: Rabbit eyes are usually rounded, almond-shaped, and dark. They bulge out from the sides of the head, maintaining a wide peripheral vision that allows rabbits to catch any animals trying to sneak up behind them. The pupils are round.

EARS: The ears vary from medium- to "over-sized," depending on species. They can rotate and swivel about independently and pick up distant sounds easily. When drawing them, visualize the base atop the skull. Also keep in mind that from the side they appear wide, but are more slender when viewed from the front or at an angle. Some species' ears have only a thin hair-covering inside, and feature large portions of naked skin. Rabbits have an "ear pocket," but it is not quite as deep or as noticeable as in some other species of wildlife.

NOSE: A rabbit's nose consists of a V-shaped "flap" on top that usually covers the nostrils. The rabbit can lift up this "flap" to reveal the nostrils and nose pad directly underneath, and rabbits are frequently seen wriggling their noses to catch a scent.

THE BODY

Rabbits have the hunched appearance typical of small animals, plus powerful hind legs and large feet. When stretched out, their bodies are surprisingly long.

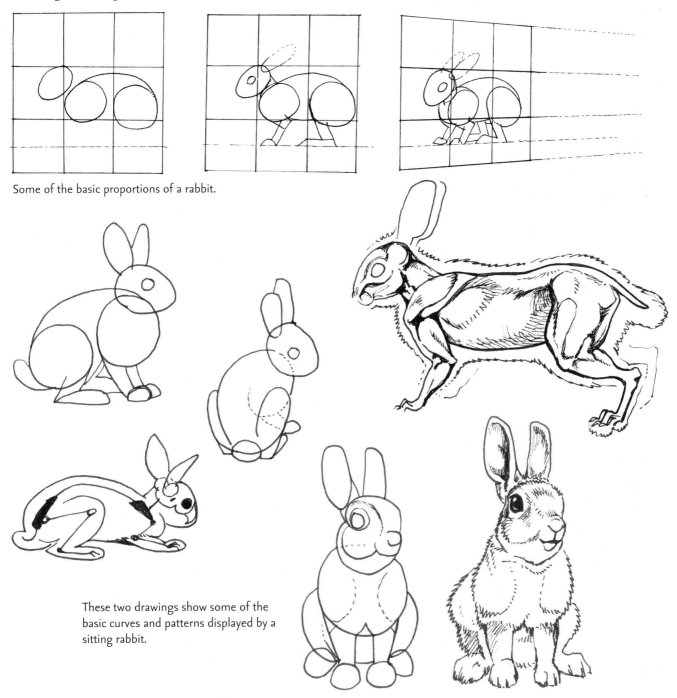

Some of the basic proportions of a rabbit.

These two drawings show some of the basic curves and patterns displayed by a sitting rabbit.

FEET: Rabbits and hares have no paw pads on their feet. Instead, the bottoms of their toes and feet are covered with thick, coarse, cushiony hair. They also have a small, not very noticeable dewclaw. When sitting, the hind foot is flat and completely touches the ground from tip to heel, but the rabbit may walk or run using only its toes.

The front foot toes of some species of rabbits and hares are not spaced in equal proportions on the foot. Instead of two middle toes jutting forward and two outer toes evenly placed a little behind, these animals' front feet feature three prominent inner toes and one small outer toe placed farther behind the others.

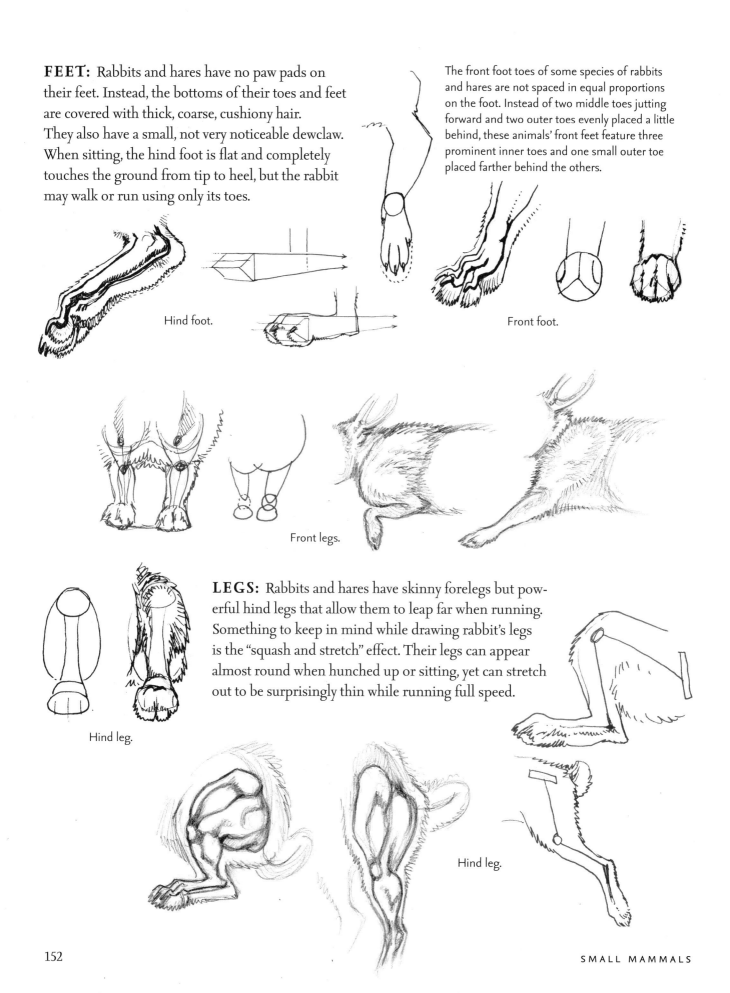

Hind foot.

Front foot.

Front legs.

LEGS: Rabbits and hares have skinny forelegs but powerful hind legs that allow them to leap far when running. Something to keep in mind while drawing rabbit's legs is the "squash and stretch" effect. Their legs can appear almost round when hunched up or sitting, yet can stretch out to be surprisingly thin while running full speed.

Hind leg.

Hind leg.

SMALL MAMMALS

TAIL: Rabbit tails are short and round. In some rabbit species, the tail is small and the same color as the body and may be hard to see at all from under the fur of the rump.

On a crouched bunny there is often a depression between the forelegs and the hind legs and a crease or compression of hair on the haunch.

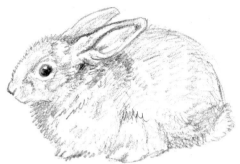

FUR & TEXTURE

Rabbits have very soft, delicate fur. The hair of many species has a dark base with light tips, giving them a salt-and-pepper effect. Some species change color from season to season. Rabbit skin is thin and a little loose, allowing for ease of movement. Their fur can also conceal their anatomy. A hunched-up, sitting rabbit may look extremely round, with little anatomy showing. However, there will usually be a few hints of the hidden limbs in the way the hair bunches or compresses.

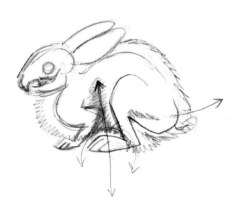

RABBITS AND HARES IN MOTION

Rabbits and hares are well-known for their tremendous leaps and bounds while escaping predators. Their hind legs are prominent in their gait. Even when walking, they have a sort of subtle "hop." Some hares, such as the black-tailed jackrabbit, may run, leaping several times before executing an especially long, high leap (perhaps to gain a better view of the surroundings or possibly to show how strong and healthy, and hard to catch, they are to a pursuer). The Arctic hare sometimes hops along on its hind legs like a kangaroo! Rabbits and hares may also lie down and stretch out like a cat when relaxed.

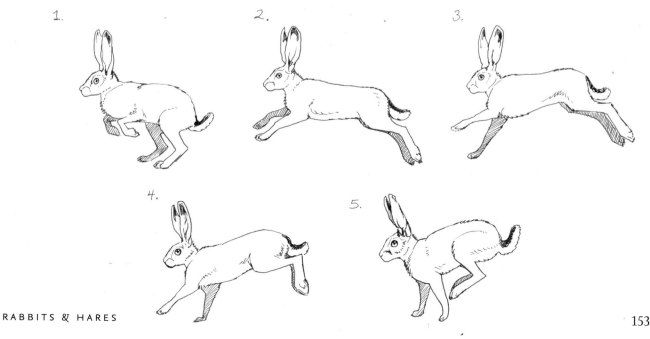

DESERT COTTONTAIL

Sylvilagus audubonii

There are numerous species of cottontail rabbits, and to the untrained eye most of them look alike. This section focuses on the desert cottontail, but contains useful information for any cottontails and most rabbit species in general. The desert, or Audubon's, cottontail makes its home in the arid Southwest—a landscape that may look almost devoid of life until sunset, when suddenly numerous cottontails will emerge from shelter to begin foraging, oversized ears on alert for danger.

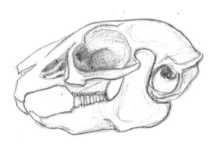

THE HEAD

Desert cottontails have the typical oval-shaped rabbit head, with a somewhat narrow snout that widens into furry cheeks. There is usually a noticeable line where the muzzle runs into the wider part of the head.

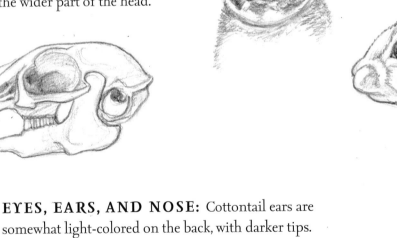

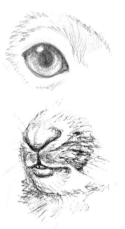

EYES, EARS, AND NOSE: Cottontail ears are somewhat light-colored on the back, with darker tips. Sometimes the sun shines through them and gives them a warm orange tone. Desert cottontails have extremely large ears in the more arid portions of their range, but may have more medium-size ears in colder areas. The nose is the typical V-shape.

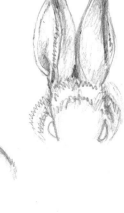

THE BODY

Like other rabbits, the desert cottontail has a slender body with strong hind legs that can be hunched up into a circular appearance or stretched out long and thin.

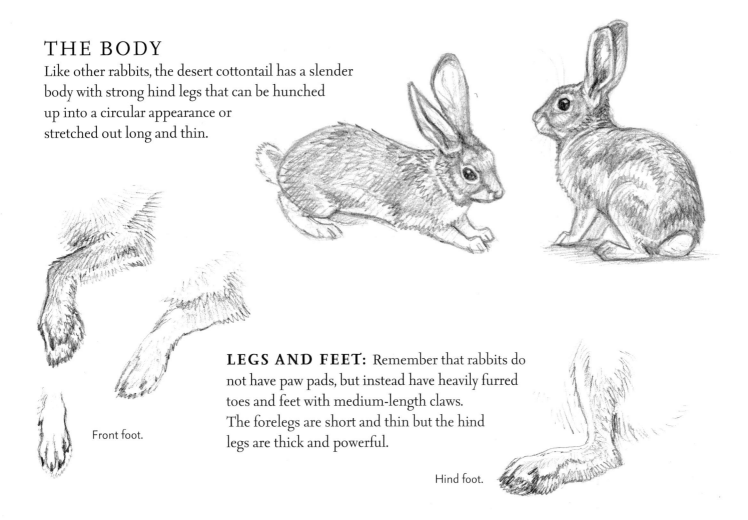

LEGS AND FEET: Remember that rabbits do not have paw pads, but instead have heavily furred toes and feet with medium-length claws. The forelegs are short and thin but the hind legs are thick and powerful.

Front foot.

Hind foot.

TAIL: All cottontails have short, round, white, and, of course, cottony tails. Usually there is some body color on the very top of the tail. In a dark woodland, sometimes the only thing one can clearly see of a cottontail is the white puff of its tail moving rapidly away.

COLOR MARKINGS

Desert cottontails have soft, gray-brown fur that is dark at the base and becomes lighter at the tips. Cottontails have a white eye ring, belly, and underside of the tail, and rusty-orange fur behind their ears on the nape of their neck. Their legs are also more rusty-orange, although sometimes a little paler and sandier than the nape of the neck. They also have white patches on their lips and muzzle, just under the nose.

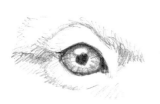

BLACK-TAILED JACKRABBIT
Lepus californicus

THIS LANKY, LOPING SPEEDSTER of the arid West is quite a sight with its gigantic, ever-alert ears. It is believed that its name derives from "jackass" rabbit, comparing its ears to that of a donkey's. However, despite its name, the jackrabbit is actually a hare, so its young are born furred and ready to run shortly after birth. Jackrabbits are fast, prolific, and apparently fairly social, sometimes seen in pairs or even large groups.

THE HEAD
The jackrabbit has a more elongated head and prominent nose than a cottontail, which appears dainty in comparison.

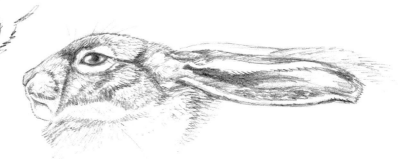

EYES, EARS, AND NOSE: A jackrabbit's eyes are a golden-yellow color with round pupils, which may appear slightly vertical and oval. Jackrabbit ears are lighter behind with dark tips. They may get ragged and torn as the hare goes through life. The jackrabbit's nose is similar to a cottontail's but bigger.

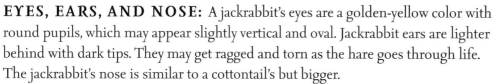

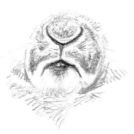

THE BODY

Black-tailed jackrabbits have bodies like rabbits, just larger and bulkier. Their heads are smaller in relation to their bodies than a rabbit's.

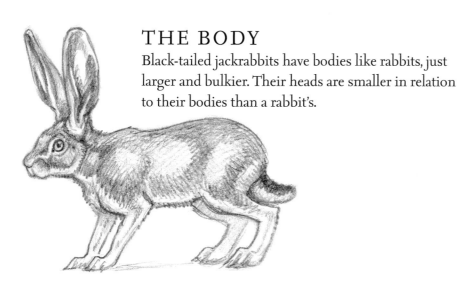

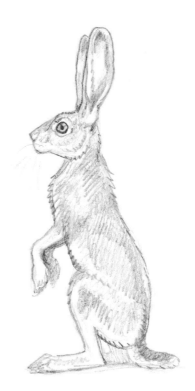

LEGS AND FEET: Jackrabbits have long, lanky, and thin legs, powerful haunches, and enormous hind feet. Note the dewclaw and the small outer toe of the front foot.

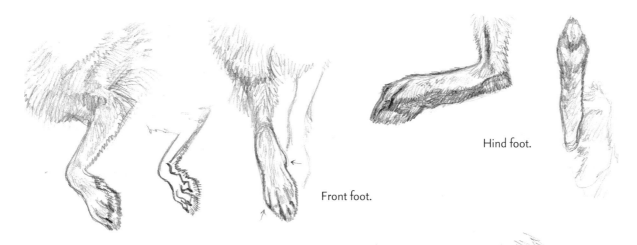

Hind foot.

Front foot.

TAIL: The tail of a black-tailed jackrabbit is, not surprisingly, black on top; the bottom is gray. Jackrabbits tails are longer than those of cottontails and may hang low from the rump or be curled up toward the sky. There is a stripe of black on the rump, just above where the tail attaches to the body.

COLOR MARKINGS

Jackrabbit fur is similar to rabbit fur, just less subtle and more distinctively salt-and-pepper. Black-tailed jackrabbits are mottled brownish-gray on top, buff on the sides and legs, and white on the belly. Jackrabbits also have white eye rings and nose patches.

OTHER RABBITS & HARES

GOING INTO DEPTH on all the rabbit and hare species is beyond the scope of this book, but here are a few of the more common and/or interesting ones.

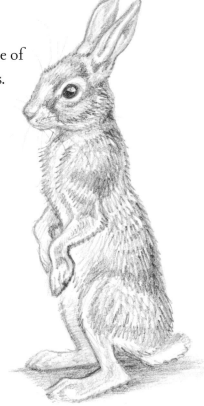

EASTERN COTTONTAIL

SYLVILAGUS FLORIDANUS

Similar in appearance to the desert cottontail, the larger eastern cottontail is found throughout much of eastern North America and into the West. In the more northern parts of its range, it has smaller ears. It is highly adaptable, but is especially at home in fields and thickets. These rabbits tend to stick to one small area, often spending a lifetime in a spot no larger than 10 acres. The brush rabbit (S. bachmani) is a small, dark rabbit that fills the cottontail's niche along the West Coast of the U.S. and Mexico.

MARSH RABBIT

SYLVILAGUS PALUSTRIS

These secretive rabbits are never far from water. They have dark brown fur with black tips, a cinnamon-colored nape of the neck, lighter undersides, and a brownish to grayish tail. These rabbits may sometimes walk on their hind legs! They often use water to escape predators, sometimes submerging so that only their eyes and nose appear above the surface. The somewhat similar swamp rabbit, also a denizen of southern wetlands, is the largest North American rabbit, weighing up to 6 pounds.

PYGMY RABBIT

BRACHYLAGUS IDAHOENSIS

The pygmy rabbit is unique in two ways: It is North America's smallest rabbit, and it is the only native rabbit that digs its own burrow system. Pygmy rabbits prefer a certain kind of sagebrush desert, living in a relatively small portion of the Interior West, and are seldom seen. Their tails are gray.

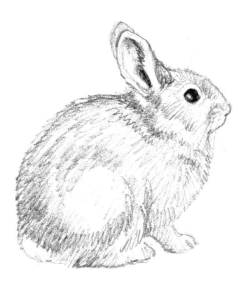

SNOWSHOE HARE

LEPUS AMERICANUS

The snowshoe hare, also called varying hare, is named for its enormous feet, which carry it easily over snow and ice. One of the smallest hares, the snowshoe is noteworthy for its seasonal color change. It is white in the winter (except for black-tipped ears), and turns brown, with a white belly, during summer. Hares in parts of Washington and Oregon stay brown all year.

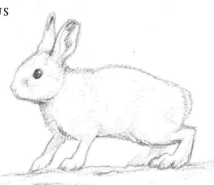

Summer (LEFT) and winter (RIGHT) coats.

WHITE-TAILED JACKRABBIT

LEPUS TOWNSENDII

Similar to the black-tailed jackrabbit in appearance, the white-tailed jackrabbit generally has smaller ears. Unlike a blacktail, it shares the snowshoe hare's color-changing ability, turning white in the winter and brown, with a white belly, in summer.

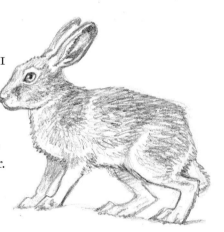

Winter (LEFT) and summer (RIGHT) coats.

PIKA

OCHOTONA PRINCEPS

The pika looks a bit like a hamster or a fat field mouse, but is actually in the same order (Lagomorpha) as rabbits and hares. Pikas live among high-altitude, rock-strewn hillsides. They can be found busily gathering vegetation during the summer months, then laying it out to dry in the sun. The pika stores this hay deep in its den among the rocks. When winter comes, it remains active inside its burrow, surviving on the food it gathered during the summer. Pikas are social animals that communicate through high-pitched bleating sounds. They have five toes on each front foot and four on each hind foot.

HOW TO DRAW A DESERT COTTONTAIL

FOR THIS DRAWING OF A DESERT COTTONTAIL, I used charcoal pencils. Charcoal is a great medium to use to achieve a soft, smudgy look that goes very well with the cottontail's delicate and rounded appearance. You can have a lot of fun as you work your way through the drawing, using your pencils and eraser to add and subtract as you go. Just be careful not to overdo dark smudges or they may end up dominating the piece and taking away from the soft, gentle effect desired here.

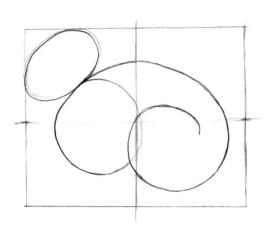

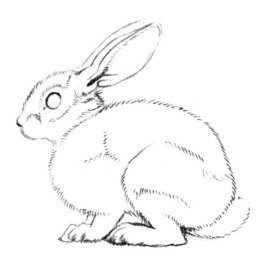

1. For the beginning sketch, I used a regular pencil. Start with the basic shapes as shown, using a box to help you measure proportions.

2. Add the face, ears, legs, and tail and build on the neck and rump. Finish laying down the details and transfer your drawing to a fresh sheet of paper, if needed. Use a 2B (medium) charcoal pencil to lay down the direction of the fur in most areas.

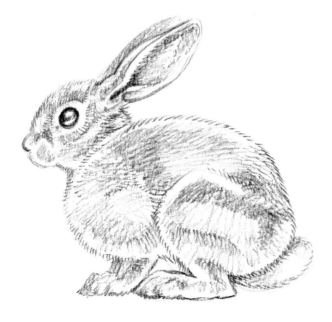

3. Using a 6B (extra soft) charcoal pencil, begin filling in space, using strokes to follow the direction of the fur and to indicate breaks and patterns. Begin shading in the eye, indicating the highlight. Using very soft strokes, shade in most of the rabbit.

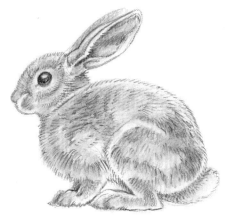

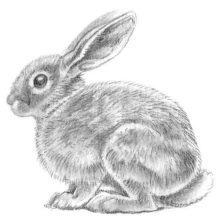

4. Wrap some tissue to form a sharp tip and use it to blend and smudge the charcoal. Smudge one part, then move on to the next. Do not smudge everything at once. Make sure to leave some details in the hair. Go back and add details again, this time with the 2B pencil. Shade in the eye, leaving the highlight, and add details to areas that need definition. Add breaks and irregularities in the hair pattern. Smudge the cottontail with the soft tissue again, working one section at a time.

5. Take out the kneaded eraser and shape a sharp point into it. Using this point, erase and pick out highlights in areas that may have become too dark, such as the front chest. Use the eraser to "draw" light hairs in smudgy gray spots. Then, using the 6B pencil, begin adding small, dark details to the head, shoulders, and under the feet. Shade in areas that have become too light, making sure to keep a sense volume to the form. Smudge again to soften. If a patch of fur looks right to you, skip over it and leave it be.

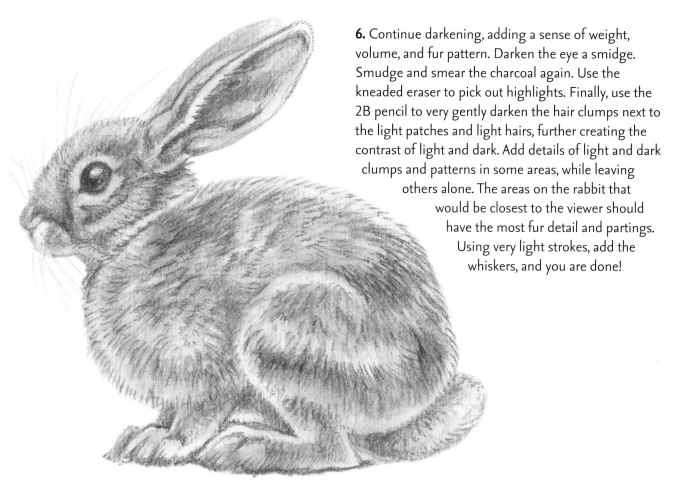

6. Continue darkening, adding a sense of weight, volume, and fur pattern. Darken the eye a smidge. Smudge and smear the charcoal again. Use the kneaded eraser to pick out highlights. Finally, use the 2B pencil to very gently darken the hair clumps next to the light patches and light hairs, further creating the contrast of light and dark. Add details of light and dark clumps and patterns in some areas, while leaving others alone. The areas on the rabbit that would be closest to the viewer should have the most fur detail and partings. Using very light strokes, add the whiskers, and you are done!

SQUIRRELS,

members of the rodent family Sciuridae, rank among the most familiar and successful of mammals. Tree squirrels, ground squirrels, chipmunks, marmots, and woodchucks have used their small size, adaptability, agility, and reproductive skill to inhabit almost every environment available, including the middle of cities. Covering every kind of squirrel is beyond the scope of this book, so here I will focus on the most familiar kind—tree squirrels (genus *Sciurus*). If you can draw tree squirrels, you can draw their relatives.

THE HEAD

Squirrels' heads have very pronounced eyes and eye sockets that lead abruptly to a narrow muzzle and typical rodent incisor teeth. From a side or three-quarter-angle view, the eye socket on the far side of the head gives the squirrel a pronounced high brow, which then falls sharply down to the muzzle.

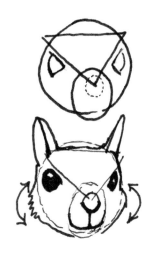

EYES: Squirrels have large, dark eyes that seem to bulge out of their eye sockets. The eyes are bright and alert for trouble. The pupils are round.

EARS: The ears of a squirrel are thin, upright, and rounded at the tip. They are not very expressive or flexible.

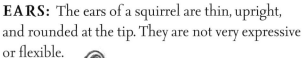

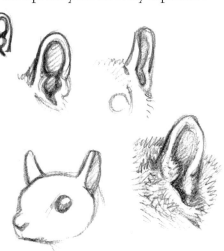

NOSE: A squirrel's nose protrudes noticeably in front of its jaws, especially when viewed from the side. Squirrels have small nostrils that are not always easily seen, except from below.

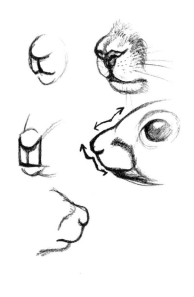

THE BODY

Squirrels have an oval-shaped body with strong, flexible arms and legs. They have the somewhat hunched appearance typical of rodents and, especially when sitting, their backs may look very humped and rounded from the side. Their full, lively tails add to the expressiveness of their bodies. Like many rodents, a squirrel can flatten its body fairly well in order to squeeze into tight areas.

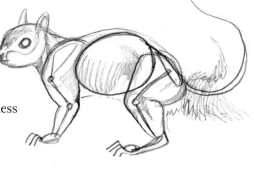

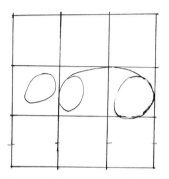 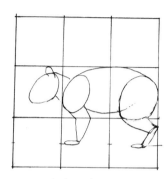 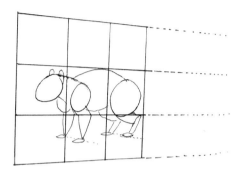

Some basic geometric shapes to keep in mind when drawing a squirrel.

FEET: Squirrels have four toes on the front foot and five toes on the hind foot. The toes are long and thin with knobby knuckles. The tips of the toes have fleshy pads and long, curved claws.

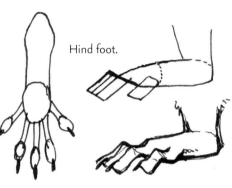

Hind foot.

Front foot.

LEGS: Squirrels have strong, supple limbs and thick thighs that run and climb with ease. Their legs appear somewhat thin if stretched, but much rounder and shorter when muscles are bunched together (the "squash and stretch" effect).

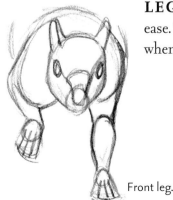

Front leg.

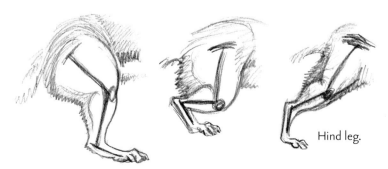

Hind leg.

TAIL: The tail of a tree squirrel is one of the most expressive and important parts of its appearance. Squirrels' tails almost seem to have a life of their own, as they flick them about, curl them over their backs to act as a parasol, or angle them behind for balance. The entire tail is about as long as the head and body and is shaped almost like a tongue, being broad, flexible, and somewhat flattened.

Underneath the fur is a rat-like tail with long hair radiating out along its entire length.

FUR & TEXTURE

Squirrel fur is soft and dense. On at least some squirrels, the hair is long and thick on their backs and almost abruptly shorter and lighter on the belly. The fur of the tail is not as silky as the rest of the body, but is still fairly soft. Like most mammals, squirrels have summer and winter coats.

The tail hair is especially long and may part width-wise along the tail when the tail is bent.

SQUIRRELS IN MOTION

Squirrels are in motion a lot of the time, climbing trees, searching the ground for food, or perhaps begging for it from humans!

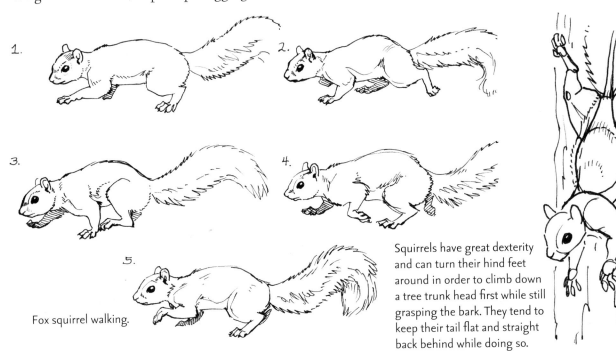

1.

2.

3.

4.

5.

Fox squirrel walking.

Squirrels have great dexterity and can turn their hind feet around in order to climb down a tree trunk head first while still grasping the bark. They tend to keep their tail flat and straight back behind while doing so.

SMALL MAMMALS

TASSEL-EARED SQUIRREL

Sciurus aberti

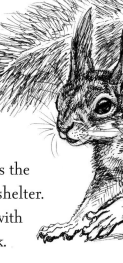

THESE BEAUTIFUL SQUIRRELS are found only in the vast ponderosa pine forests of the "Four Corner" states: Arizona, New Mexico, Utah, and Colorado. They are as dependent on these trees as the panda is on bamboo, using them for food and shelter. They are also colored similarly, so that they blend in with the charcoal grays and rich red-browns of the pine bark.

THE HEAD

The tassel-ear's skull is noticeably wide and round, with a lot of space between the eye sockets. It also has a very narrow muzzle, home to a lot of fleshy lip muscle and whiskers in life. Of course, as the name implies, the ears are very distinctive.

Looking for a tassel-ear? Evidence of this squirrel's presence includes clipped pine bough tips, pinecone shreddings, and small clipped twigs stripped of their bark.

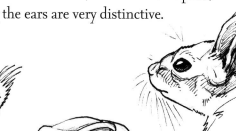

EYES, EARS, AND NOSE: Tassel-ears have round pupils and dark, beady eyes. In summer, the squirrel's hair is shorter and the ears may not be tasseled at all, but they still have long ears—longer than any other squirrel featured in this book. The ears may be a rich red-brown in the back and almost black on top. The nose juts out from the muzzle and is dark gray around the nostrils and on top.

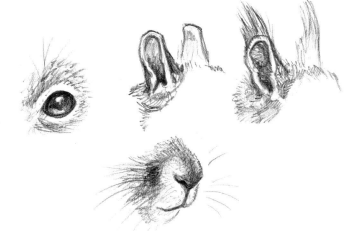

THE BODY
Tassel-eared squirrels are large tree squirrels—not quite as big as fox squirrels, but close.

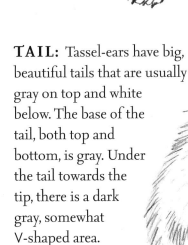

LEGS AND FEET: The tassel-eared squirrel's legs are flexible and strong. The feet have pronounced joints and dark claws.

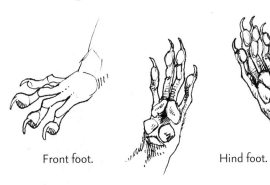

Front foot.

Hind foot.

TAIL: Tassel-ears have big, beautiful tails that are usually gray on top and white below. The base of the tail, both top and bottom, is gray. Under the tail towards the tip, there is a dark gray, somewhat V-shaped area.

COLOR MARKINGS
Tassel-eared squirrels come in several color variations. The most common and widespread is the Abert's squirrel. It is a grizzled dark gray on top and white on the belly, with a black stripe on its sides separating the two base colors. Abert's squirrels found in the southern parts of their range have a rich reddish-brown patch on their back and reddish-brown ear bases. More northern squirrels may be gray and white (but with no red), or they may be a solid black color!

Lastly, there is an isolated subspecies of Abert's squirrel called the Kaibab squirrel (*S. a. kaibabensis*), which is found north of the Grand Canyon in Arizona. This squirrel is all-black, except for an all-white tail!

Abert's squirrel fur.

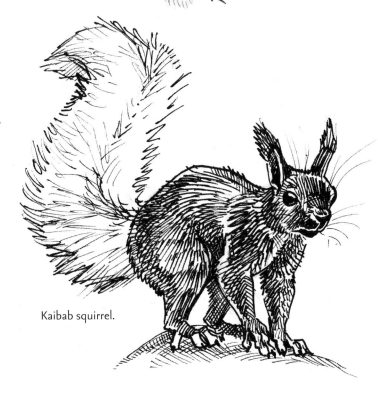

Kaibab squirrel.

OTHER SQUIRRELS

THERE ARE MANY DIFFERENT KINDS OF SQUIRRELS found in North America, and this book cannot feature them all. However, here is a brief overview of some of the more common or noteworthy species.

EASTERN GRAY SQUIRREL

SCIURUS CAROLINENSIS

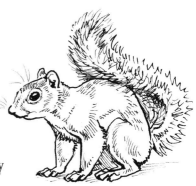

This squirrel is native to much of the eastern half of North America, as well as having been introduced to other areas, both in North America and abroad. This squirrel is generally gray in color with a white belly and some rusty-red accents. However, some populations of this squirrel regularly feature all-white or all-black individuals. There is a western gray squirrel species, which is mostly gray and white, without rust accents.

FOX SQUIRREL

SCIURUS NIGER

The largest of the tree squirrels, the fox squirrel may be named for its similarity in color to a red fox. The most widespread color phase is orange-red, with darker fur on the back and brighter orange on the belly. Other variations include some fox squirrels in southern states that may be black, with white on their noses and a silvery-black or dusky back, or a reddish body color with black and white markings on the head. Endangered Delmarva fox squirrels are mostly gray.

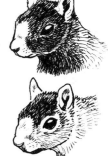

Fox squirrel color phases.

RED & DOUGLAS'S SQUIRRELS

TAMIASCIURUS HUDSONICUS AND T. DOUGLASII

These small squirrels are known for their chattering at forest intruders. They have large heads and big eyes. Red squirrels (shown here) are, naturally, reddish, with white bellies and eye rings and a black stripe on their sides. Douglas's squirrels are usually darker and grayer, with grayish to orange undersides. Both may have ear tufts in winter.

FLYING SQUIRRELS

GLAUCOMYS SPECIES

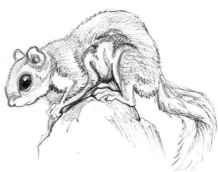

Flying squirrels do not actually fly, but have parachute-like folds of skin between their legs that they use to glide from tree to tree. They are nocturnal and have enormous eyes. There are two species of flying squirrels in North America: the northern (G. *sabrinus*) and the southern (G. *volans*), which is shown here.

ROCK SQUIRREL

Spermophilus variegatus

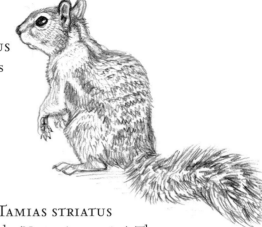

The rock squirrel is easily mistaken for a tree squirrel because of its bushy tail and occasional inclination to climb trees. It has mottled, salt-and-pepper backsides and whitish markings on its shoulders. Some are black. Rock squirrels are found in parts of the West.

CHIPMUNKS

Neotamias species and Tamias striatus

There are many species of western chipmunks (Neotamias species). They usually have strong facial and side stripes. The eastern chipmunk (Tamias striatus) lacks the distinctive facial stripes of western chipmunks. The golden-mantled ground squirrel (Spermophilus lateralis) could easily be confused with an eastern chipmunk, but they do not share the same range.

Western chipmunk.

Golden-mantled ground squirrel.

Eastern chipmunk.

PRAIRIE DOGS

Cynomys species

There are five species of prairie dogs in western North America. The prairie dog is a keystone species, meaning that a large number of other animals depend on it for food or the provision of shelter. A Gunnison's prairie dog (C. gunnisoni) is shown here.

ROUND-TAILED GROUND SQUIRREL

Spermophilus tereticaudus

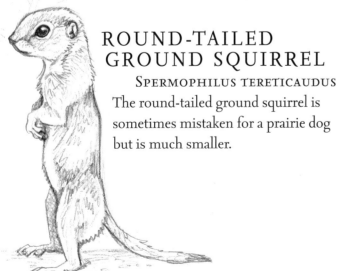

The round-tailed ground squirrel is sometimes mistaken for a prairie dog but is much smaller.

MARMOTS

Marmota species

Marmots, which include the woodchuck (also called groundhog), are large, burrowing squirrels. Think "wide and bulky" when drawing them.

Woodchuck (TOP) and yellow-bellied marmot (BOTTOM).

HOW TO DRAW AN EASTERN GRAY SQUIRREL

I USED A MECHANICAL PENCIL FOR THIS DRAWING. It is not a traditional art tool, but I often use mechanical pencil for fun and know other artists who do as well. I really like the crisp control it gives me. Other times I find a traditional pencil has a variation of line that can better create the effect I'm after.

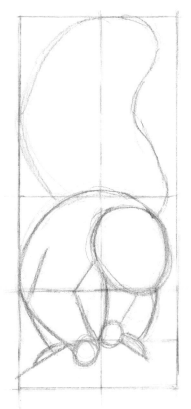

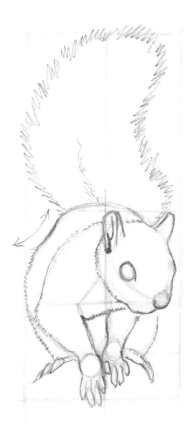

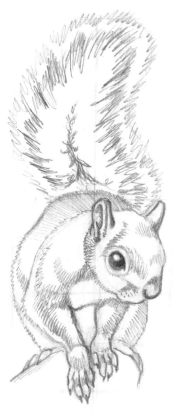

1. First I drew a rectangle and divided it in half; then I divided the lower part in half again, and again, as shown. I then began blocking in the squirrel's head and body.

2. I continued blocking in details of the head, tail, and feet and put in the final outline. I used an arrow to show where I "scooped in" a little bit on the backside, in the area of the squirrel between the bulge of the back and the bulge of the hindquarters.

3. I began to shade in the head and body, getting a feel for the form. I put in the white eye ring and white band on the tail. Note how I used almost horizontal strokes to indicate the hairs that are the most flattened and farthest away from the viewer, and used more vertical strokes in the less compressed area of the tail. I darkened the eye, but softened the highlight to make it look believable. I defined the dark cracks in the base of the fur in the tail, which will help make the surrounding hair look more fluffy and three-dimensional.

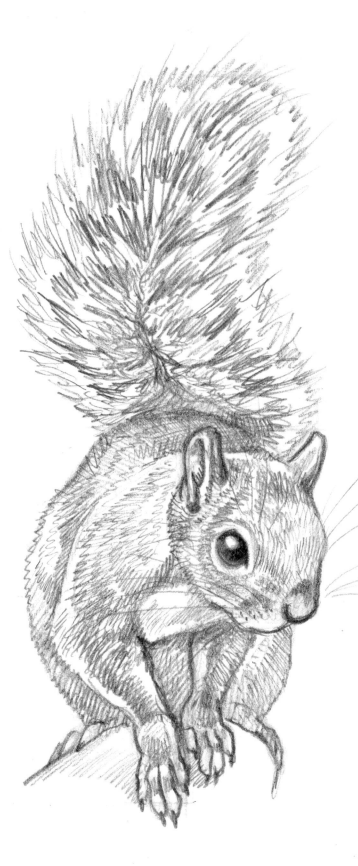

4. I continued to shade in the form, added fur details, and defined more of the tail, adding random longer strokes and more dark base crevices. I used minimum pencil pressure and short, squiggly lines to shade in areas around the face for a soft, short-haired effect. I used soft, longer strokes to connect the shorter fur, defining the back, front leg, and elsewhere. I shaded in the hind legs, using the darker areas to "pop" out the white edges of the front legs. I shaded the back and the tail base as needed, without letting these areas get too dark, or they would have popped out. I used horizontal, continuous, scratchy strokes to put "bands" into the tail. Finally, I added whiskers and gave a little shadow to the object the squirrel is standing on.

MICE & RATS

MICE & RATS seem to be living examples of the old adage "the meek shall inherit the earth." They are small, usually timid rodents that face a world full of enemies, yet are some of the most plentiful and successful mammals on earth. Mice and rats feature prominently in our imagination and in our storybooks and cartoons. There is an immense number of species in this family of rodents (Muridae), so I will focus primarily on common species, such as the harvest mouse and the deer mouse, with a detailed discussion of the brush mouse.

THE HEAD

Mouse heads are somewhat egg-shaped with a slightly pointy tip at the nose.

House mouse skull.

Some mice, such as the deer mouse (LEFT) have huge eyes that almost dominate their heads, while others have fairly normally proportioned eyes (RIGHT).

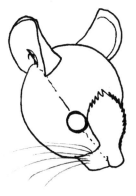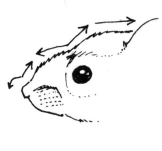

The muzzle of a mouse often features a prominent Roman nose in profile, leading down to a narrow, pointed tip that sticks out slightly from the rest of the muzzle.

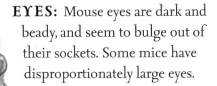

EYES: Mouse eyes are dark and beady, and seem to bulge out of their sockets. Some mice have disproportionately large eyes.

EARS: The ears of a mouse or rat are almost paper thin. They look wide from the sides but are quite narrow from the front, with a slight upward tilt of the tips. The ears are firm enough to hold their shape for the most part, but bend easily if touched. Most mouse ears are hairless, or nearly so.

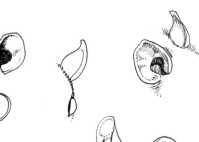

NOSE: As mentioned above, the muzzle of a mouse is often Roman-nosed, narrowing as it extends down to the nose tip. Underneath the pointy, protruding nose are fleshy lips. The lower lip is often bare and pink. Abundant whiskers are located just behind the nose on the muzzle.

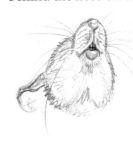

THE BODY

Mice have large heads and no noticeable neck. A mouse has short legs, delicate, pointy-toed feet, and an overall round appearance, in addition to a long, sometimes hairless tail. A rat is similar, but its head is smaller in proportion and its features tend to be sturdier and more defined.

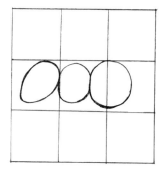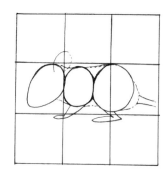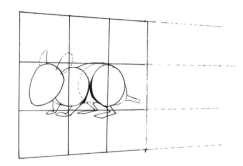

You can use a grid to help visualize a mouse's or rat's build.

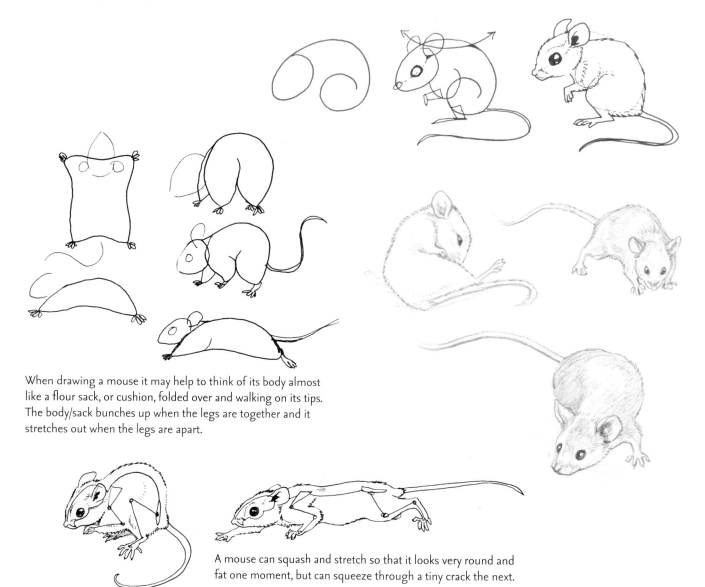

When drawing a mouse it may help to think of its body almost like a flour sack, or cushion, folded over and walking on its tips. The body/sack bunches up when the legs are together and it stretches out when the legs are apart.

A mouse can squash and stretch so that it looks very round and fat one moment, but can squeeze through a tiny crack the next.

SMALL MAMMALS

FEET: The front foot of a mouse usually has four toes and the hind foot has five. The toes are delicate-looking and have small but noticeable claws. Most of the foot is hairless and pinkish in color, although this varies by species. The most noticeable part of a mouse's legs would probably be the long hind feet: Pay attention to the ankle and where it is located.

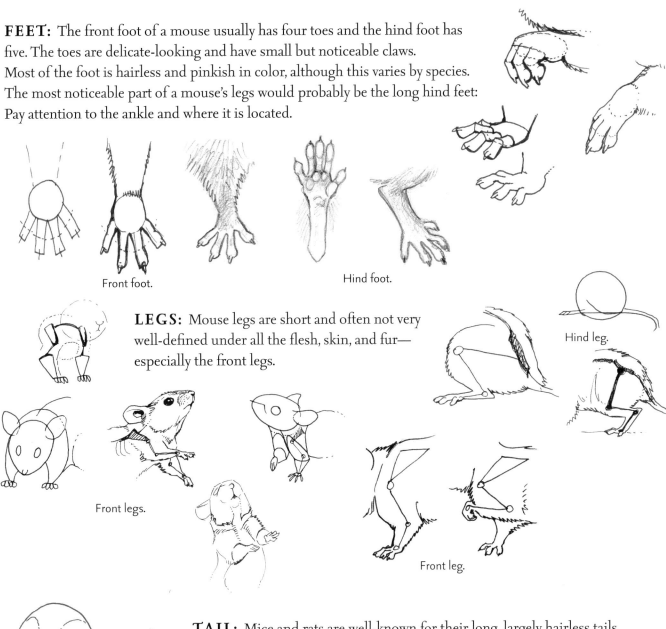

Front foot.

Hind foot.

LEGS: Mouse legs are short and often not very well-defined under all the flesh, skin, and fur—especially the front legs.

Hind leg.

Front legs.

Front leg.

TAIL: Mice and rats are well-known for their long, largely hairless tails. However, the amount of hair present depends on the species. Some mice and rats have fairly hairy tails: the bushy-tailed woodrat's namesake is exceptionally furry. The "average" mouse tail has some hair, but from a distance it may not show up very well. Mouse tails are often pinkish and usually scaly. Other tails may be bi-colored: dark on top and white below. Rat tails appear heavier than mouse tails, and the base on the rump where the tail attaches may be thicker.

FUR & TEXTURE

Mouse fur is very soft and sleek. It varies in color and ranges from furry and warm to smooth and glossy. Mice have such small limbs that their fur and skin can sometimes obscure some of their anatomy; studying the structure underneath is critical to a realistic portrayal.

MICE & RATS IN MOTION

With their short legs, mice and rats seem to glide over the ground with a rapid pitter-patter of feet. Their tails are usually stretched out behind them. They seem to always be in motion, moving from one spot to another, grooming themselves, or standing on their hind legs, front paws tucked up, and waving their head up and down as they seek information about their surroundings.

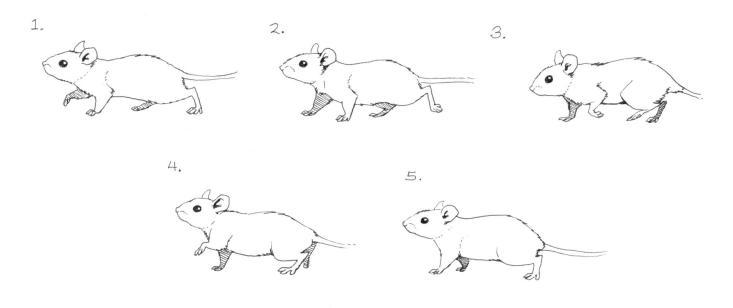

1.

2.

3.

4.

5.

COMPARING MICE & RATS

Mice and rats are very similar animals, but there are some key differences, the most noticeable being that rats are usually larger. Mice have comparatively large heads on small bodies and their legs (especially the front legs) are very delicate and undefined. A rat's head is much smaller compared to the rest of its body, and its proportions are generally larger. Its legs are more defined and muscular-looking than a mouse's, and the space between the front legs and hind legs is greater. The tail is often thicker than a mouse's, and a rat has more muzzle than a mouse, as well. There is some variation between species, and this is only a general guide.

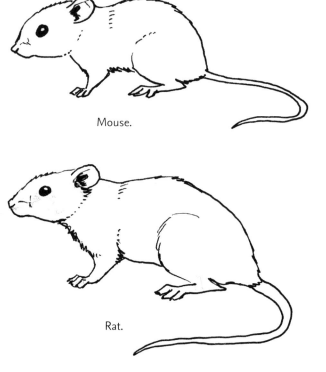

Mouse.

Rat.

BRUSH MOUSE

PEROMYSCUS BOYLII

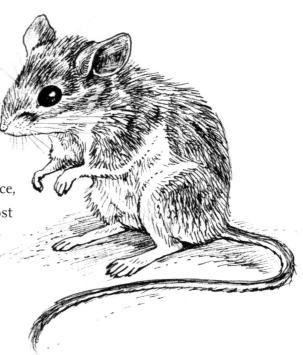

THE BRUSH MOUSE is a mostly southwestern species closely related to the more well-known white-footed and deer mice. It is a skilled climber and builds nests of dried vegetation, often found under rocks or in brush piles. Brush mice, like deer mice or white-footed mice, are sometimes the most abundant mammals in a given area, yet are only infrequently seen due to their nocturnal and secretive habits.

THE HEAD

A brush mouse's head is similar to a deer or white-footed mouse's head, with large eyes and a very pointed nose and muzzle.

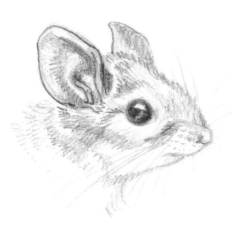

EYES, EARS, AND NOSE: The brush mouse has typical large, dark, bulging mouse eyes. The ears are oval-shaped, with a slightly pointy tip. The nose is small and surrounded by many whiskers.

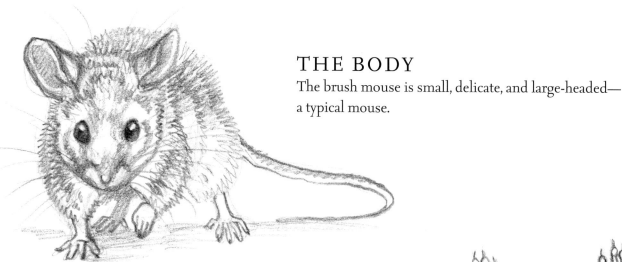

THE BODY
The brush mouse is small, delicate, and large-headed—
a typical mouse.

LEGS AND FEET: The front foot has four toes and a stubby bump
where a thumb might be on our hands. The hind foot has five toes,
but the inner toe is a bit farther up the foot than the others.

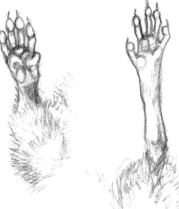

Front foot. Hind foot.

TAIL: The brush mouse's tail is long
and skinny. It is somewhat scaly,
but hair is present.

COLOR MARKINGS
The brush mouse is similar to a deer or white-footed mouse in coloration, with a gray
or brown top, buff-colored sides, and a white belly. The hair has a dark gray base.
The feet are lightly furred with white hair on top and naked below, showing pink skin.
The ears are essentially hairless. The tail is lightly furred, with dark coloration on top
and white below. The whiskers are black.

OTHER MICE & RATS

As there are far too many species of mice and rats to cover them all in this book, here are some of the more common and/or interesting ones.

DEER & WHITE-FOOTED MICE

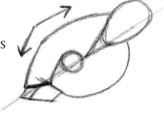

Peromyscus maniculatus and Peromyscus leucopus

These two species are very similar in appearance to each other and to the brush mouse. They have very large eyes, brown or gray dorsal areas, and white bellies. Their tails are bicolored: dark on top and white below. Their heads feature very large eyes and a Roman nose. Widespread and prolific, they enliven many a North American landscape.

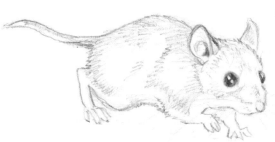

NORTHERN GRASSHOPPER MOUSE

Onychomys leucogaster

This unusual mouse is actually a predator! Identified by its short (only one-third to one-half the total body length), thick, white-tipped tail, it stalks the night, searching for prey, which might include insects, scorpions, or even other mice! This tiny hunter even "howls like a wolf," producing a high-pitched, prolonged cry while it points its head up and opens its mouth wide.

MEADOW VOLE

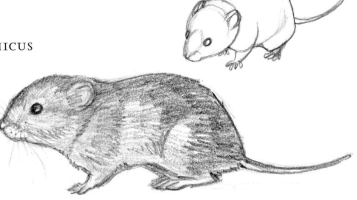

Microtus pennsylvanicus

Voles, close relatives of mice and rats, usually travel through runways in tall grass, underground burrows, or other shelter to feed and keep an eye out for predators. Voles usually have small features and a relatively chubby appearance. The red tree vole (Arborimus longicaudus), found along the Pacific Coast, spends its entire life in trees such as Douglas fir.

WESTERN HARVEST MOUSE

REITHRODONTOMYS MEGALOTIS

There are several species of harvest mouse, most of which are
brownish above and white below. The western harvest mouse is
shown here. It has a naked tail and pink feet. Harvest mice
eat mostly seeds, storing them away for later use, but
may take an occasional insect as well.

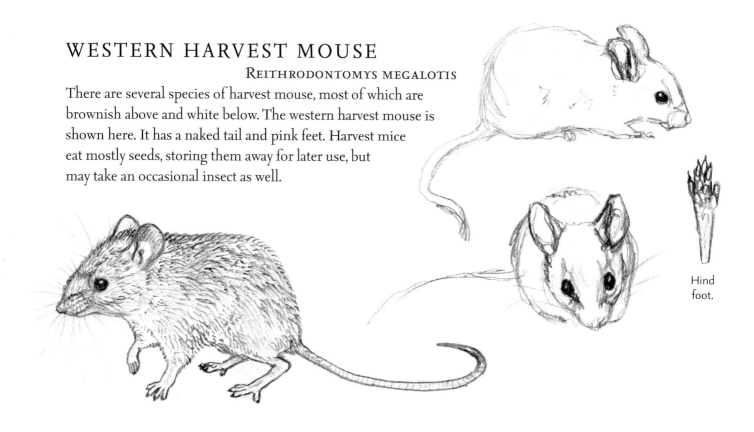

Hind
foot.

WHITE-THROATED WOODRAT

NEOTOMA ALBIGULA

Several species of woodrats live in various parts of North America. Also called packrats, woodrats are well-
known for their strange habit of "trading" items. A camper leaving his or her watch by the sleeping bag late at
night may wake the next morning to find the watch gone, and a shiny pebble in its place! This phenomenon
probably has more to do with the rat carrying one item in its mouth, finding something better, and leaving
the old item to carry away the new. Woodrats take all these found objects to their nests, which are usually quite
large and obvious piles of sticks, cactus, other vegetation, and occasionally things like bones or human litter.
Generally, these rats are brownish-gray on top with white bellies. As its name implies, the white-throated
woodrat has a white throat, as well as feet and belly.

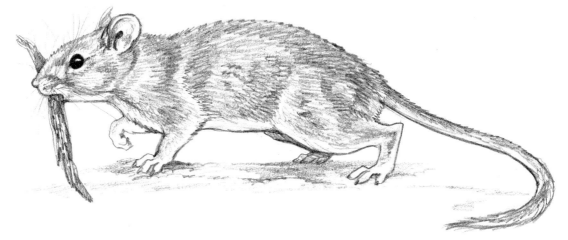

ORD'S KANGAROO RAT

DIPODOMYS ORDII

Kangaroo rats are not really rats at all. These interesting nocturnal rodents are adapted to a desert climate, and some species are capable of going a lifetime without ever having a drink of water, getting all the moisture they need from their food. They have external cheek pouches in which they can carry their food, which consists of seeds and other vegetation. Like their namesake, kangaroo rats can hop along quickly on powerful hind legs, making a quick getaway from numerous predators. They have sleek runner's bodies, small ears tucked tight to their head, and large eyes. They have a very Roman-nosed muzzle, which narrows to a more pointed nose tip. The kangaroo rat's head is very large compared to its body.

DESERT POCKET MOUSE

CHAETODIPUS PENICILLATUS

The pocket mouse is also not really a mouse, and is more closely related to the kangaroo rat. Like the kangaroo rat, it has cheek pouches for carrying food and is adapted to a desert climate. It can hop along like a miniature kangaroo, but is not as graceful or strong at it as a kangaroo rat is. The desert pocket mouse is grizzled brown above and lighter below, with a bicolored, tufted tail. Its feet are mostly bare and pinkish, but the hind feet have some light hairs on top.

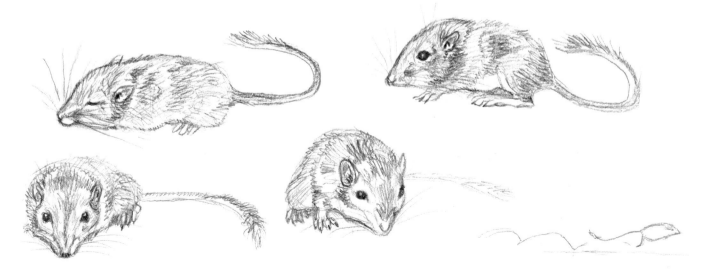

HOW TO DRAW A WESTERN HARVEST MOUSE

I USED A 2B GRAPHITE DRAWING PENCIL to portray this western harvest mouse. Like all mice, it is small, round, soft, and timid-looking. As you work on this subject, be sure its legs and other features do not look too well-defined, or you will lose some of the soft, almost pillow-like form of the mouse. A high-contrast, bulging eye will effectively convey some of the nervous tension often apparent in such small creatures.

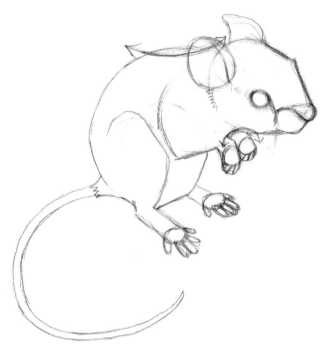

1. Block in the basic body shapes as shown.

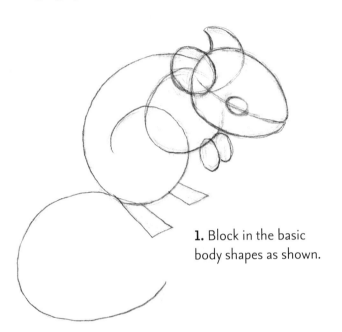

2. Add details, defining more of the shape of the mouse. Add subtle "dips" to the head to indicate the bulge of the far-side eye and the nose. Add the closest hind leg and add an elbow to the closest front leg, and flesh out the tail. Block in more of the feet, nose, and ears. Continue refining the details on the mouse. Add form to the nose and muzzle, and draw in the toes. Add a slight depression behind the head, as shown, to emphasize the bulge of the back and shallowness of the shoulders.

3. Finish the basic drawing outline, shading inside the ear canal, the farthest front foot, and other major compression/depression areas. Begin adding tone and texture that you can build upon, throughout the body. Begin hinting at a highlight in the eye. Remember that mouse eyes bulge out from their sockets.

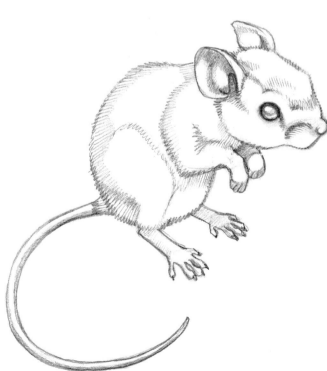

SMALL MAMMALS

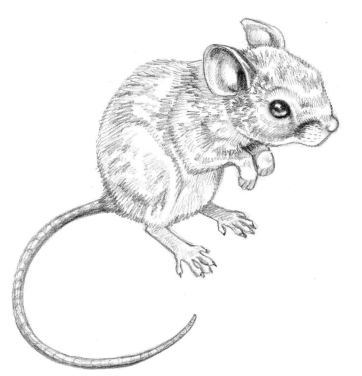

4. Continue shading the fur. Add squiggly lines on the areas that appear to be facing the viewer (these will be breaks and partings in the fur later on). You should keep the fur facing away from the view smoother and less detailed, because you wouldn't be looking into it and seeing its partings. Add soft rings to the tail, keeping in mind how the "ring" wraps around the tail. Add the roots of the whiskers near the nose. Shade the eye. Darken the spots where the muzzle meets (and compresses into) the rest of the head, on the ears, and under the chest.

5. Using a soft and broad stroke, shade in most of the mouse's body. Just be sure not to obscure the previous pencil strokes too much. Allow the areas behind the ears and under the chest to darken, hinting at changing angles of the form. Shade and darken the hindquarters and the feet. Go back over the tail and add scales. Darken inside and along the base of the ears, along the back, under the belly and chest, and anywhere the form needs to be deepened. Make sure the ears are "readable" against the fur of the head. Add shading and hair details to the back and forearm, softening the contrast between light and dark but leaving shiny, glossy "highlight" areas. Keep the light line that separates the head and shoulder, but darken and soften the shoulders. Add whiskers and you are done!

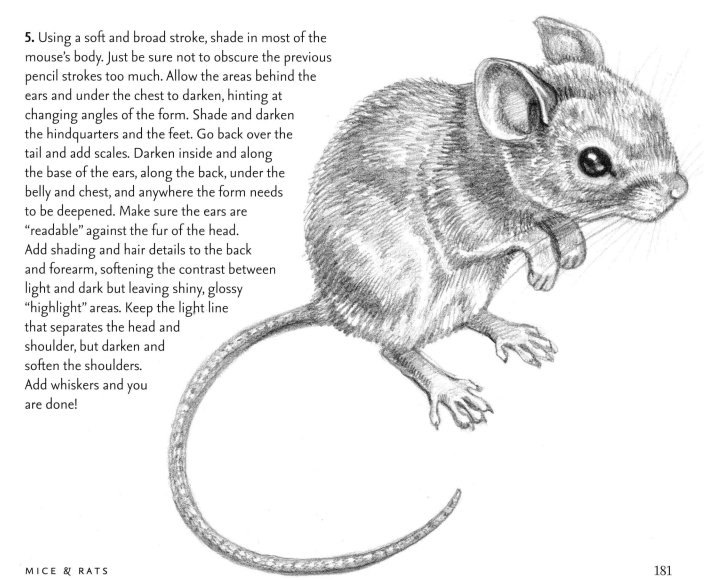

BEAVER

CASTOR CANADENSIS

THE INDUSTRIOUS BEAVER is North America's largest rodent, weighing up to 60 pounds or even more! Beavers are well-known for their ability to dam streams with sticks and logs, creating a rich wildlife habitat known as a beaver pond.

THE HEAD

A prominent feature of the beaver's head is its teeth. This is particularly obvious when looking at the skull. The beaver uses its teeth constantly, chewing down trees and cutting branches. However, the teeth do not always show on the live animal unless its mouth is open and chewing on something. The eyes, nose, and ears are all positioned fairly high on the head, so that they are exposed above water when the beaver is partially submerged.

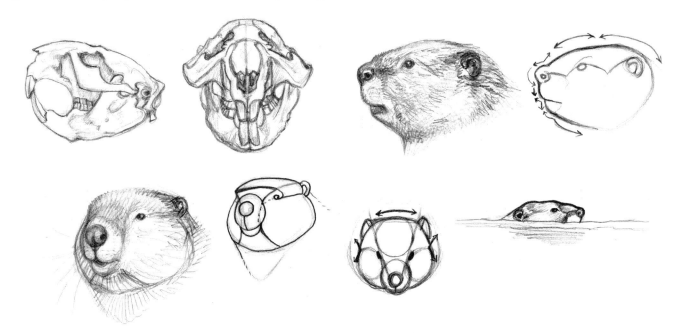

EYES, EARS, AND NOSE: The beaver's eyes are small, dark, and beady and the ears are small and round. The nose and nostrils are also rounded and there is a long space between the nose and upper lip.

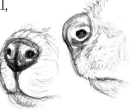

SMALL MAMMALS

THE BODY

The beaver is a rather round, well-fed looking creature. It has the hunched appearance of a rodent and its head seems an almost neckless extension of its body. There is a certain sleekness to this rodent, too, and few distinct or harsh edges to its body.

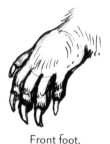

Front foot.

Hind foot.

LEGS AND FEET: A beaver has short legs. The hind foot is webbed; the front foot is not. Both feet have five toes.

TAIL: The beaver has a very distinctive tail: flat, scaled, and oval-shaped. It can be slapped on the water's surface as a warning and used as a rudder while swimming. The base of the tail is thick and contains oil glands the beaver uses when grooming to keep its fur waterproof.

COLOR MARKINGS

The beaver is an overall brown color, with a darker tail, nose, ears, and eyes. It has an exceptionally soft, spongy, buoyant, and thick fur coat, which has been highly prized by humans for centuries. Whether the fur is wet or dry greatly affects the animal's appearance.

When the pelt is dry (TOP LEFT), a beaver looks much lighter, furrier, and rounder. When wet (BOTTOM LEFT), the pelt clings to the animal.

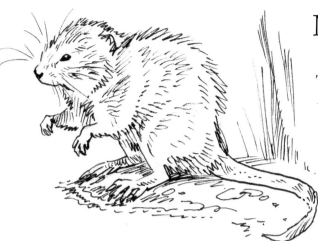

MUSKRAT

Ondatra zibethicus

The muskrat, like the beaver, is an aquatic rodent with a thick, lustrous pelt. However, it is not a close relative of the beaver. It is in the same family as mice and rats, and is basically a large vole. Often spotted swimming in cattail ponds and marshes, it builds lodges and complex tunnels and runways. As it's name implies, the muskrat possesses strong musk glands used for scent marking.

THE HEAD

The muskrat has a small, oval head with prominent teeth. Like most rodents, it has no visible neck.

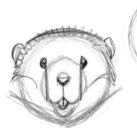

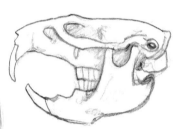

THE BODY

The body is furry and oval-shaped, with no harsh lines. The front and hind feet each have five toes. The hind feet are partially webbed. The muskrat's long, scaly, and thin tail is flattened vertically and tapers to a point.

Hind foot.

COLOR MARKINGS

The fur of the muskrat is much like a beaver's. Its claws are light-colored and its lips, throat, and belly may be much lighter than its backside.

PORCUPINE

ERETHIZON DORSATUM

"WALKING PINCUSHION" aptly describes this large, slow-moving rodent. The porcupine carries about 30,000 hollow, barbed-tip quills that make most predators think twice about dinner. Porcupines can't throw their quills, but they are loosely attached and come off easily. Protected by their coat of armor, porcupines wander about the countryside, searching for the inner bark of trees and other vegetation.

THE HEAD

Porcupines have very blocky, square heads, small eyes, and dark faces.

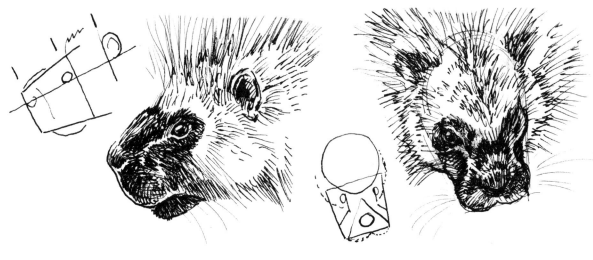

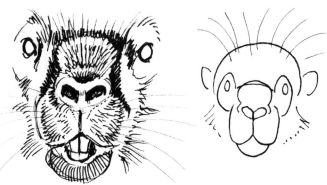

EYES, EARS, AND NOSE: The eyes are small and beady, but sometimes the whites of the eyes may be visible. The ears are round, dark, and sometimes partially obscured by hair. The porcupine's nose is somewhat heart-shaped, with open nostrils.

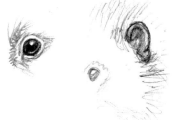

THE BODY

Porcupines, who are almost never in a hurry, have very pudgy, rounded bodies. They look a little bit like big, bristly, long-legged guinea pigs.

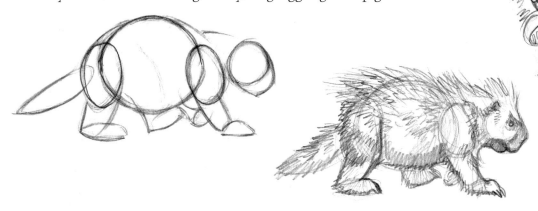

LEGS AND FEET: The porcupine's legs give it a waddling, almost club-footed appearance. Hair covers the top of the feet and tends to obscure toe details, but the long claws show through. The bases of the feet are padded. The front foot has four toes; the hind foot has five.

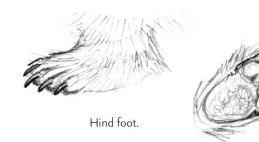

Hind foot.

Front foot.

TAIL: The tail is somewhat short, has a thick base, and is covered with many quills.

COLOR MARKINGS

The porcupine sports two coats: one a coat of long, thin hair and the other a short, thick cushion of quills. The quills are whitish, with dark tips, while the hair is partly dark gray-brown and partly yellow to tan. Overall this creates a very yellow-tinged, salt-and-pepper look to its coat.

The full winter coat makes the porcupine look exceptionally furry, while in spring or summer porcupines are much scruffier looking.

Many times one will encounter porcupines that have little hair around their rump area, creating an almost circular pad of bristling quills to present to an enemy. I've included an example of that here.

186

OPOSSUM

DIDELPHIS VIRGINIANA

THE OPOSSUM is North America's only marsupial, raising its young in a pouch in the female's belly. It is also one of our oldest species of mammals, having been around about 70 million years and still going strong. It possesses fifty needle-sharp teeth, the most of any North American land mammal. These slow-moving marsupials are well-known for "playing 'possum," where the animal feigns death in an attempt to discourage would-be predators. The opossum may not be the swiftest, strongest, or even the brightest animal around, but it seems to be doing something right, and should be around for a long time to come.

THE HEAD

Opossums have very pointed faces and prominent muzzles. When their mouth is open, their pink lips form a sort of grimace and they can seem like they are "all teeth." Their dark eyes contrast with their white faces and they have a profusion of whiskers.

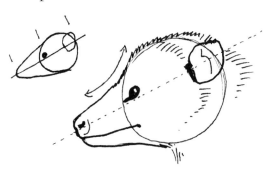

EYES, EARS, AND NOSE: The eyes are dark and rounded, but slightly pointed down at the front (tear duct) and up at the opposite end corner. From these points, opossums may have some dark coloration on their fur, further accenting the contrast of the dark eye to the white face. The ears of an opossum are rounded, almost oval-shaped. They are thin, hairless, and crinkled, with tips that are slightly pointed and upturned from the top angle. In the northern parts of their range, 'possums get frostbite and sometimes lose parts of their ears. The ears are black and usually have white to pinkish tips. The opossum's pink nose is very noticeable and shiny. The nose's edge is not sharply defined. It has very upturned nostrils and a vertical wedge in the center of its nose.

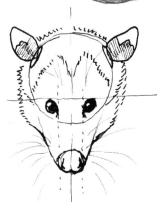

THE BODY

The opossum has a hunched, rounded body with short, sturdy legs.

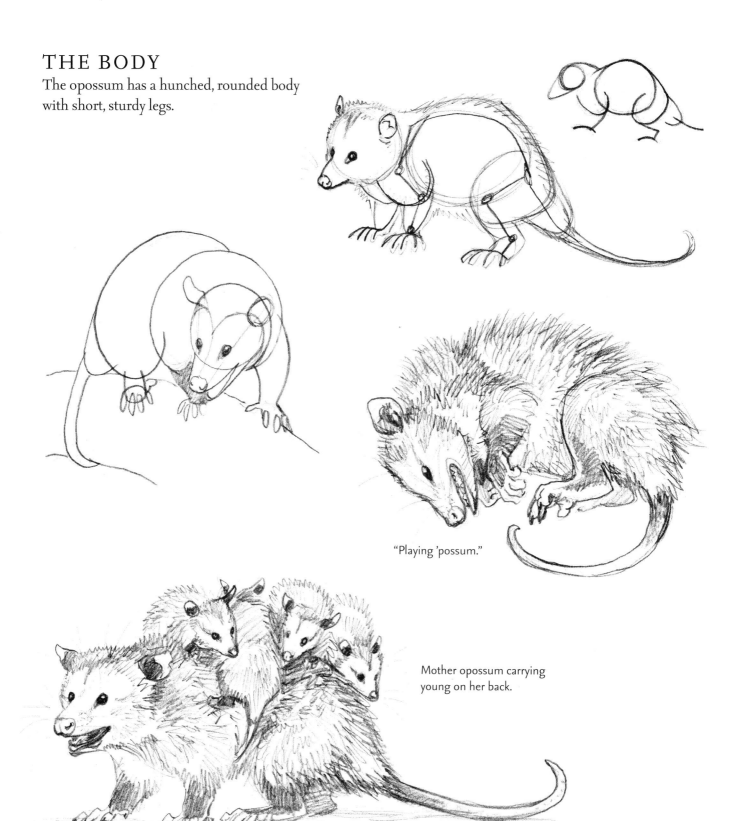

"Playing 'possum."

Mother opossum carrying young on her back.

LEGS AND FEET: Opossums have short but sturdy legs that are dark gray in color, ending in pink, hairless toes. As the leg goes down toward the toes the hair gets shorter. The top of the main part of the foot is dark, but the bottom palm, like the toes, is pink. The hind foot features a clawless, opposable thumb that helps in tree climbing!

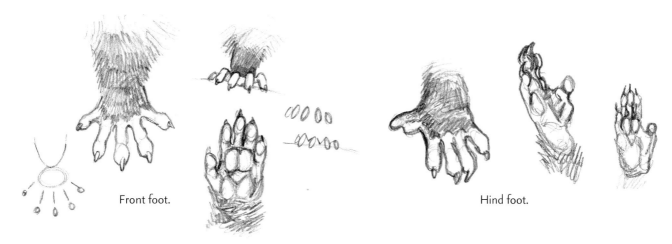

Front foot.

Hind foot.

TAIL: The opossum has a hairless, prehensile tail. Opossums are famous for hanging by their tails, which frees the rest of their feet for other uses, such as climbing or plucking fruit. However, only young opossums are able to hang solely by their tails—older 'possums are too heavy and need the additional support of at least a hind leg to help them. The tail has a dark base that extends beyond the fur line, then abruptly changes to a pinkish or pale color.

COLOR MARKINGS

Opossums are creatures of contrast as far as coloration goes. They have white faces accented by dark ears and eyes and bright pink noses and lips. Their light grayish bodies are bordered with gray-black legs, which in turn are tipped with bright pink toes. The fur coat of a 'possum is a very salt-and-pepper, grizzled looking thing. Basically, it looks like it has a grayish base with lots of whitish hairs springing from it. Some opossums are very scruffy looking, but some can be quite handsome, in my opinion.

NINE-BANDED ARMADILLO

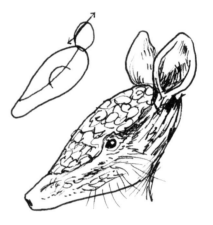

Dayspus novemcinctus

The armadillo is a definite contender for oddest mammal. Related to sloths and anteaters, the armadillo is the only mammal in North America that is armored with heavy, bony plates. It can roll into a ball, protecting its soft underbelly and presenting a predator with only hard scales to sink its teeth into.

THE HEAD

Armadillos have very elongated heads. Their eyes are small and they tend to keep their noses down toward the ground. They have a plate of armor above their eyes on their forehead. Some possess hair along the jawline.

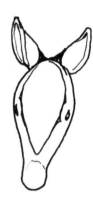

EYES, EARS, AND NOSE: The eyes of an armadillo are tiny and dark. The armadillo's nose is long, but lacks any strong features, and the ears are somewhat pear-shaped.

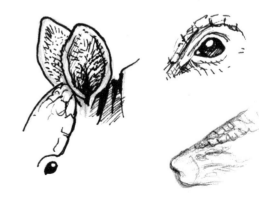

THE BODY

The armadillo has a hunched appearance, but can move surprisingly quickly when it wants to. There are usually nine bands running vertically around the middle of the creature, hence it's name, *novemcinctus*, which means "nine-banded."

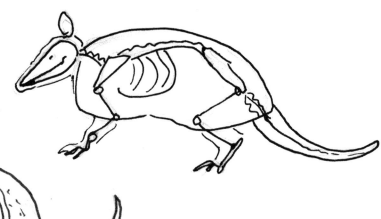

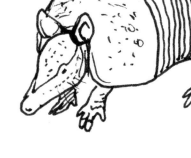

LEGS AND FEET: The armadillo's front foot has four toes. Its hind foot has five toes.

Front foot. Hind foot.

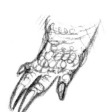

TAIL: The armadillo's tail is long, pointed, and covered with scales.

COLOR MARKINGS

The armadillo is a grayish creature without much hair; most of what little hair it has is found in its smooth belly and lower, non-armored areas.

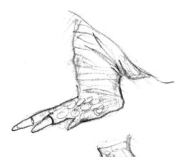

Most of the scales on the armadillo's armor plates are circular (LEFT), but the bands and tail feature more M-shaped scales (RIGHT). The M-shaped scales have darker edges toward the front and are light where they face back toward the rear of the animal.

INDEX

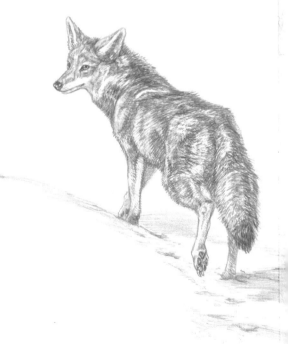

I hope you have enjoyed this artistic journey through the rich and fascinating world of wildlife. It has been a very rewarding experience for me. May your own future journeys be as fulfilling!